The Practical Handbook of
COLOR
for Artists

BARRON'S

The Practical Handbook of COLOR for Artists

Original title of the book in Spanish: *Manual práctico del color para artistas*
© Copyright 2012 ParramonPaidotribo–World Rights
Published by Parramon Paidotribo, S.L., Badalona, Spain

Production: Sagrafic, S.L.

Translated from the Spanish by Michael Brunel and Beatriz Cortabarria.

First edition for the United States, its territories and dependencies, and Canada,
published 2013 by Barron's Educational Series, Inc.
English edition © 2013 by Barron's Educational Series, Inc.

All inquiries should be addressed to:
Barron's Educational Series, Inc.
250 Wireless Boulevard
Hauppauge, New York 11788
www.barronseduc.com

Editor: María Fernanda Canal
Assistant Editor: M. Carmen Ramos
Text: Gabriel Martín Roig
Exercises: Josep Asunción, Armand Doménech, Mercedes Gaspar, Gemma Guasch,
Gabriel Martín, Esther Olivé de Puig, Oscar Sanchis, David Sanmiguel, and Ivan Vinyals
Graphic Design: Toni Inglés
Photography: Estudi Nos & Soto
Layout: Estudi Toni Inglés

ISBN: 978-1-4380-0196-8
Library of Congress Control Number: 2012026177

Library of Congress Cataloging-in-Publication Data
Manual práctico del color para artistas. English
 The practical handbook of color for artists / translated from the
Spanish by Michael Brunel and Beatriz Cortabarria.—First edition.
 pages cm
 Translation of: Manual práctico del color para artistas.—Barcelona :
Parramón ediciones, S.A., c2013.
 ISBN 978-1-4380-0196-8
 1. Color in art. 2. Color. 3. Painting—Technique. I. Title.
 ND1488.M2513 2013
 701'.85—dc23 2012026177

Printed in Spain

9 8 7 6 5 4 3 2

The Practical Handbook of

COLOR

for Artists

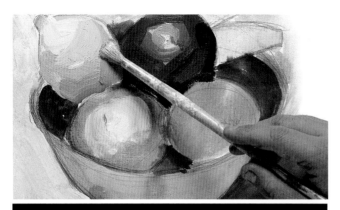

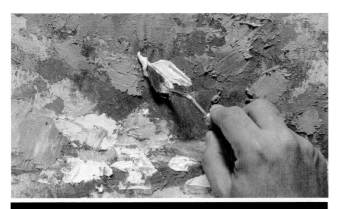

A World of Colors

Color is the basic artistic element of painting, the primary language that the artist uses to communicate and organize the great number of different visual stimuli to explain any concept. However, in essence, it is an abstract concept, it has its own meaning, and it takes on the value of a symbol, able to communicate and reaffirm an idea.

The distribution of color on the surface of a painting is a very powerful design element, a basic attribute of the painting that contributes to creating the form and structure of the model that is being represented. The colors interact with each other on the support, affecting and relating to each other and causing a great number of different effects. Because of this, the medium of painting lives up to its full potential and richness through these mixtures and combinations. This means that color is expansive, it does not toe the line or remain enclosed by the outlines, since it can be blended, gradated, and mixed with nearby colors to contribute in great measure to accentuate the imitation of nature in art, with the intention of increasing the sense of truth and reality.

The study and mastery of color mixtures and combinations is very important for any artist, since it makes their work better and easier, and it helps them better control the final result of any painting. Another fundamental aspect that may not be obvious is the emotive component, which is able to stimulate our senses. Colors affect our emotions much more than we think and can create such disparate states as sadness, desperation, torment, unease, and violence; all in subtle or very evident ways, meant to attract attention or stimulate desire.

Therefore, knowing colors and using them well is essential for any artist. Mastering the combinations of colors in a work creates a valuable opportunity for increasing the artistic value of a painting, emphasizing certain elements so that the objects represented take on the importance they require.

■ **"Color**
 is nothing
unless it relates to the theme
 and increases the effect
 of the painting in
 the viewer's imagination."
 Eugène Delacroix

EXPLORING COLOR
Perception, Schemes, and Synthesis

Before beginning to paint with colors, it is necessary to learn to see, observe, and recognize the colors in the model itself. To be able to identify and classify them, you must first know how they are distributed, classified, and located within a universal scheme that is known as the color wheel. This simple operation will help you to understand how colors are related to each other so you can make better use of them. Using them correctly adds character or a distinctive atmosphere to any theme. Learning to evaluate colors and work with them is the first step toward creating successful artwork. The lack of confidence among many beginning artists is in great part due to an ignorance of these schemes and basic principles for classifying colors. It is very important to have an understanding of these diagrams and color scales to be able to adequately use color.

DIAGRAMS AND SCALES

On The Lake. Berthe Morisot (1841–1895). This is a beautiful color exercise where each brush mark tries to capture a brief impression of light. The short brush marks suggest groups of colors and the reflections on the water.

It is surprising to discover that it is often difficult to recognize the colors on a real model, especially for those who are not accustomed to painting. Over time, both amateur and professional painters develop a greater sense of appreciation and ability to distinguish colors and their shades than people outside the world of painting.

A good way of learning to identify colors is to learn some basic schemes that will help classify them. Seeing them in an ordered framework and understanding how they relate to one another will help you to differentiate and identify them more clearly in objects and their environment. Therefore, if you hope to master and manipulate colors, you must first understand the basics: their origin, the spectrum, the order in which they are generally seen, and the most effective mixtures and combinations. To this end we will use diagrams and scales consisting of the gradations of colors in all the ranges, and scales that organize them and group them into families.

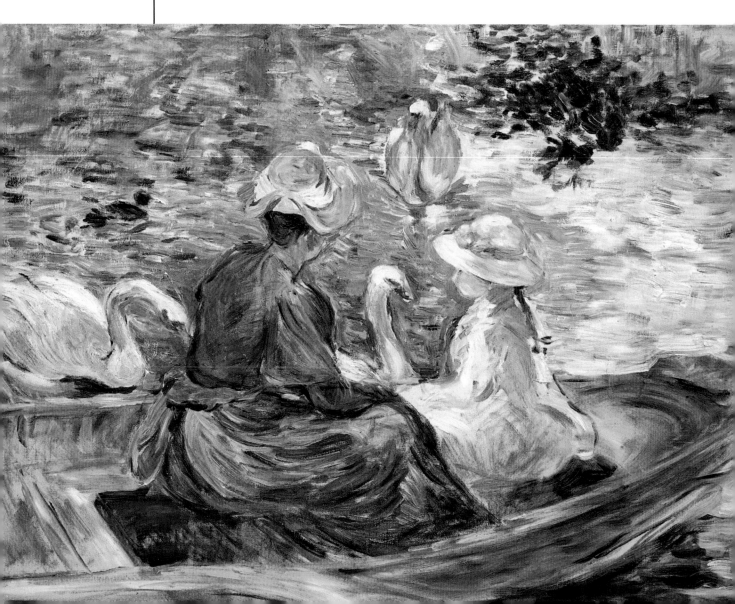

■ **"Drawing and color**
are not completely separate;
as the painting progresses, so does the drawing.
The more harmonious the colors,
the more exact the drawing."

Paul Cézanne

Line and Color

Some schools of painting treat the
stroke or line as the most intellectual
element of a painting because it
organizes, limits, and gives structure
to the work. Color is seen as a
genuinely sensorial element, a pure
reflection of the artist's expression
and state of mind.

A Wide Range

The important thing in this first chapter is color itself, independent
of nature, as a component in an order that exists on its own, apart
from nature, and that must be analyzed before starting to paint.
Whether you are painting with oils, acrylics, or watercolors, the
ranges of color are extremely wide, which sometimes creates
doubt. It is not necessary to buy them all; a few will be enough,
just those that are strictly necessary. However, to make choices it
is a good idea to know beforehand what your needs will be,
which colors you will use most and why.

Major paint
manufacturers sell a
wide range of colors.
They supply cards that
are a good tool for
identifying colors or
consulting a specific
shade or tendency.

The Color Wheel

Throughout history, researchers have attempted to organize colors in different ways, in both two-dimensional and three-dimensional formats, with different variables in mind. Finally, theoreticians and artists opted for a simplified form and illustrated a rational study of color harmonies with a color wheel (sometimes called a color circle). This wheel of colors shows the segment of visible light from the solar spectrum discovered by Newton, and it puts them in a specific order: red, orange, yellow, green, ultramarine blue, and violet. Its objective is to interrelate the colors of the spectrum and their derivations, defining their many transitions. It is based on the three basic colors and their resulting mixtures, a subtractive system that is usually adopted by professionals who work with paint, because it is thought that by mixing the three primary colors it is possible to create all the rest.

Specifications of the Color Wheel

This is based on the idea that the pure colors are derived from the three primaries: cyan blue, magenta, and yellow. When two of these primary colors are mixed with each other in equal amounts, secondary colors are created. Therefore, between each pair of primary colors all around the color wheel is a new color resulting from the mixture of the pair. Generally, tertiary colors are also included, inserted between each pair of contiguous colors, the result of mixing the primary colors in unequal proportions. The circle is then complete. Notice that the primary colors magenta, yellow, and cyan blue form an equilateral triangle within the circle. The secondaries orange, violet, and green, are located between the primary colors and form another triangle.

To understand how a color wheel is constructed, just imagine a fan with three blades, which are the primary colors: yellow, magenta, and cyan.

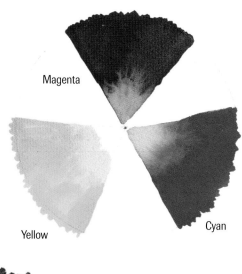

Magenta

Yellow

Cyan

Between the primary colors ❶ we can place the secondary colors, which result from mixing the primaries in equal proportions ❷, and the tertiary colors, which result from mixing the same colors in unequal proportions ❸.

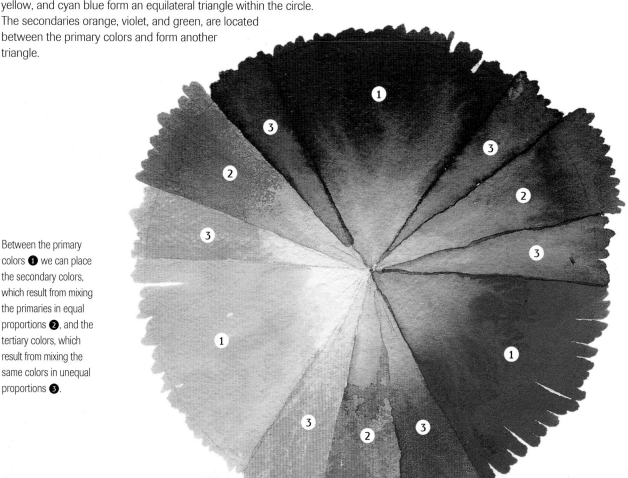

Cyan blue and magenta, in practice, are usually replaced with ultramarine blue and cadmium red or similar colors.

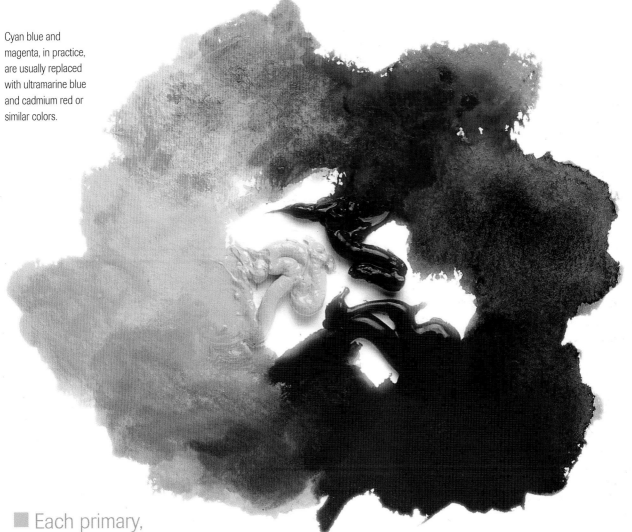

■ Each primary, secondary, and tertiary color has a level of **total saturation**, or brightness. This means that is has not been mixed with black, white, or gray.

From Theory to Practice

Contrary to what is stated in the color theory, it is not possible to mix the infinity of colors perceived by the eye, or those that are practical for use in painting, with just the three primary colors cyan blue, cadmium yellow, and magenta. In practice, cyan blue and magenta are used less frequently; they are usually replaced with ultramarine blue and cadmium red. However, this does not invalidate the theory; the results are very similar using these colors.

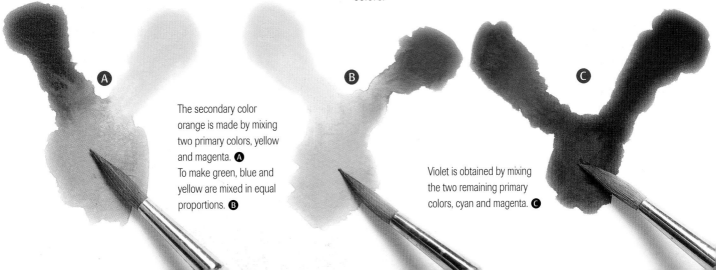

The secondary color orange is made by mixing two primary colors, yellow and magenta. A
To make green, blue and yellow are mixed in equal proportions. B

Violet is obtained by mixing the two remaining primary colors, cyan and magenta. C

Shades of Color

It is very important to understand the levels of saturation, tone, and value of a color to be able to model a form, locate the planes of a painting, and express volume. Accurate differentiation between the gradations of a single color creates an immediate sense of the space and content in a painting. Juxtaposing different gradations of one or several colors in a work creates intense and interesting results, since the differences between shades and tones add mysterious contrasts. Juxtaposing colors also adds movement and rhythm, carrying the viewer from lighter values to darker ones, in other words, from light to shadow.

Amount of Saturation

The amount of saturation or intensity of a color refers to its strength and vividness. A color is at its most saturated when it is pure, with no added black or white, maintaining the inherent strength of the original pigment. Cadmium yellow will lose intensity when it is mixed with white or if a bit of brown or black is added to it. Saturation can be reduced when a color is mixed with a small amount of another color that is diametrically across from it on the color wheel, for example, violet, the complement of yellow. Consequently the color will become grayer. The purity of the color, however, should be preserved in the areas where the greatest amount of light falls on the model.

When a single color shows small variations in shade or intensity, it is called gradations of color.

Here the most saturated yellows and oranges are seen in the sand, the area most exposed to the light. The yellow, when mixed with brown, black, or violet, loses saturation and becomes gray.

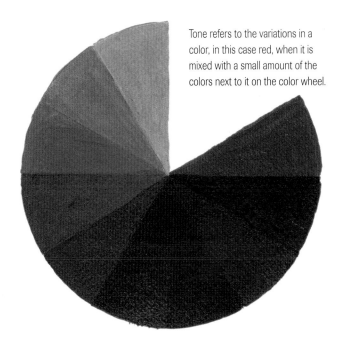

Tone refers to the variations in a color, in this case red, when it is mixed with a small amount of the colors next to it on the color wheel.

The values of a color are made from lightening it with white or darkening it with black. The result is a value scale.

The Difference Between Tone and Value

Very imprecise and contradictory words abound in the terminology used for talking about colors. To avoid confusion we will define these two concepts so that the artist will not use them arbitrarily. Thus, tone is an attribute of color that refers to how far that color has moved toward a neighboring color. For example, a yellow may have a green or orange tone. On the other hand, value refers to the transition from light to dark that can take place within a specific color, that is, each step in the variation of a color on its way to becoming black or white. Therefore, mixing a color with a little black or white will change its value without altering its tone.

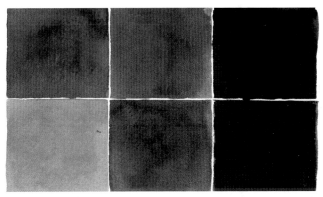

By mixing a little red with violet, yellow, black, and raw sienna, you can create a group of values of the same color, in other words, a small color scale.

The different red tones harmonize easily with one another although they differ from each other in intensity. This sketch was made by combining different gradations of red.

Monochromatic Schemes

Amonochromatic painting only uses one color, combining its diverse tonalities and variations, lightening it with white and darkening it with black or another color from the color wheel. In the beginning it can be difficult to learn to practice monochromatic painting, but limiting the color will help you to focus and pay more attention to the intensity of light in each area of the painting and to the values in the model.

A Monochromatic Scheme

This will allow you to pay full attention to the changes in value and the relationships of the shapes on the entire plane of the painting. When painting a monochromatic theme, you do not always use just one color; often you can add black and white to achieve variations in value and saturation and thus avoid monotony. One way of using monochrome to create harmony in a painting is to start with an analogous color scheme that uses several values that are adjacent on the color wheel. A wide use of analogous colors can include three or four adjacent shades with many variations in value. Another way of working with monochrome is using a single range of colors and adding to it a discordant color, for example, a range of blues with small amounts of burnt sienna.

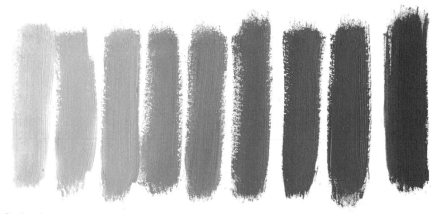

Single-color, monochromatic ranges are based on lightening that color with different quantities of white.

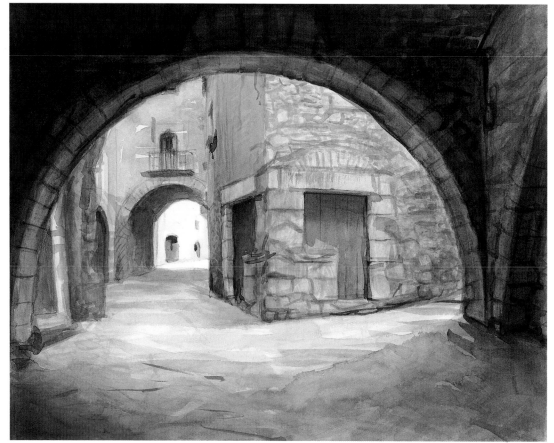

This monochrome wash was made with ultramarine blue watercolor and a small amount of black. White is not used with watercolors. The lightest tones are made by thinning the paint with water.

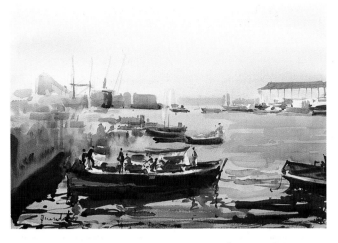

This monochromatic watercolor scene has an added discordant color, a small amount of burnt sienna to represent the figures.

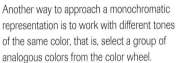

Another way to approach a monochromatic representation is to work with different tones of the same color, that is, select a group of analogous colors from the color wheel.

Achromatic Colors: Black and White

Black and white are achromatic colors since in a way they can be considered "not colors." White is the absence of color, and black is the combination of all colors at once. By mixing these two colors you can create monochromatic representations of any subject. The different tones are created by mixing both colors in unequal proportions. You can make many grays with them; however, for painting it is best to work with four or five, like a dark gray, two medium grays, two light grays, and black and white.

This monochromatic representation is in black and white, painted with gouache. A third color could be added, like blue or violet, to increase the range of grays and introduce greater variety.

Grisaille

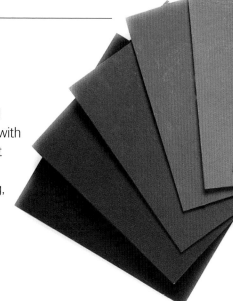

This painting technique is based on monochromatic work, generally black and white, that produces a strong sense of relief. This is done using chiaroscuro with several shades, making several different gradations of a single color. Any subject with clearly differentiated areas of light and shadow are strong candidates for being represented with grisaille. It can be used as the first phase of any painting, especially if it is diluted with thinner as a preparation for later applications of layers of brighter colors. This will look similar to an interpretation made with charcoal or chalk.

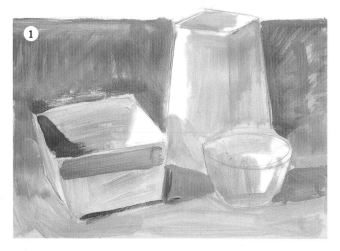

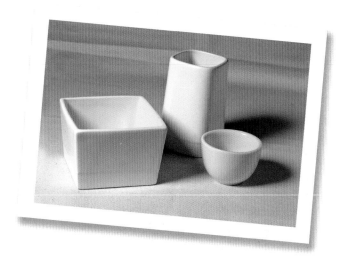

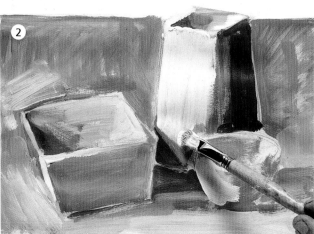

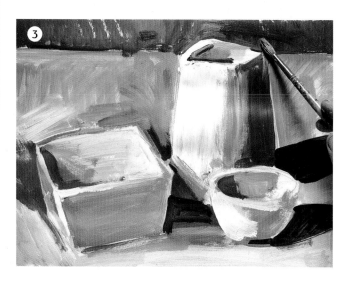

❶ Here the oil representation will be done in black and white, as a grisaille. The first shading is painted over a pencil drawing, in very diluted grays.

❷ The lightest and darkest areas are painted with absolute values, which means using pure black and pure white in the darkest and lightest areas, respectively.

❸ Now work on the middle areas. Two or three different values of gray will be enough. Make sure that they are gradated to represent the volume of the objects.

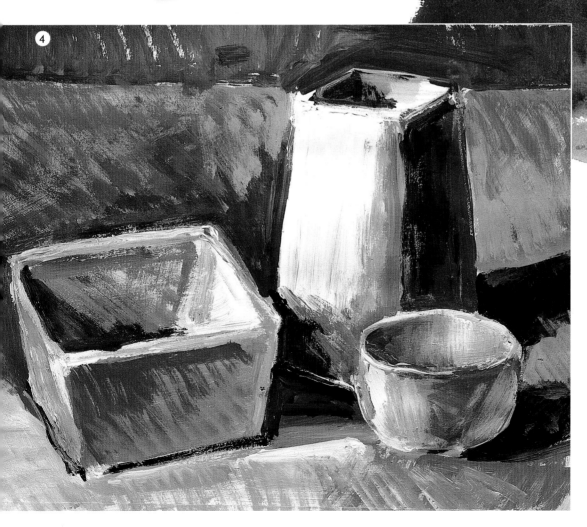

■ For the artist, **the grays** are colors in their own right, and they make up a chromatic family that is larger than you can imagine. Most of them appear on the palette with little effort, since they result from an accumulation of unequal mixtures of paint.

Black and white are opposites, and "not colors." Mixing the two will create a range of light with no participation of the colors that appear on the color wheel.

This grisaille exercise can also be done with watercolors, in which case it would be best to use Payne's gray, which acts as a lighter substitute for black.

❹ In the finished exercise each of the shaded areas has its own value. The grisaille, or gray tonal scale, adds to the clarity of the subject with clearly defined outlines due to clean contrasts between the values.

Two Analogous Colors

Until now, we have painted the monochromes with a single color and the intervention of black and white. Now we will use a bichromatic scale, painting with two colors from the color wheel and their analogous or adjacent colors. This allows us to increase the range and possibility of tones in the final painting, showing the differences produced in a shade when using a mixture in which one or the other color is dominant.

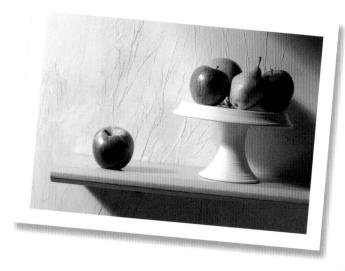

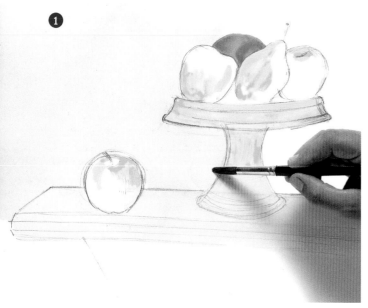

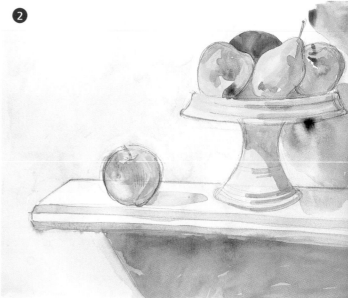

Still Life with Two Colors

In approaching this bichromatic work with watercolors, we will mainly use crimson, yellow, and mixtures made with them. The result will be an interesting range of oranges. Although it is obvious that the colors used to paint the subject are not close to the original colors, the warmth of the yellow combined with the strength of the crimson and colors with a reddish tendency will give the finished painting great brightness and expressivity.

❶ Begin painting the watercolor still life with two colors: crimson and yellow. Sketch the subject in pencil and cover the lightest areas with different gradations of diluted yellow.

❷ Paint the shadows of the fruit with very diluted crimson. Create a range of orange tones to paint the orange and the areas of medium tone.

This two-color range was created with lemon yellow and cadmium red oils.

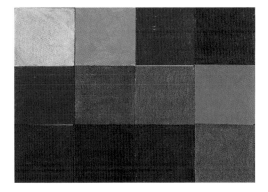

In mixing red with its analogous colors, the artist will find quite a wide range of different colors, characterized by their luminosity and delicate shades.

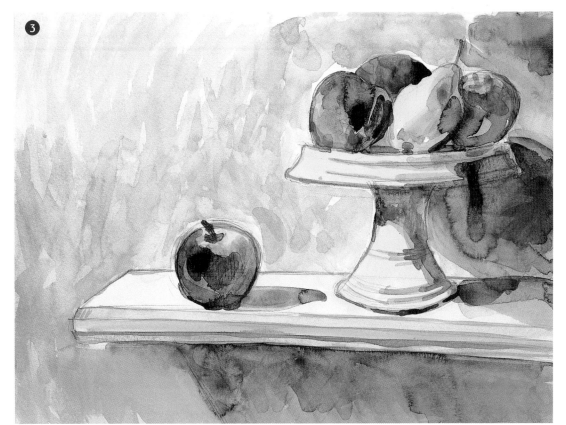

❸ Use a lot of crimson and some yellow to create a red that you can paint over the fruit and some of the projected shadows to intensify them. This will make the more illuminated areas stand out.

White is not required when painting with watercolors, but it is with acrylics and oils, when it is used to lighten the colors or make them less saturated.

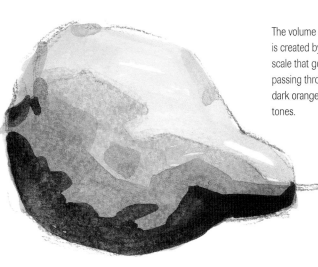

The volume of the pieces of fruit is created by using a simple tonal scale that goes from yellow to red, passing through light orange and dark orange. There are only four tones.

Creating Form with Color

Form can be seen because of color. The intensity and distribution of the colors in a painting usually determine the forms of the subject and make the composition immediately visible. Defining the form with color requires you to simplify what you see and to pay attention to the juxtaposition of colors so you can define the outlines of the objects. Color helps emphasize the forms and the main motifs of the painting.

Using Contrast as a Tool

Using colors of the same tone and near each other on the color wheel will not work to differentiate the planes since there is little contrast between them. The outlines will tend to run together or be too much the same. Contrast is the main tool used for separating an object from the background. A form painted with light colors stands out better on a dark background. But if you wish to achieve the greatest amount of contrast and create a stronger suggestion of the figure advancing, you must juxtapose two complementary colors.

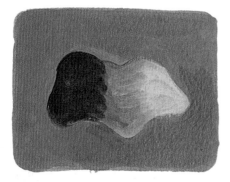

To create contrasts between color ranges, paint the object with warm colors while covering the background with cool ones.

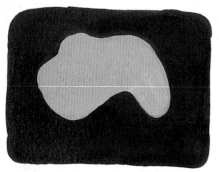

When using a single color range, the form can be separated from the background by a difference in values, with a very light green on a darker blue.

Blurred Brushstrokes

When you lay out a painting with blurred outlines and brushstrokes, the use of color is very important for identifying the object.

The greater the difference between the colors used in the painting, the easier it will be to distinguish the form of any object.

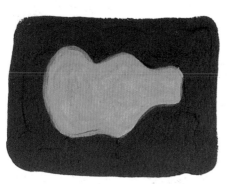

The greatest amount of contrast is achieved by juxtaposing complementary colors, which are farther apart on the color wheel. In this case they are yellow and violet.

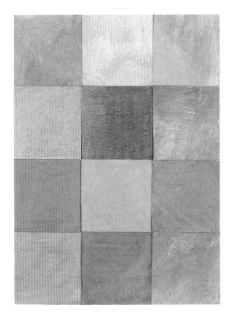

Although these colors are different and many of them are opposite each other on the color wheel, their value or light is very similar, and the contrast is weakened.

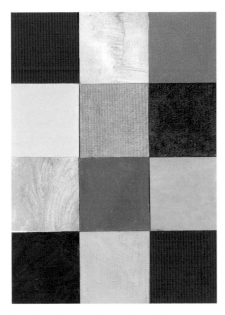

Here the colors contrast more strongly because of the difference in brightness and color. This is a much better combination if you want the colors to contrast with each other.

Making Shapes Stand Out

If you wish to make a shape stand out it should be contrasted with colors that are very far from it on the color wheel and that are of different values. It can be very effective to create forms by contrasting warm and cool colors or complementary colors with each other. Juxtaposing different amounts of brightness or saturation between colors also helps the forms stand out by strengthening the contrast. Combining both factors will result in a stronger contrast between the object and the background, and it will persist even if the outline of the object is blurry or broken.

The choice of colors, here a contrast between cool and warm, clearly distinguishes the object from the background and strengthens the focal point of the painting.

Opposites: Complementary Colors

Colors that are located directly opposite and farthest away from each other on the color wheel, that is, at opposite extremes of the circle, are complementary colors, and mixing them will turn them gray or brown as they neutralize each other.

Fighting for Attention

There are three main groups, each containing a primary color: blue and orange, red and green, yellow and violet. Each pair of these opposite colors produces a particularly powerful and vivid contrast. The juxtaposition of complementary colors can create a very vivid, and even disturbing, visual sensation. Opposite colors compete with each other for the viewer's attention, and sometimes places where the two colors meet will cause a physical effect, a sort of fluttering or vibration.

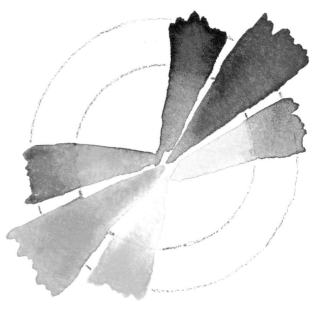

When using the complementary colors it is helpful to include the split complementaries in the range, which are the tones adjacent to the complement on the color wheel.

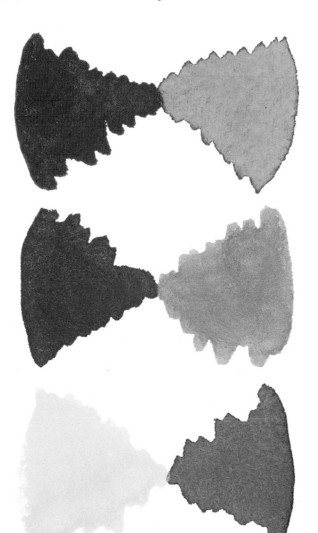

Split Complementaries

When painters use complementary colors they not only use the two diametrically opposite colors but also make use of split complementaries, that is, the tones adjacent to the pure complementary. For example, violet is the complement to yellow, and its split complements are blue violet and red violet. The use of these colors is necessary to achieve the greatest possible number of shades.

■ The **contrast between complementary colors** is the result of the opposition of colors on the color wheel.

Complementary colors are opposite each other on the color wheel. Red is the complement of green, blue of orange, and yellow of violet.

The areas of most intense light and shadow are painted with the complementary colors yellow and violet. Including the adjacent colors allows you to take the violet toward crimson or blue and the yellow toward orange.

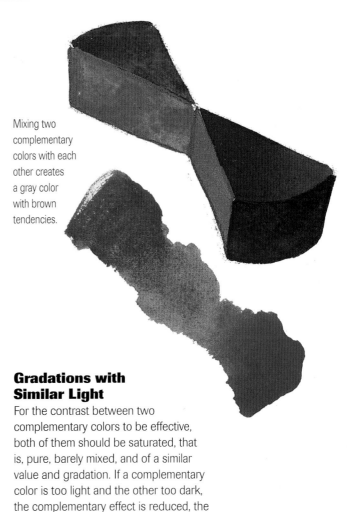

Mixing two complementary colors with each other creates a gray color with brown tendencies.

Gradations with Similar Light

For the contrast between two complementary colors to be effective, both of them should be saturated, that is, pure, barely mixed, and of a similar value and gradation. If a complementary color is too light and the other too dark, the complementary effect is reduced, the tonal contrast lost in the light and dark tones.

When there is a difference in value or clarity between two complementary colors, one being darker than the other, the vibration effect between them is reduced.

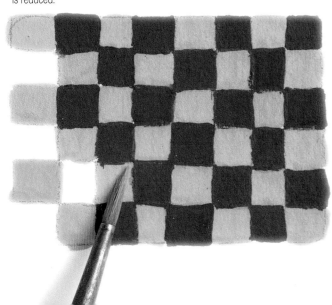

To increase the vibration between the two colors, they should be painted with similar value.

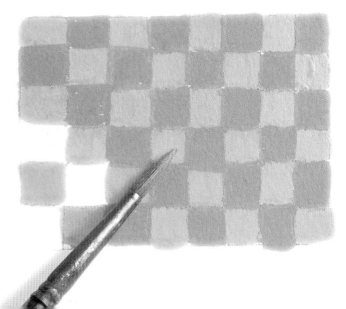

Complementary Color Effects

The background is very important in any painting. One way of understanding how complementary colors work is to see how a subject responds to backgrounds of different colors. The impact that its complement can have on an element that is in the foreground is enormous, based on the amount of space it occupies and its surrounding area.

A Still Life with Napkins

A simple still life composed of several napkins painted with a range of blue colors will help us study and understand how much complementary colors can influence the painting. The wall in the background is stucco, and it has been painted a different color in each case: blue, yellow, and pink. With the yellow, the tendency of the napkins is toward even more blue. Against a pink background they tend to look like greenish blue, resulting from the effect of the reddish complementary color. The blue background confers a violet tendency, resulting from the effect of the wall strengthening the complement of blue, which is red.

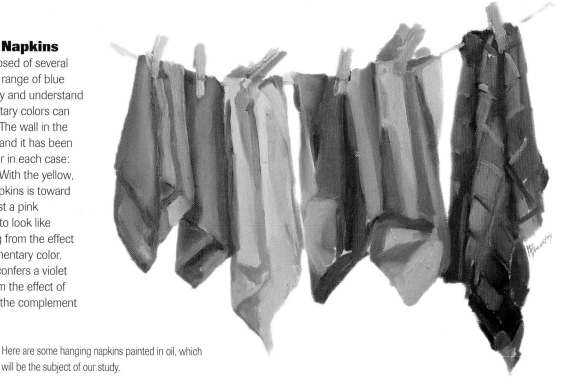

Here are some hanging napkins painted in oil, which will be the subject of our study.

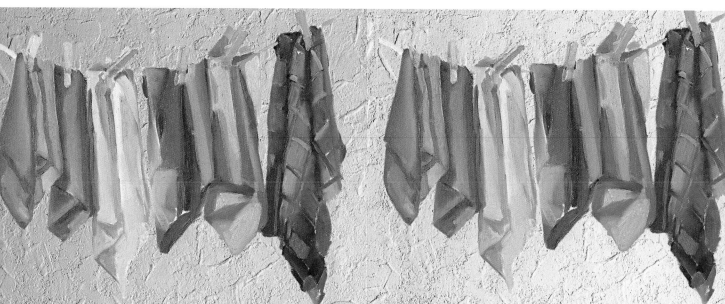

The background is painted blue. The napkins show a violet tendency because the red in them is induced by the blue wall, which is the complement of red.

Now yellow predominates. The blue in the napkins looks even more blue because of the influence of yellow's complement, which is blue violet.

Checking the Effect

To verify the effect of complementary colors you can look at a gray circle surrounded by different colors. First stare at each one of the circles for a good while. The one that is surrounded by bright orange causes the gray to look bluish. The green makes the gray look pink, and the violet makes it look slightly yellow. Each color casts its complement in the circle.

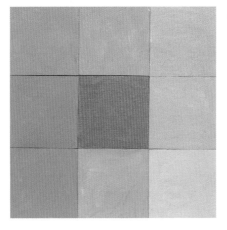

Surrounded by grays, green seems to be very dull.

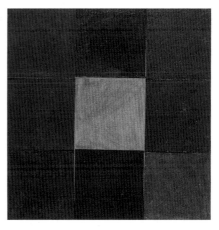

Green becomes stronger and more vivid when seen against its complement, red.

Warm bright colors tend to look much more saturated and expansive when they are surrounded by dark colors. In this example, we show four circles of equal size, but the two in the center seem brighter and look slightly larger in size than the blue and violet.

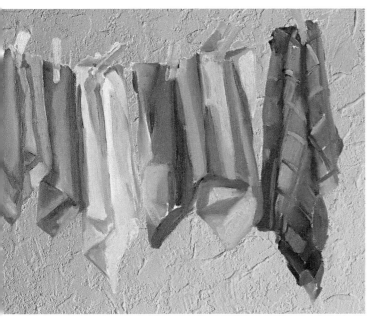

Now the background is painted pink. The blue in the napkins looks greenish blue because the complement of magenta is green.

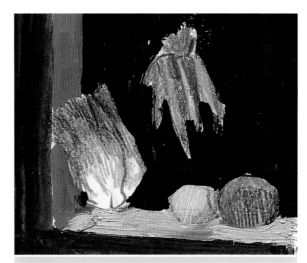

Color on a Black Background

A dark background always makes colors look brighter because of simultaneous contrast. This approach was often used by the great Baroque painters.

Experimenting with Backgrounds of Different Colors

One of the basic aspects of composition in painting is the relation between figure and background. The background not only notably affects one's perception of the colors of the depicted objects, it also often marks the tendency of the range of colors that will be used. That is, it can be used as a base color and the rest of the colors generated from it. This means that the support will be covered with a background color that acts as a base color, and colors with tonal variations will be added over it, which will harmonize with the background color.

The Close Relationship Between Color and Background

It is very important to correctly choose the colors to create the atmosphere of the painting. If the background has a blue or violet tone, the colors should be nearby on the color wheel and be soft and not too saturated so the picture creates an intimate atmosphere. The colors do not fight each other or contrast too much and are not perceived in isolation but are associated with each other in a close mutual relationship.

The color that covers the background on the support will often determine the colors that are going to be used in the painting, whether for harmonizing or for creating contrasts.

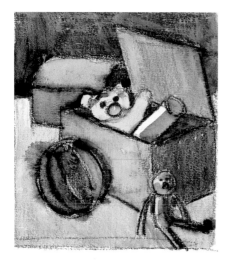

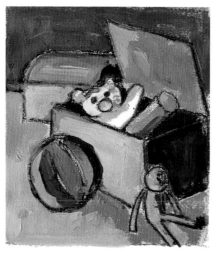

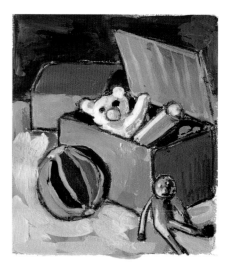

To construct a still life that is solid, visually balanced, and pictorially efficient, it is very important to control the spatial structure of the background and its colors. You should experiment using the same composition with different colors, beginning with those most closely related to the background color. This range of dominant blues looks cool but bright.

Here the dark blue colors combined with the grays and greens give the painting a dull feeling.

The three examples show different psychological perceptions. The violet and pink tones create a warm and inviting feeling.

The Same Object with Different Backgrounds

This time, we will play with simple melodic ranges, re-creating different chromatic harmonies based on different background colors. We are not working with either contrasting complementary colors or an exaggerated clash of colors. On the contrary, the point is chromatic harmony and a representation of an object that can be clearly identified, with its transparency and reflections.

The subject is handled with a simple range based on the orange background, with the addition of red, crimson, brown, and white.

Looking at the model from a lower point of view, we darken the background, but this does not keep the green background from seeping through the entire surface of the support.

"The **quality of a color** does not exclusively depend on itself, but also on the colors that surround it."

Eugène Delacroix

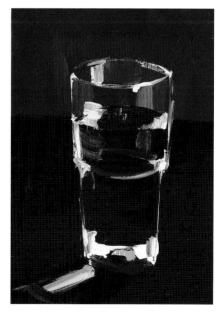

A background painted with cadmium green creates a brighter contrast. The colors used are monochromatic, black and white that are blended in some areas with the fresh green paint.

In this example, the background color is less manipulated. There are no dark areas within the glass, which is constructed with a few strokes of white paint.

The last example was painted with a bicolor background. The glass was built up with white, but the dark areas were painted with a mixture of the two background colors.

Chromatic Scales

When the feelings for a subject are complex and varied you can choose one of two approaches: treat them in a very full and detailed manner, or suggest the subject in a more selective way, revising the intensity of the shades and tones to organize the differences and similarities in a more deliberate way. Here, we analyze four basic methods for developing chromatic schemes that make the subject more comprehensible. The objective is to highlight the role of color and its autonomy in respect to the shapes, forgetting about textures and details.

Synthesis forces the subject to be summarized in large areas of color. This allows you to study the shapes and the relations that are established between the colors.

Synthesizing Colors

You can depict the image in a painting eliminating less important details and generalizing others, much like you can summarize a story or something that happened to you. This is called synthesis, and it is a way of summarizing a form in a pure state. In this approach you must simplify the forms and paint each zone with large areas of more or less uniform color. It is a matter of putting together saturated colors as if the painting were a puzzle of juxtaposed geometric shapes. The painting becomes a synthesis of colored sensations based on the subject, where the integration of shape and color into a single system is achieved with great economy. The repetition of colors and shapes in the schemes creates a sense of order that is anything but loud and disturbing.

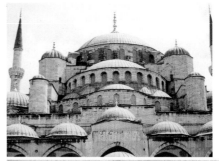

It is a good idea to experiment and work with saturated, unreal colors and figure out how they can be related. Then, it is a matter of making a work of greater magnitude with them.

When the subject presents a great number of shades or variations of the same color, it is important to simplify and unify all the areas of the painting with these variations using flat washes.

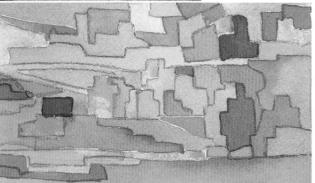

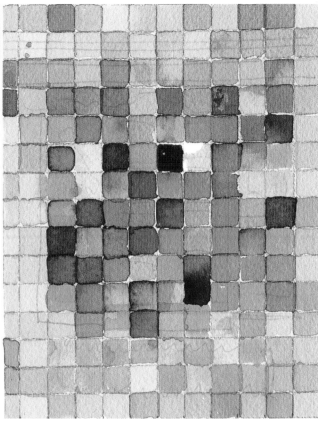

This graphlike scheme was made by first drawing the squares on the support. Then each square was painted with the color that appears in each of the different areas of the image.

■ The best way to **synthesize** is to simplify the colors of each area. Once those colors are identified and each area outlined, they are painted with flat colors, with no gradations and no attempt at representing volume.

Here we have done an exercise synthesizing a forest by fragmenting the space with small geometric shapes with vivid, flat, saturated colors.

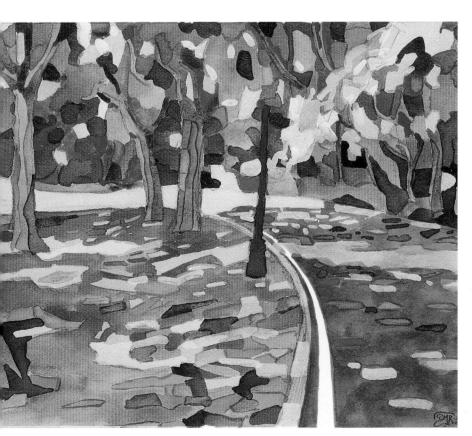

Yellows, blues, reds, and violets have been added over the greens of the vegetation. They are strange colors, but they make sense if the basic dynamic of synthesis is extremely colorful.

Study in Solid Colors

The best method for simplifying each one of the areas of color is to use totally flat colors—thick uniform colors that offer a very simplified vision of the model. Since we are working with areas of color that are flat and not gradated, the volume of the forms is created by scaling the tones: using lightened colors in the lightest areas and dark colors in the more shaded areas. This way of working is very reminiscent of the techniques for applying gouache. Many artists believe that simplification is a useful starting point, a first step before developing the subject in detail.

An Acrylic Exercise

Here we create some flat brushstrokes, taking advantage of the fast drying time of acrylic paint. This keeps the paint from accidentally mixing where the edges meet. Although acrylic paint in itself is a good medium for making flat shapes, we have added an acrylic painting medium to exaggerate the effect. In any case, to make areas of flat solid color with acrylics with few or no brush marks, you can apply several layers of solid paint.

The model should be very simple with clearly differentiated shapes. It is a good idea to avoid very intricate scenes.

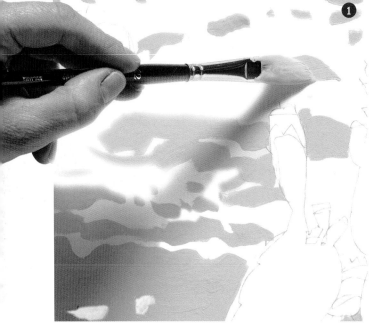

❶ Make a preliminary pencil drawing, and then outline the model with thin lines. Work first with the lightest colors using very thick paint.

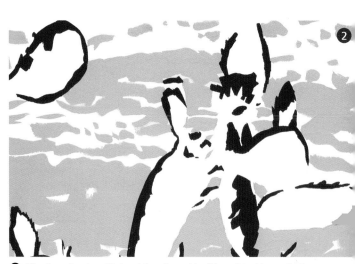

❷ After the yellow has dried and there is no risk of the paint mixing, paint the darkest areas of the cactus with burnt sienna.

3 Paint the interior of the cactus with turquoise blue. The edges between the colors will not always be perfect. It is preferable for the blue to slightly overlap the sienna. After it is dry you can make corrections with a second coat of paint.

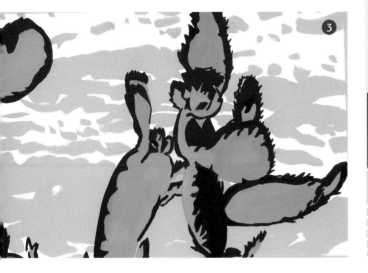

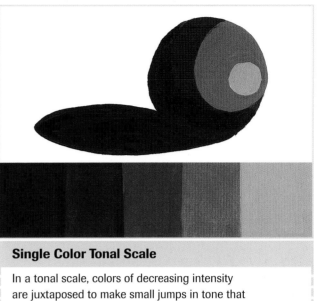

Single Color Tonal Scale

In a tonal scale, colors of decreasing intensity are juxtaposed to make small jumps in tone that go from darkest to lightest.

4 To finish, complete the sky with pale pink and finish the flowers with a smaller brush, with whitened strokes to preserve the harmony of the work.

HARMONY AND CHROMATIC RANGES

Harmony is one of the compositional techniques with color, and it is supported by the order and correct application of the chromatic ranges, that is, the combinations in which are used modulations of different colors of the same tone, or in other words, a succession of colors that are very near each other in the color circle. When we speak of chromatic ranges we are referring to the families of harmonic colors, colors that do not clash with each other. The intent of everyone is to represent a theme on a canvas, paper, or wood, in a harmonic manner, according to the artist's free interpretation. Thus, any scene can be represented with the colors that the artist chooses, guided by the need to create a different esthetic, a personalized use of colors and harmonic ranges.

Landscape Near Colloge-Bellerive. Ferdinand Hodler (1853–1918). The harmonic range of gray colors gives this scene a special atmosphere that reminds us of the cold days of winter.

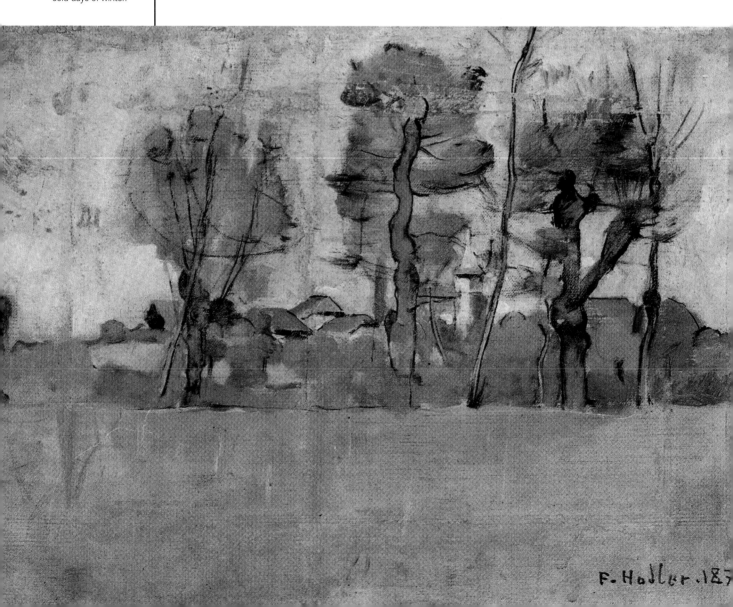

Simple Harmonies

The simplest harmony is one in which are used tones from the same range or same sector of the color wheel. The most closely related tones are those of the same color, connected through intermediate tones made by mixing the two. The range may be increased by adding a little black or white to the mixture.

This is a restrained harmony with very few colors. Values of the same color are very widely developed because of the consistent use of chiaroscuro.

■ Observing paintings by **the great masters** and analyzing the way some artists use color helps develop your sense of color and your ability to choose effective combinations.

The Color Range on the Palette

When you create a range of colors it is best to begin with a base color and add small amounts of a second color; this way you will create ranges that flow from one color to another. It is always easier to darken a tone than lighten it with another, so it is best to choose a base color that has a light tendency. It is a good idea to avoid colors that are too dark.

On the palette the greens cross their adjacent colors (blues and yellows) to create a harmonic range of greens.

The Importance of Color Ranges

The term "range" has its origin in the field of music. In a musical context, it means the group of tones that are used to compose a melody. Although it is a loosely defined concept, and it is even used to define the entire chromatic spectrum, here we focus our attention on the harmonic ranges, which include a very small number of colors that must be in harmony with each other. The choice of or use of a range is not just a question of taste, the artist must be aware of the basic techniques of color mixing and choosing those that will be used in the painting. The best approach is to use a base color and begin mixing it with small, even minimal amounts, of other colors.

The First Ranges

To create the first ranges of color begin with a base color and lightly mix it with another that is not too far away on the color wheel, for example, light blue with violet, or yellow and crimson. These should be mixed in very different amounts. If you mix a tiny amount of an adjacent color to each mixture you can create subtle ranges of colors. In most of these mixtures, especially in those where a dark color predominates, it is a good idea to add some white.

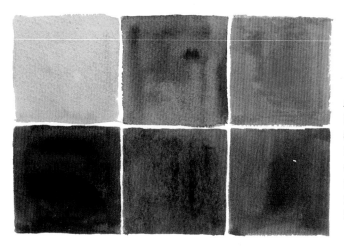

A range of earth tones in watercolor, from above to below and left to right: golden ochre, burnt sienna, raw sienna, English red, raw umber, and burnt umber.

This example of modeling was done with a simple harmonic range of earth tones. Among them are burnt sienna, yellow ochre, and burnt umber.

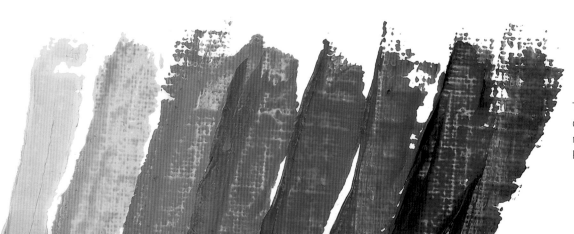

This range of green oil colors was made by mixing yellow and Prussian blue.

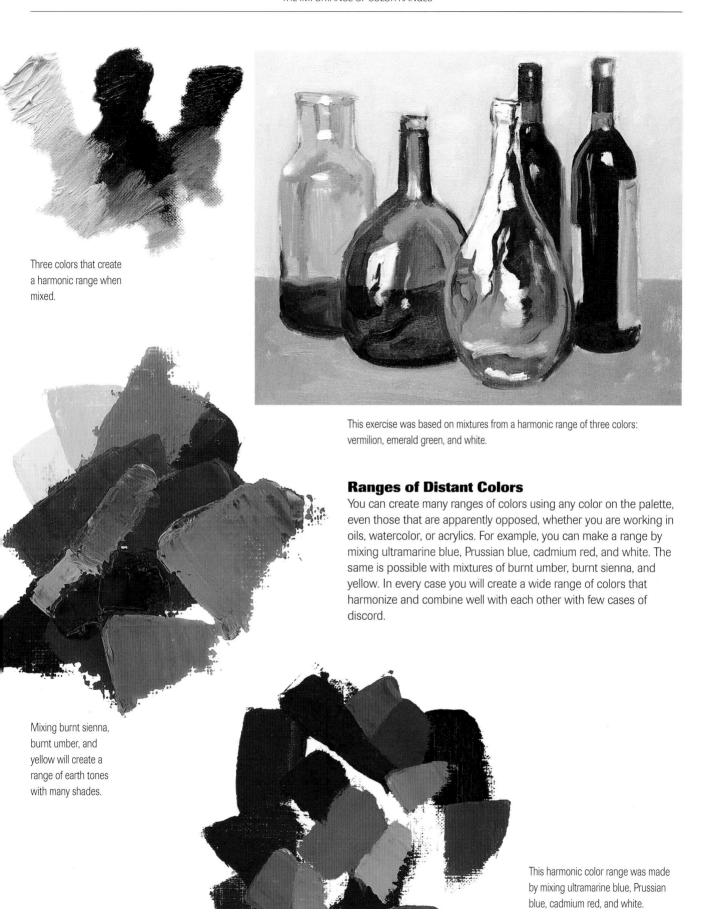

Three colors that create a harmonic range when mixed.

This exercise was based on mixtures from a harmonic range of three colors: vermilion, emerald green, and white.

Ranges of Distant Colors

You can create many ranges of colors using any color on the palette, even those that are apparently opposed, whether you are working in oils, watercolor, or acrylics. For example, you can make a range by mixing ultramarine blue, Prussian blue, cadmium red, and white. The same is possible with mixtures of burnt umber, burnt sienna, and yellow. In every case you will create a wide range of colors that harmonize and combine well with each other with few cases of discord.

Mixing burnt sienna, burnt umber, and yellow will create a range of earth tones with many shades.

This harmonic color range was made by mixing ultramarine blue, Prussian blue, cadmium red, and white.

The Warm Color Ranges

The division of colors into warm and cool groups is based on the thermal feelings they transmit. The warm colors have a stimulating effect and give you a sense of activity, joy, and dynamism. It is no surprise that physiological research reveals that under a red light our bodies secrete more adrenalin. Referring to the radiation of the light spectrum, warm colors are the longest light waves, and by extension all mixtures of them produce the previously mentioned subjective reaction of warmth.

The warm colors consist of reds, yellows, and earth tones, which transmit a feeling of heat and energy.

Components of the Warm Range

The range of warm colors has a common denominator, which basically is composed of red and yellow, whether in pure form, mixed with each other, or mixed with small amounts of other colors. The main components of the warm color range are the following: crimson, red, orange, yellow, ochre, and earth reds. Any mixture of these colors and even with others will result in another warm color.

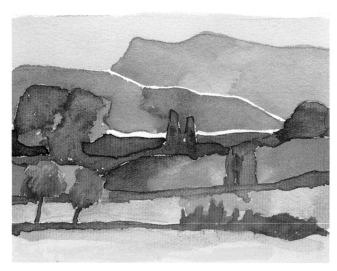

The warm colors are considered to expand and advance, for this reason the foreground of a landscape is usually painted with warm tendencies.

The warm colors are derived from yellow and red, including ochres, pinks, and even some greenish yellows.

Warm Colors Expand and Advance

Warm colors seem to advance or move toward us, and we perceive them to be more powerful; they generate an impression of nearness and come off the surface that contains them. Based on these laws of color, we can assume that to a viewer standing in front of two equal areas, one painted red and the other blue, the latter will seem smaller. Warm colors increase the apparent size of objects, while, on the contrary, cool colors will tend to make them look smaller.

A range of warm
colors painted with
watercolors.

Warm Light and Cool Shadow

Between sun and shadow there is not only an opposition of light and dark, but of warm and cool. If the illuminated areas are warm, then cast shadows must be cool.

The artist can resolve the brightest areas of a painting with a range of very saturated warm colors that will strongly contrast with the blue background.

Harmonizing a Still Life with Warm Colors

This still life was painted with a range of warm colors. The treatment is very stylized, with an interpretation that is very near Cubism. This harmonic range runs from the matte warmth of the ochres and earth tones to the vibrant yellows and oranges, with intense reds and the shadowy strength of burnt umber. The colors do not need to be forced too much or be overly saturated; the painting should be about creating a harmony that summarizes different moments of color. The painted harmonies are always inventions suggested and inspired by nature, and if they are in agreement they will produce an unmistakably natural feeling. This painting was done in oils.

The reference for this exercise is a simple still life composed of elements related to breakfast.

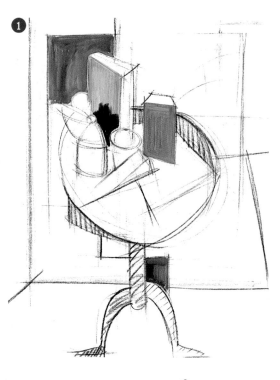

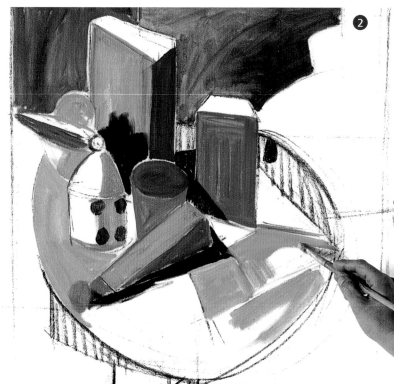

❶ After making a charcoal drawing, paint boldly and without hesitation. Cover large areas with mixtures of red and yellow.

The paint that covers each segment of the painting should be slightly diluted, barely mixed or blended.

❷ The clear separation of the areas in the drawing will help you apply flat planes of color with no blending or gradations. The surface of the table is painted with very light reds.

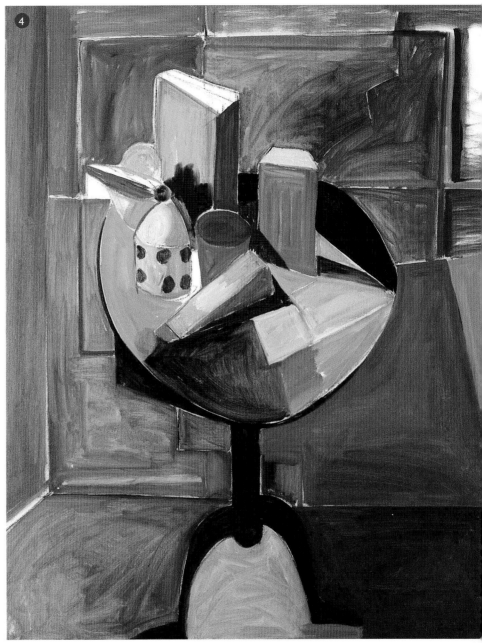

3 The planes on the background are much larger, diluted mixtures of earth tones and orange. Here the brushstrokes are much more vigorous.

Working exclusively within a color range does not mean limiting the color; it will actually unify all of the colors used.

4 In the lower part of the background and on the floor are gray tones with warm tendencies. They are areas of shadow that attempt to balance the more saturated warm colors that are used on the more illuminated parts of the model.

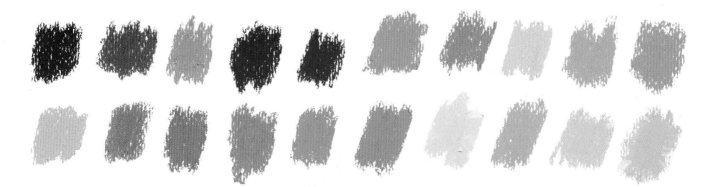

The Cool Color Ranges

The cool colors are located in the part of the spectrum that corresponds to the shorter wavelengths, those nearest ultraviolet. Visually they are perceived with sensations that are opposite those that are related to the warm colors. The bluish colors feel cool, but they also transmit a feeling of tranquility, seriousness, and they produce an effect of relaxation and a laid-back feeling. Research has shown that they reduce the speed of heartbeats and relax the muscles. Therefore, they are colors related to the lack of light, winter atmospheres, cloudy skies, and nighttime.

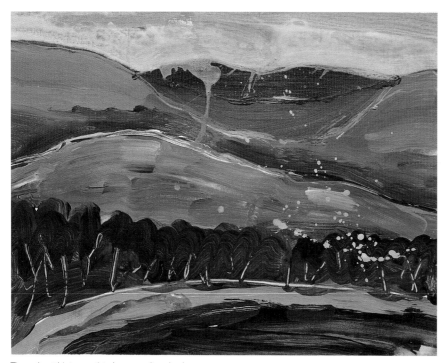

Throughout history, artists have used cool colors as a way to represent distance, and even solitude and loneliness.

A Composition with Cool Colors

The cool colors on the palette are the blues, blue greens, greens, and some violets. It is true that the greens are made of blue and yellow, so the less yellow contained in the mixture, the cooler the color. The same is true of the violets, which are composed of blue and magenta or red; the greater the amount of blue in the mixture, the cooler the resulting violet. Any mixture that is made using cool colors will result in other cool colors.

The cool colors include an immense variety of tones like gray and brown, as long as they have blue or green tendencies.

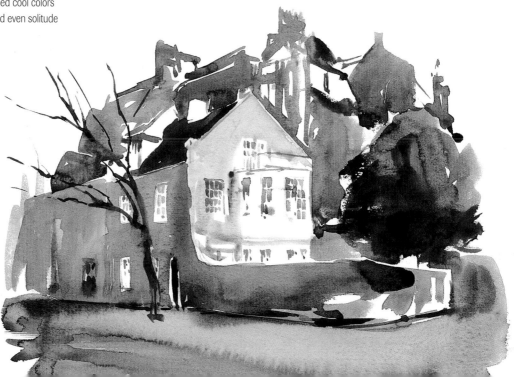

Distant Colors

Cool colors are attributed to sensing the perception of distance, because when a form gets farther away, no matter what color it is, it tends to become less bright and more bluish. This effect can also be noted when looking at a landscape from an elevated point of view; the farthest mountains tend to look blue, affected by the atmosphere in between. The small particles of dust and water that float in the air impede the passage of red and yellow rays of light; the only ones that reach the retina are blue and violet. Blue gray is frequently associated with distance, as well as rainy and foggy landscapes. They are depicted with gradations that go from blues to greens, including some violets.

The colors mixed from a range of cool colors are not as bright, but they create an interesting harmony among all areas of the work with no abrupt changes.

This still life was painted almost completely with only colors from the cool range, mixtures of greens, blues, and violets.

When you mix greens and blues from the tube, whether oils or acrylics, you can create a wide range of rich shades.

The cool colors, mainly blues and greens, create an impression of actual cold.

A Rural Scene in a Cool Color Range

Now we will do an exercise that puts into practice the use of a cool color range. However, it is difficult, if not impossible, to find a subject consisting of only cool ranges or warm ranges. The secret of creating a good combination and coordination of colors resides in introducing contrasts, like small notes of pink (a bit warmer) among violets and blues. Thus, a cool violet can seem warm when it is surrounded by cooler colors, but its temperature drops next to warmer colors. For this reason it is important to incorporate certain warm tones in a painting full of cool colors; although it may appear contradictory, this warm tone will help cool the entire painting even more. This exercise was done in acrylics.

The starting point is this rural scene. The work will be painted with a limited range of blues and violets.

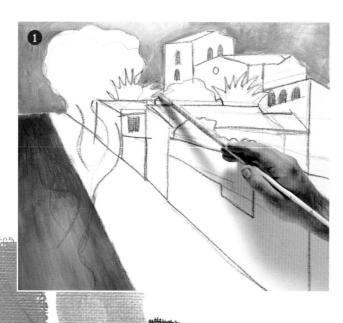

❶ Draw the buildings loosely, emphasizing the diagonal lines to create a sense of space. Use a light lilac tone for the sky. The side of the road is a gradation that goes from ultramarine blue to violet.

❷ Use white to lighten new applications of blue on the side of the road and on the tree in the background. More intense violets and blues are added to create gradations by blending the colors.

The different tones of blue and violet should be clearly differentiated. It is a good idea to test them on a piece of paper before applying them to the painting.

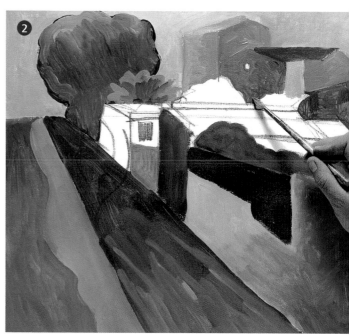

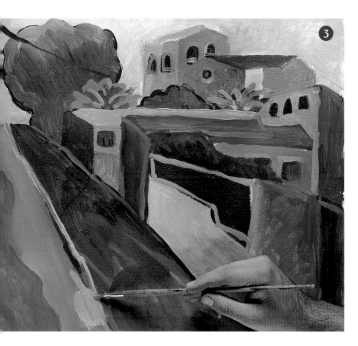

3 The entire surface is constructed with strokes of bluish and white paint that fit into one another like a puzzle. The blue range is only altered by the presence of magenta, which gives it some faint touches of warmth.

4 To finish, add a few more lines to modify the outlines of some areas and resolve the form of the tree in the foreground.

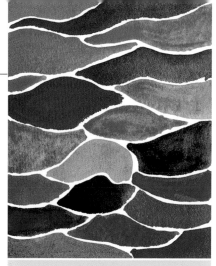

Juxtaposing Colors

Although it is true that a range of similar colors creates harmony, it is a good idea to introduce some contrast to enrich the effect of the painting—a note of warm color that will attract the viewer's eye. This effect is referred to as juxtaposition.

The Chromatic Range of Neutral Colors

The range of neutral colors (also known as broken colors) is created by mixing pairs of complementary colors. This fusion will result in a range of grayish and brown colors that harmonize very well with each other. Neutral colors can also be created by mixing earth tones with their complementary color or by adding a shade of any color to a neutral gray.

Mixing Complementary Colors

Neutral colors result from mixing complements: red and green, blue and orange, or yellow and violet, among many others. These mixtures should be made in equal parts, that is, 50 percent of each shade, which will create a pure neutral color. They can also be mixed in unequal parts: 25 percent of one and 75 percent of the other, which will create neutrals with a tendency toward one color or the other. Mixing them with different amounts of white will create a sequence of values of that particular tone.

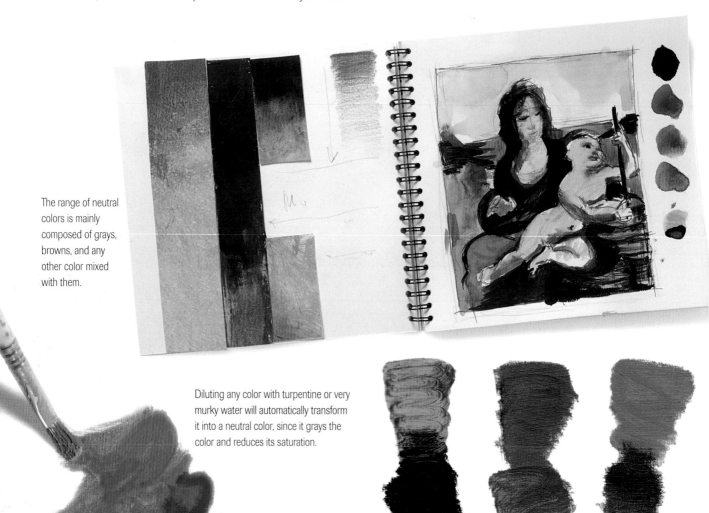

The range of neutral colors is mainly composed of grays, browns, and any other color mixed with them.

Diluting any color with turpentine or very murky water will automatically transform it into a neutral color, since it grays the color and reduces its saturation.

Neutral colors are the product of mixing two complementary colors.

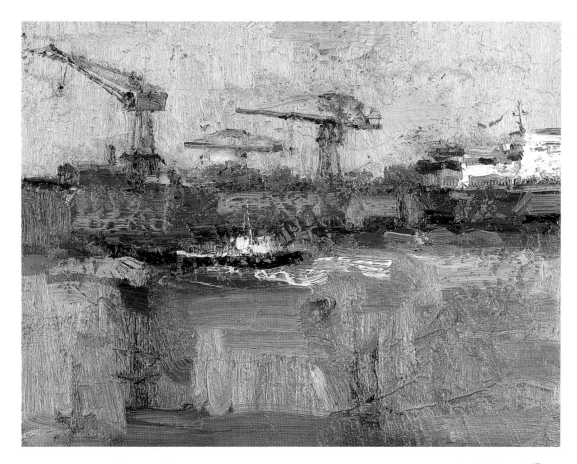

This painting is dominated by a range of neutral colors with a large number of grays that even minimizes the saturation of the blue and red.

If you add brown and white to any color, in this case violet, it will become a neutral color.

Harmony with Neutral Colors

At first you may think that a painting done with neutral colors would be monotonous. However, if it is done well, the result could be very effective and of high artistic quality. The white will greatly help eliminate shrill colors and soften the contrasts. Broken colors are very somber, making them best for figurative representations in a formal, conventional approach. There is another advantage: the color range is wider, with the most tonal variations available to the artist.

We recommend mixing complementary colors in unequal proportions to create cleaner neutral colors, and adding white to them to brighten and make them grayer.

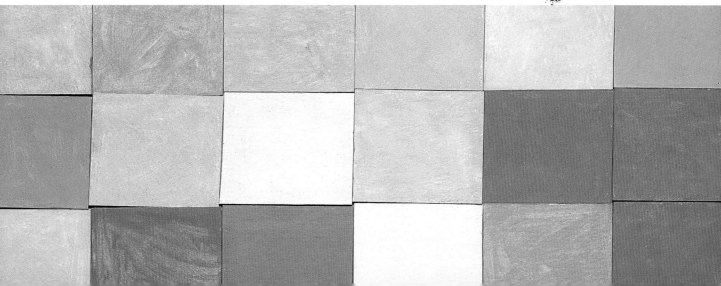

A Harmonic Still Life with Neutral Colors

This still life is a good motif for practicing with the neutral color ranges. It is characterized by the presence of a large number of grays and browns, some of which are cool tones, like the green vase, although they are not very saturated. The grays are made by combining earth tones with blue, violet, and white.

It is best to work with restraint, since an excessive combination of tones will dirty the colors, and a systematic use of neutral colors can ruin the harmony and create a muddy effect. The medium used in this exercise is oil.

It is possible to neutralize the browns and give them a grayer tendency if they are mixed with their complement, blue.

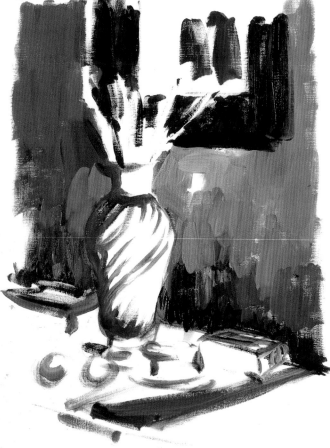

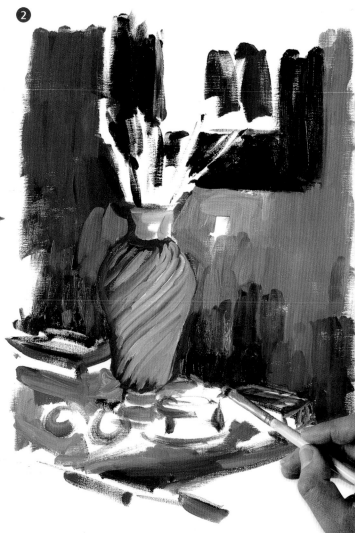

1 The preliminary drawing is done directly with a brush and blue paint diluted with turpentine. The background is a symphony of neutral colors: ochre grays, browns, dark chestnut, and green grays.

2 Paint the vase with a neutral green made by mixing green with brown and white. Then add strokes of bluish grays in the foreground. This area should be much whiter and lighter than the background.

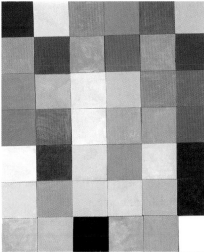

Broken Grays

Neutral grays are those that are obtained from mixing black and white, grays with no color tendency. Broken grays are richer, since they always have a tendency toward some color. Grays with chromatic tendencies can also be created using earth tones mixed with their complements, which are generally blues.

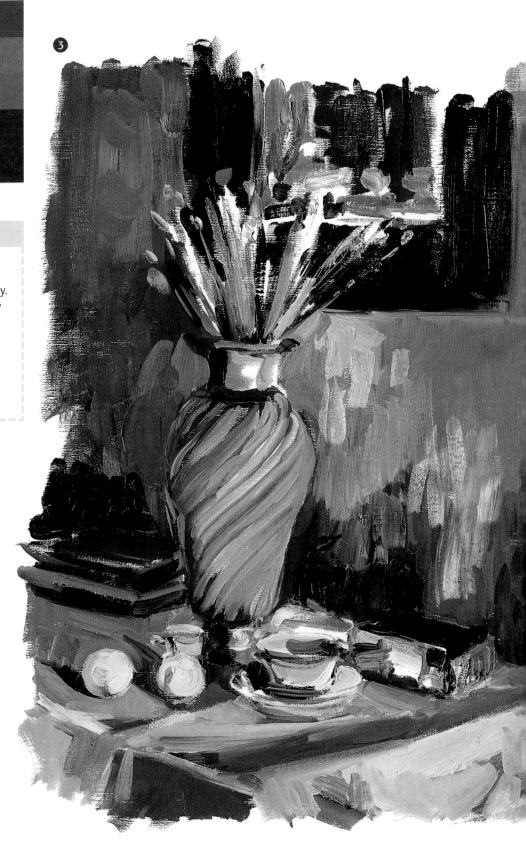

3 The objects in the foreground are reinforced with broken colors with a yellowish tendency, which is warmer. Finally, the only note of vivid color is introduced, which is the orange brushstrokes that suggest the painting in the background.

Contrasting Ranges

Harmonizing colors from the same range is an approach linked to the classic and academic styles, while contrasting saturated colors belonging to different ranges is usually related to new styles that tend to break with tradition. Making use of these contrasting colors is a good way to personalize paintings and catch the viewer's attention. You must dare to use contrast, to combine different color ranges yet choose appropriate groups of color, to avoid results that are too aggressive or shocking.

Contrasting Ranges and Distance

The most common and at the same time most effective color contrast is that produced by colors of a warm range against a cool one. Paintings based on these contrasts create a lot of energy and show a very attractive personal touch. In addition, the contrasting colors create a sense of space by themselves. The contrast between two ranges of color suggests a distance between them; there is always a group of colors that seem closer and others farther away. This is accentuated when a warm color is contrasted with a cool one. The warm colors should be used to paint the nearer planes, while the cool colors should be used for the farther ones. This effect becomes more evident in representations of landscapes.

This group of figs painted with a range of cool greens and violets strongly contrasts with the warm background of reds and yellows.

A To see how warm colors advance more toward the viewer, paint the background with cool colors. Then use saturated yellow and orange to paint the nearest tree.

B The saturated warm colors used to paint the tree and foreground "throw" the cool colors surrounding them toward the background.

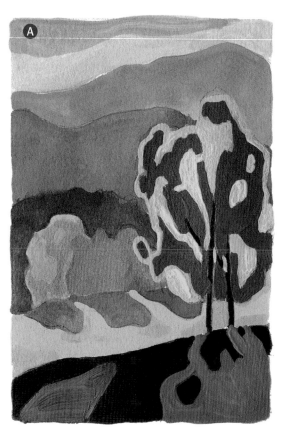

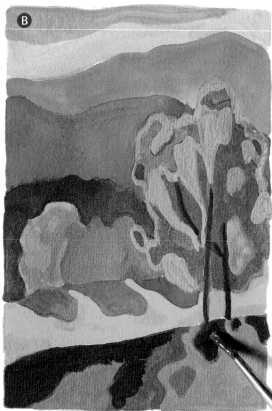

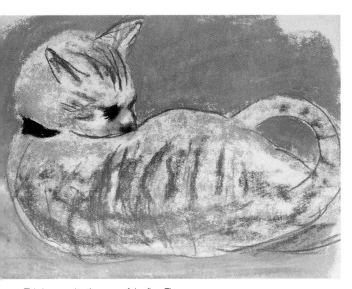

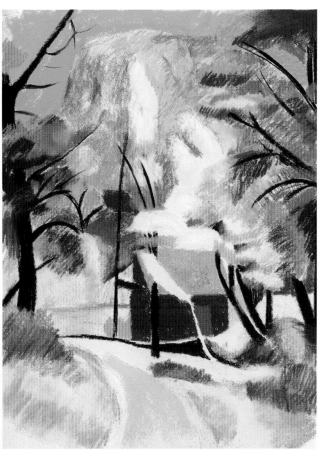

This is opposite the case of the figs. The cat is painted with warm colors on a background of blue.

■ To **make the foreground stand out,** paint with warm colors and surround them with cool colors, which visually recede to the background.

The greens in the foreground are yellower and the house an intense red, while the background is covered with violets and blue colors. Creating contrast with color ranges creates space and depth without using perspective.

There are three basic ways of making warm colors cool:

Ⓐ Mixing them with a color from the cool range, in this case cyan blue.

Ⓑ Dilute the paint with water so it will lose saturation, and consequently, chromatic strength.

Ⓒ Reduce the saturation of the color by mixing it with white. The white cools it by reducing the strength and brightness of the color.

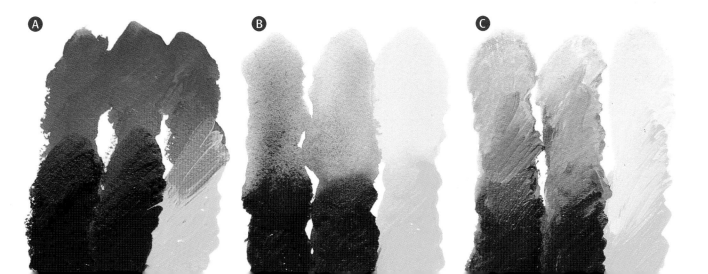

Harmonic Triads

It is possible, in a single painting, to combine groups of colors from different ranges (cool and warm), expressively balanced, in such a way that the warm colors compensate for the rest and relaxation produced by the cool colors. Harmonic triads are a combination of three colors that are equidistant on the color wheel, that at the same time teach a lesson of restriction and variety, a formidable use of warmth and coolness with a great number of shades. There are numerous options when it comes to harmonic triads, but just like when you are using complementary colors, you must be very careful that your choice of colors is in good taste, that it is not unpleasant and too garish.

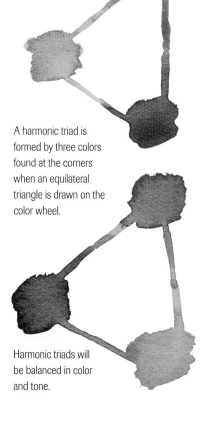

A harmonic triad is formed by three colors found at the corners when an equilateral triangle is drawn on the color wheel.

Harmonic triads will be balanced in color and tone.

Harmony with Three Colors

Harmonic triads are created in a painting by using three colors that are the same distance from each other on the color wheel. Beginning with any color as a starting point, you can draw an equilateral triangle on the color wheel to find the other two colors that form the harmonic triad. Although there will not be a complementary color effect among them (which will eliminate tension), the three colors will compensate for this with brightness and strength.

1 As an experiment, paint a landscape in watercolor using a harmonic triad. Use orange for the foreground and green for the middle ground.

2 Apply violet blue to the farthest planes. In the washes, add a drop of red or green so it will better relate to the other planes.

3 Strengthen the previous washes with orange and ochre (orange with a bit of green). The combination of three harmonic colors will result in a color study with no dissonance of colors.

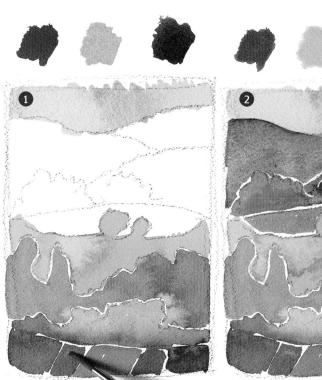

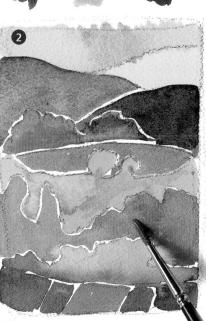

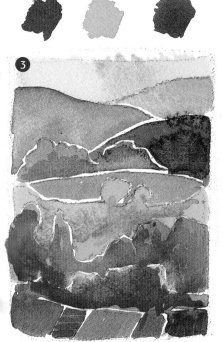

Choosing the Three Colors

Choosing a trio of colors is quite simple if one of the colors is defined. For example, if green is desired, it is just a matter of drawing an equilateral triangle on the color wheel with one corner on the green to know what the other two colors will be. The other two colors will be on the other two corners. Thus, the harmonic triad will consist of green, light orange, and violet. The best advice for using harmonic triads is to choose tertiary colors that are not so bright, or else mostly use one of the colors for accenting details on the other two colors.

❶ Again we are using a harmonic triad in watercolor with green, violet, and red. We begin by drawing a simple flower with pencil. Then we apply violet washes on the background and green on the stem and the leaves.

❷ To finish, we add several reddish values on the flower, blending them with shades of orange and crimson, which relate better to the violet background.

❸ After resolving the details of the petals by building up brushstrokes, the three colors (green, violet, and red) harmonize perfectly. They are not present in just one area but spread more or less evenly throughout the entire painting.

PIGMENTS AND PAINT
Particles of Color

Painting is the art of distributing particles of color on the surface of the canvas, board, or paper. Therefore, the pigment powder is the most essential and basic element of the painting process. The word "color" defines the sensorial impression produced in the human eye when it perceives the rays of light. But in this book we use the same word to define the materials as well as the substance of the painting that produces specific sensorial impressions on people. Even though until this point we have explored the classification and cataloging of colors, their ranges, and the possible color combinations among the different groups from a very perceptive and theoretical standpoint, now we are going to approach the study of color from a material point of view, as a pictorial substance—the understanding and use of paint as a coloring element—and as a procedure, as well as its color possibilities.

INTRODUCING THE COLORS: THE STARTING POINT

Pigments are substances with a particular chemical composition that are used to manufacture commercial as well as artists' paints. All the paints are made of these pigments agglutinated with oil, acrylic, or glycerin mediums depending on whether they are oil, acrylic, or watercolor paints. The level of quality of the final product depends on the quality of all the ingredients. Major paint manufacturers commercialize a wide range of paints made with different pigments of mineral or chemical origin (titanium, cobalt, cadmium) to produce paints that will bear similar names. Therefore the color charts that represent the different color brands, which are better if they are painted than printed, are a reliable reference for learning about the different types and tones of a particular color that is commercially available.

Wheat Field With Cypresses. Vincent van Gogh (1853–1890). This artist's painting style was characterized by the use of pure, saturated colors without excessive mixtures.

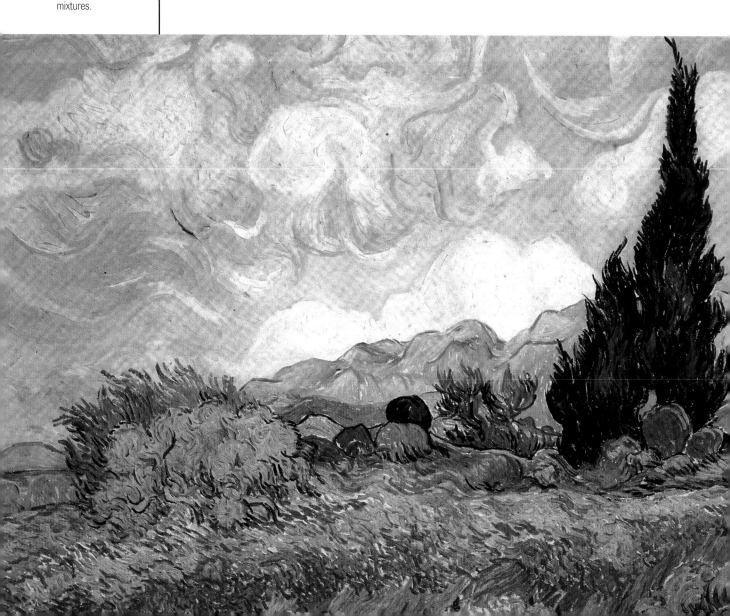

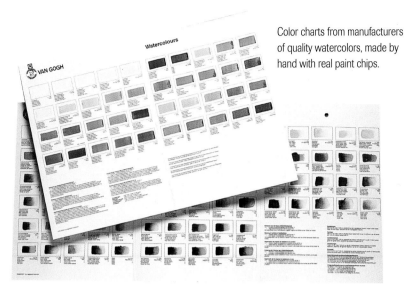

Color charts from manufacturers of quality watercolors, made by hand with real paint chips.

Knowing the Paints

The industry uses a universal code for all pigments independent of the medium (gouache, watercolor, acrylic…) and of their origin. Different brands do not always use the same pigments for the production of paints that bear the same name; therefore the only valid reference is the one that appears on the tube or jar. Each paint container should display the name of the pigment that was used to manufacture the paint. Furthermore, this information is usually accompanied by symbols or letters that indicate a manufacturing guarantee and also information about the properties related to their transparency, permanence, and strength.

■ **Paints are chemical compounds** that can be used to express our experience of colored light and transform it into something physical.

Be Careful with Imitations

The name of the paint on the container does not always coincide with the name of the pigment. In low-quality paints, the name of the pigment is often followed by the word "hue" in parentheses. This means that the paint is an imitation of the color or the pigment. It is best to avoid low-quality paints and imitations.

Different brands may sometimes use different pigments to manufacture paints that bear the same name; therefore the only valid reference is the one that appears on the tube.

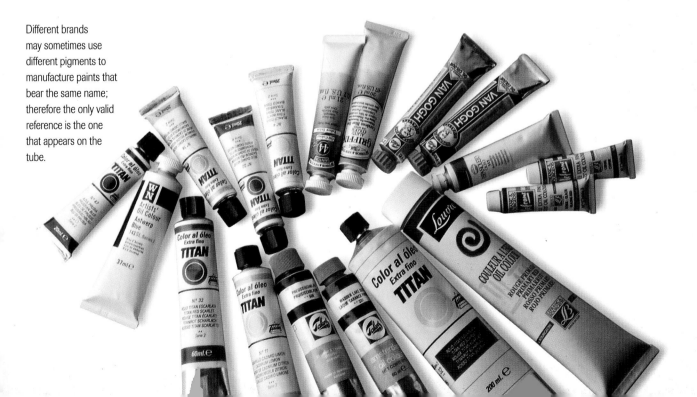

Pigment Forms

Pigments are the materials used to tint and color objects. They are used in different fields: in the plastics industry, textile, cosmetics, and even in food. The majority of the pigments that are used in manufacturing and in visual arts are dry colorants, usually in the form of fine powder, although in illustration it is common to use dyes in liquid form (India ink, sepia, or anilines).

From Pigment to Paint

Paints are made of mediums or agglutinates, which act as glues, and pigments. The final product is the result of mixing both. Pigments are finely ground and mixed with the liquid agglutinant, until each pigment particle is completely impregnated with it. The characteristics of the components of each medium produce the properties of the different paints and conditions their application on the support and the working techniques.

To turn powdered pigments into paint, the pigments are added to a vehicle or agglutinant, a neutral or colorless material that acts as an adhesive.

■ The most important component of paints is **the pigments,** whose prices vary considerably. Nowadays most of the pigments are synthetic; however, the price differences still exist.

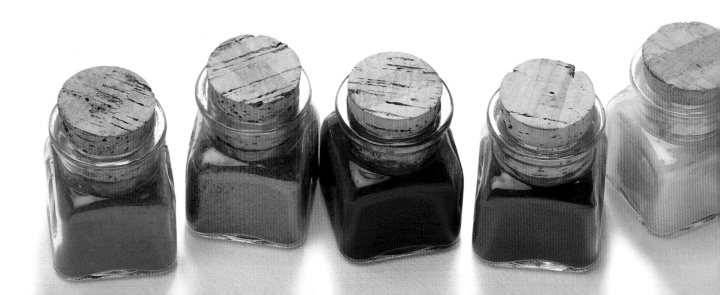

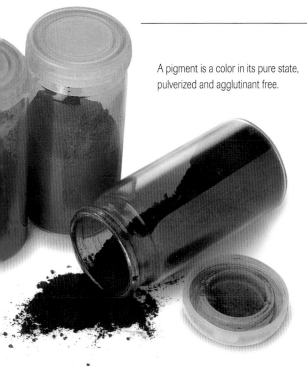

A pigment is a color in its pure state, pulverized and agglutinant free.

Powdered Colors and Dyes

Pigments are fine pulverized colors of a particular chemical composition that are used for the manufacturing of every type of paint, commercial and artistic. In general, there is a difference between a pigment, which is insoluble in a vehicle (forming a suspension), and a dye, which is either a liquid or soluble in the vehicle (resulting in a solution). A colorant can be a pigment or a dye, depending on the vehicle in which it is used. A pigment can also be manufactured from a dye by precipitating a soluble dye with metallic salts.

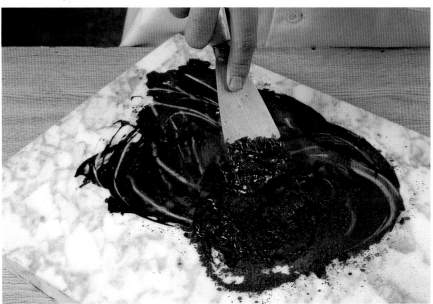

Oil paints are a mixture of pigments and linseed oil.

Pigments and Antiquity

Pigments were already used by the first artists that decorated prehistoric caves, and during the course of history they have been a fundamental element of visual arts. The main natural pigments used were of mineral or biological origin, which made them readily available and affordable.

The need for more affordable pigments given the scarcity of certain colors, like blue, paved the way for synthetic pigments. The majority of the current pigments are synthetic.

Coloring Power

The ability to color something and the power to alter the appearance of another color are attributed to pigments. The tinting power of pigments is specific to each color; so, one gram or one ounce of zinc white has greater tinting power that one gram or one ounce of titanium white. This is due to the fact that the coloring ability of a pigment increases when the size of the powder particles decreases, and vice versa: it diminishes when their size increases. Therefore, as a result of this, the tube of white titanium paint (acrylic, oil, or gouache) is more opaque and has greater covering power than the same amount of zinc white.

What Are the Best Pigments for Painting?

It all depends on what they are used for. If the goal is to create a dense and opaque painting: cadmium yellow, cadmium orange, cadmium red, yellow ochre, burnt umber, ultramarine blue, cadmium green, and emerald green, among others, would be the chosen colors. Notice the presence of numerous pigments derived from cadmium: this group of colors has a high level of pigmentation. If, on the other hand, you want to work with glazes or with thin layers of paint, the pigments do not need to have much coloring power. In this case, it is better to choose lemon yellow, transparent ochre, zinc green, zinc white, light crimson lacquer, vermillion, cobalt violet, and rose lacquer. Notice the low pigmentation provided by the paints denominated lacquers or followed by the term "transparent." On the other hand, we have already mentioned the low intensity of the groups of colors derived from zinc.

Low-quality colors are more transparent and have less covering power. Compare these two blues: a medium- to high-quality level and one from a low quality.

When you dilute with paint, you reduce the paint's coloring power, which will create transparencies.

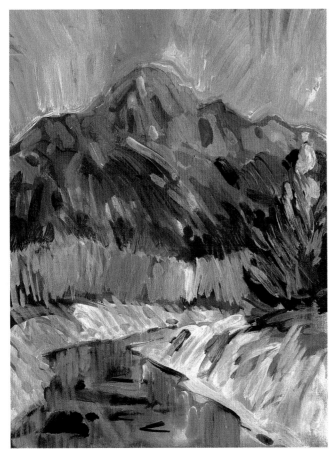

When the paints are applied without being overly mixed, in an opaque layer, they show strong colors and saturation.

All dilutions distort and reduce the strength of the colors. The latter appear lighter but less intense.

Checking the Coloring Power

When you work with different varieties of the same color, you will soon notice that there are differences in the coloring power between the different types. This becomes obvious when you make your first mixtures on the palette. At that time, you will see that to lighten green you need up to five or six times more lemon yellow than cadmium yellow. This difference is also reflected in the price; therefore in the end you are paying more because the more transparent paints are used up faster when you want to create the same results than with other more opaque paints.

Cadmium yellow has more pigmentation power than other yellows. You need less of it to create green.

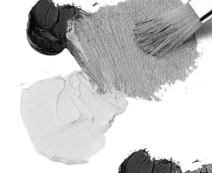

■ The purpose of a color's **dominant tendency** should be to promote expression in the best possible way.

When you add lemon yellow, which has a low coloring power, to ultramarine blue, you need a greater amount of it to create green.

Blue, the Color of Depth

Blue is the primary color par excellence. To begin with, this color is considered a cool color. This idea stems from experience; after all, our skin turns blue when we are cold. Blue conveys an even cooler feeling than white, and despite reminding us of the color of the sky, it also means light, and the shaded side of a block of ice always has a blue undertone. But not all blues are equally cool; each one has its chromatic tendency depending on whether it is closer to red or to green.

Blues, as they come out of the tube, tend to be very dark, to the point that they appear black when they are applied very thickly.

The painter's palette should have two or three varieties of blue. If you use pure color, it will be very deep and beautiful.

The Color of Eternity

Despite being considered a cool color, blue has the most fans. The reason for this is that blue is always associated with good qualities and benevolent sentiments that are not the result of simple passions. The sky is blue, and therefore it is also the color of the divine, the color of all things eternal. The stronger the gradation between light and dark blue on the sky, the farther away our eyes seem to be able to see. This happens because psychologically blue tones create the feeling of distance and spatial depth.

From left to right and from top to bottom: phthalocyanine, cyan blue, permanent violet, ultramarine blue, cobalt blue, and Prussian blue.

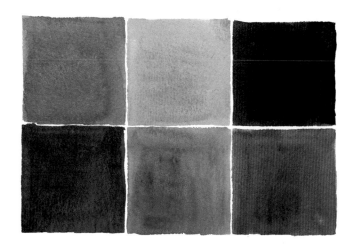

Blues for Artists

The blue most commonly used by artists is ultramarine blue, which is slightly violet and has a deep and rich tint. Cobalt blue is a little lighter and acquires a cerulean undertone when mixed with white. Prussian or titanium blue has a green, cold, metallic tint; when used in its pure form, it is very deep and beautiful, and mixed with white, it produces a wide range of floury blues. Phthlocyanine blues are made of organic synthetic pigments; they are very luminous, transparent, and go a long way. Titanium blue and Prussian blue are cheaper than ultramarine blue, and cyan and cobalt are more expensive. The latter can cost five times as much as Prussian blue.

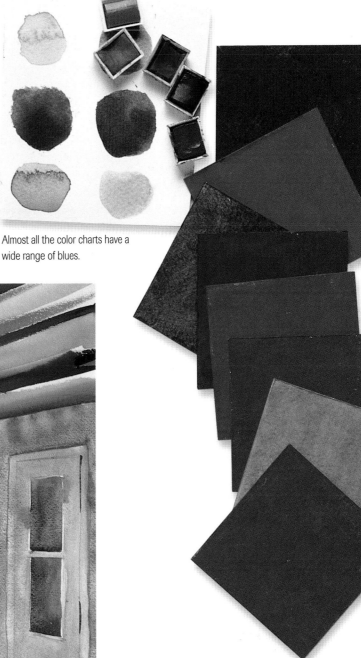

All the blues mentioned and illustrated in the range here are included in this interior painted with watercolors.

Almost all the color charts have a wide range of blues.

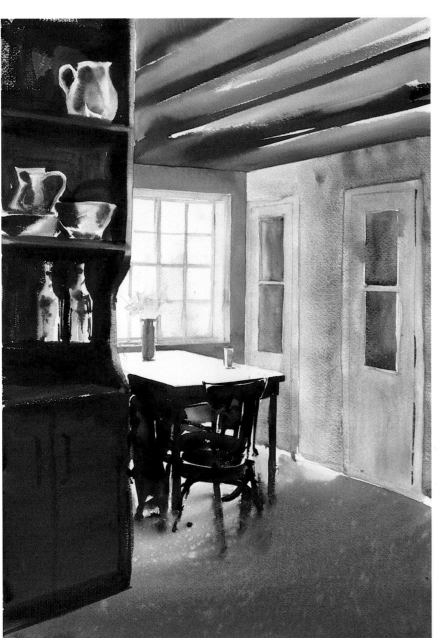

"The deeper **the blue**, the more it calls man to the infinite, awakening in him a desire for purity and, finally, for that which is ultrasensitive."

Wassily Kandinsky

Vermillion

Dark Vermillion

A Passion for Red

Red is one of the most coveted paints by artists. It corresponds to the lowest light frequency discernable by the human eye. It is the most vigorous of all the colors, the color of strength, energy, and life that is associated with fire and blood, all of which have an existentialist significance in every culture. The psychological and symbolic effect of blood makes red the dominant color in all the vitally positive sentiments. Red is taken commonly as the opposite and the nemesis of blue, even though they are not complementary colors. If blue represents a very low temperature, red represents incandescent heat.

Uplifting and Outstanding

In the world of painting, red is used to attract the attention of the viewers and to uplift their spirits. That is why red is used for warning traffic signs, like stop signs and traffic lights, and for prohibition. The universal meaning of red is danger. It is considered an extroverted color, a color that projects forward, that advances toward the spectator. It is therefore a very useful color for highlighting certain areas of the painting or for making some parts stand out against others or against a cool background. There is no other color that is more salient or that captivates audiences as much. However, its potent and vibrant nature can also cause problems for the painter; therefore it is important to keep this color under control and to avoid covering large areas with it.

Crimson

Crimson Lacquer

Red paints range from orange red to purple, which increases the artist's range and choices.

Bordeaux Red

A Variety of Reds

The range of hues spanning from orange to violet is so large it is important to have two or three of them on the palette. Cadmium red is the most commonly used; it is solid, dense, and opaque, and the most powerful one of all the paints in this range. There are other more transparent reds that are very suitable for working with glazes: alizarin crimson, quinacridone pink, or naphthol red. Alizarin crimson deserves a special mention; it is a true classic on the painter's palette. It was a necessary color before the arrival of compound paints based on biological pigments. With crimson you can obtain wonderful violet tones and excellent orange colors.

This watercolor has been painted with cadmium red, vermillion, and crimson, which have been contrasted with a small amount of green mixed with water.

■ The power of **red colors** on any palette is indisputable; they are indispensable for conveying the idea of vitality.

From left to right and from top to bottom: vermillion, quinacridone pink, quinacridone crimson, cadmium orange, cadmium red, and quinacridone magenta.

The saturation and luminosity of commercially available reds vary considerably according to the pigments used in their manufacturing.

Yellow, the Color of Light

Yellow is the warmest, most luminous, and brightest color on the painter's palette. It is the color of light and optimism. Sunlight, although strictly speaking has no particular color, is perceived as yellow, that is why this has become the color of light. Together with red and orange, they are the colors of emotion. Yellow brings happiness, it is bright, joyful, and symbolizes luxury. Vincent van Gogh had a special predilection for this color, especially in the last years of his life.

The Stability of Yellow

Yellow paints represent the most fragile tones. Artists are somewhat unsure about yellow because the other colors easily overpower it. No other color is as unstable as yellow; a small amount of red makes it orange; a touch of blue turns it green, and a small amount of black muddies it and drowns it. This is why yellow is almost always used unmixed. Even though yellow is more dependent on all other colors when it comes to combinations, it cannot be replaced when adding nuances to the reds and to lighten the greens. Thanks to yellow, these colors can be customized in a personal way.

Black and Yellow

Yellow contrasts most with black. That is why the mixture of both is used to highlight announcements or warning signs. Although they can be used in juxtaposition, you should avoid mixing them on the palette. It is not a good idea to add black to yellow, because it turns into a greenish tone that is not very appealing.

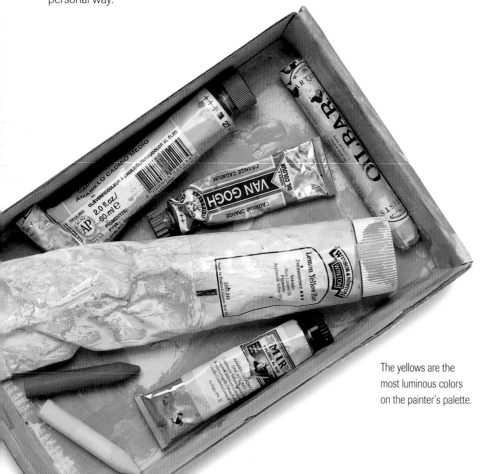

The yellows are the most luminous colors on the painter's palette.

■ The margin of variation for **yellow** is very limited, and it turns green, orange, or brown very quickly.

Moderate Use

Yellow is the color with the most positive vibration. Golden yellow is intensely spiritual and favors compassion and creativity. However, it is a color for small applications; you should not abuse it. Because of its brilliancy, pure yellow can be too stimulating for the psyche and the nerves if used extensively. It can also cause mental irritation to the point that it can become excessively harsh for the viewer. Therefore, it is important to tone it down with other colors to arrive at a darker range that contrasts with lighter and more luminous shades of it.

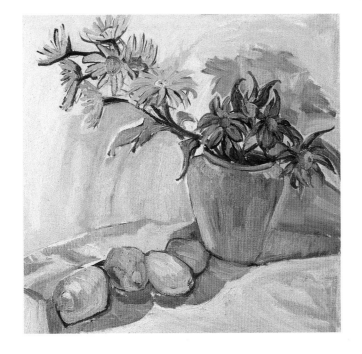

This harmonic still life is painted in a range of yellows. The various tones are achieved by mixing yellow with a touch of green, red, and violet.

From left to right and from top to bottom: hanta lemon yellow, azo yellow, medium cadmium yellow, light cadmium yellow, Indian yellow, and dark cadmium yellow.

Yellow is shiny and stimulating, it conveys the feeling of lightness. When it interacts with the other colors it loses its importance, and it turns green yellow or red yellow, or yellowish white.

Study of an Alley in Yellows

To start working with the first mixtures, we propose a very simple architectural painting using a wide range of yellows that will be toned down with violet, white, ochre, red, and earth tones. It is not an easy exercise, because the wide range of yellows is one of the most difficult ones to work with since it does not offer as many variations as other colors. The contrast in the following scene is very radical; it will be important to paint the tones correctly with a dominant yellow hue and without getting lost in the details, while pursuing an especially colorful outcome. We used gouache.

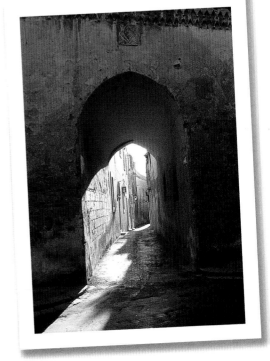

The picture is a narrow alley street with an arch. A bright light illuminates the passage.

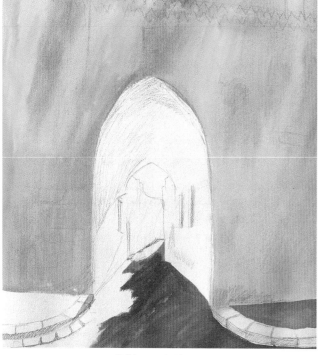

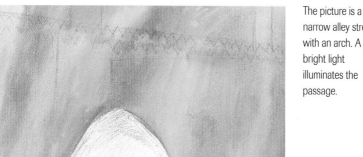

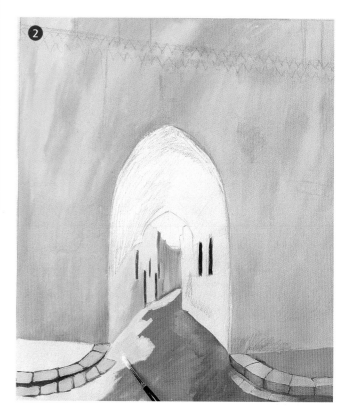

❶ We started with a pencil drawing. Then we painted the area of the wall with an even layer of strong orange yellow, and the shadows on the ground with burnt sienna blended with yellow and ochre.

❷ The illuminated areas were painted with a beige color, resulting from lightening yellow and then mixing it with burnt sienna. We painted the stone blocks bordering the sidewalk with yellow and a touch of violet and white.

The limitations of yellow are overcome by mixing it with small amounts of other colors. Then, the wide range of tones created is spectacular.

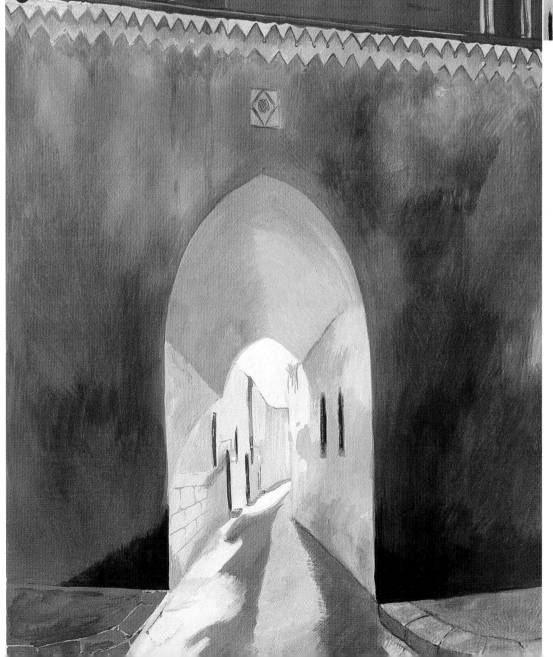

❸ We finished defining the façade with various yellow tones darkened with sepia or violet. For the shadow of the vault we use medium orange.

❹ This is the final result. We have darkened the wall considerably with orange colors toned down with browns and sienna. It is important to blend the brushstrokes while the paint is wet.

An Array of Greens

Green is more than a color; it is the essence of nature. It represents harmony, exuberance, and freshness. It is an extremely well-balanced color, because it is made up of warm yellow and cool blue. In the old color theories, it was considered a primary color. These theories did not classify colors according to their origin or technical mixture of pigments but in function of the psychological effect caused by them, which made green an independent color. Because of its nature, greens adapt perfectly to colorist paintings; they offer more possibilities for chiaroscuro than most colors, and some tones rival in brilliance and intensity the most brilliant hues on the palette.

To represent nature, artists normally use a range of greens mixed with some blues.

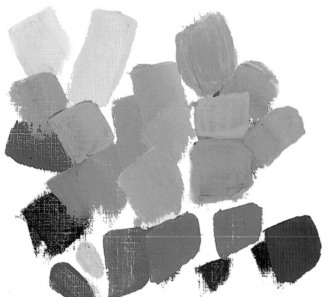

A Wide Range of Greens

Green is the one color on the palette that experiences the greatest change and also the one that offers the widest range of variations. All the green tones can be combined easily even with each other. Green pigments used in the manufacturing of paint are not very intense but combined with yellow and blue pigments generate a wide catalog of colorations. This means that you can have a wide range of greens, from the lightest to the deepest, without using white in the mixtures, that is, without changing its chromatic power.

Green results from the balanced fusion of the emotion and warmth of yellow and the depth and coolness of blue. It can be considered a warm color.

A landscape painter usually has three or four very different greens on his palette.

A Natural Green

Painters rarely use green colors from the tube; they usually blend them with yellows and blues depending on whether they want lighter or darker tones. The natural effect of green does not depend on the natural color of the pigments, which often are very artificial looking; it is created with the colors that are added in the mixture: blue, ochre, yellow, sienna, or gray, which make it look absolutely natural. In addition, if we add small amounts of red to the mixtures of greens with yellows and blues, we can make olive or earthy greens.

■ **Green** has a strong affinity with nature and connects it with the artist and the viewer.

A painting harmonized with a wide range of watercolor greens. The lightest areas are achieved by diluting the color with water or by mixing green with yellow.

Here are the four most commonly used greens in oil painting. From left to right and from top to bottom: cobalt green, permanent green, emerald green, and sap green.

The wide range of green hues makes it possible to produce paintings with a variety of tones that are based exclusively on this single range.

Orange and Violet

Although green has often been considered the fourth primary color, orange and violet do not get the same consideration; they clearly play a secondary role. We think of red, yellow, and blue before we think of orange and violet, and that is why we do not consider them indispensable, although they are important on the palette (especially when working in a colorist style). All mixed colors seem ambiguous, subjective, and insecure, but they are an excellent complement to adjacent primary colors in the color wheel.

Orange, a Transitional Color

Red and yellow separately clash too much with each other, while orange unites and harmonizes. Red represents the culmination, and orange is the transition to that culminating state. The dynamic aspect of orange is its similarity with red; therefore, it also becomes a showy color in the realm of passion and excitement. Although orange is easy to obtain with simple mixtures, it is worth having an orange color on the palette to have it available whenever it is needed in very saturated form. The most common orange is cadmium orange, a solid and covering color like all the cadmiums, and it is also quite dominant in the mixed colors.

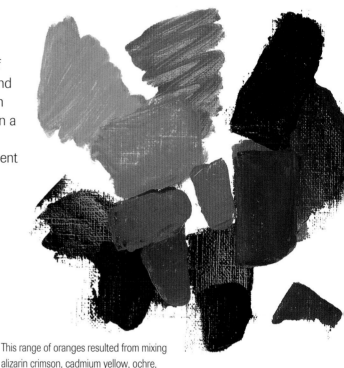

This range of oranges resulted from mixing alizarin crimson, cadmium yellow, ochre, and white.

"It is not surprising that energetic, healthy, and firece men like **the color orange**. A prediction for it has been observed in wild peoples."

Goethe

Orange is a secondary color that is considered a transition from yellow to red.

Face of a boy painted with cadmium orange washes. The lightest colors are created by adding water to the paint.

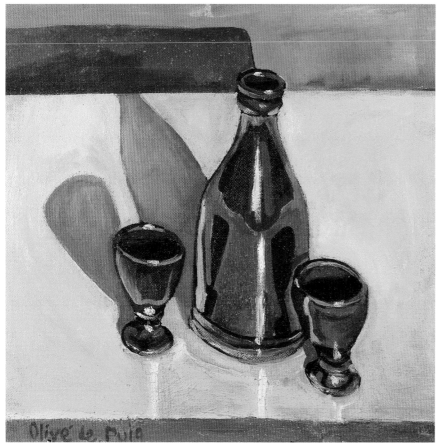

The power of this simple still life resides in the contrast between the glass objects in violet shades against an orange background.

From Violet to Lilac

In no other color converge such opposing qualities as in violet; it is the union of red and blue, of male and female. The union of two colors that are psychologically opposite is what determines the symbolism of violet. All this fascination adds to its rarity and extravagance because violet is one of the colors that is least present in nature. Therefore, the artist must make a conscious selection of this special color. If you try to obtain violet from mixing red and blue, you will often get brown. This is because as soon as a small amount of yellow is added, it turns brown. Violet is only obtained by mixing magenta with blue, which should not contain any yellow either. However, the easiest approach is to use violet pigment directly, which would guarantee a luminous color. In terms of quality, the most recommended one is cobalt violet, one of the most expensive colors.

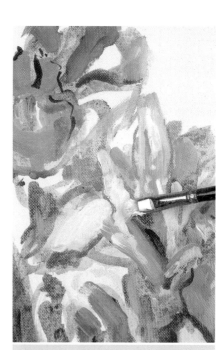

These variations of violet and lilac colors result from mixing cobalt blue with crimson. We have added a small amount of white to better adjust the values.

Violet or Lilac?

Violet is the mixture of red and blue, while lilac results from violet and white. In lilac, the red, the blue, and the white are almost equally balanced.

The Earth Tones

Earth tones use natural pigments of mineral origin, unlike colors that use vegetable or animal pigments. They are readily available because they are manufactured by pulverizing minerals rich in iron oxide. For this reason, they are mostly red, orange, and yellow. All their shades are very sought after by artists because their colors correspond to a variety of natural materials and because this group of colors is easy to combine with other more lively colors.

Variations of burnt sienna mixed with ochre, English red, and white, with which we obtain a perfect color harmony.

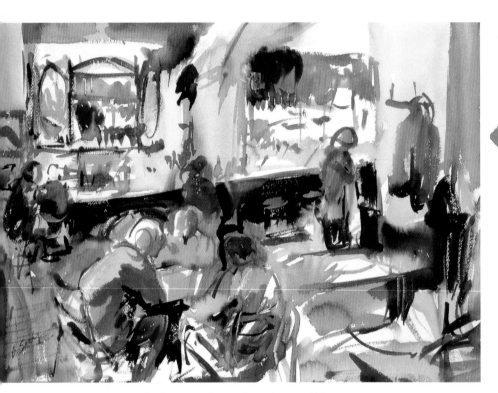

This interior was painted with a variety of watercolor earth tones, which range from light ochres to deeper dark browns.

A Variety of Earth Tones

Earth tones are very stable solid paints that should not be missing from any painter's palette. Most of them have a yellow-brown earthy pigmentation, although many turn red when they are heated because they contain iron. This is the reason why they can be considered shaded warm colors.

The most common colors are: raw sienna, which has a yellow-brown pigment that turns more into an auburn color when heated; ochres, which can fluctuate between orange and bright yellows; red earth tones, like English red, which are dark, almost maroon; and raw umber, which has a black undertone.

From top to bottom and from left to right: transparent golden ochre, burnt sienna, raw sienna, English red, raw umber, and burnt umber.

They Go Well with Any Color

Because of the warmth and richness of their colors, in addition to their quick drying time, earth tones are recommended as base colors for any composition. Due to their lower color strength, they are particularly suitable for combinations with brighter colors; therefore, they are very useful as supporting colors for saturated red, yellow, and green tones. The harmony based on earth tones is warm and charming. Mixed with blue or violet they provide a variety of grays or dark, deep, and warm colorations.

■ **Iron oxide–based pigments** are easy to obtain; therefore they are the least expensive paints on the market.

Earth colors include a large number of different pigments, all of them of natural origin.

The warmth of the earth colors is unparalleled and enormously useful for creating harmony in well-balanced paintings.

Seascape with Earth Tones

Among the earth tones you can find the yellows, ochre, sepia, and raw sienna, which include iron oxide in different quantities and combinations resulting in an extremely wide range of colors. This generous array of hues has not been ignored by artists, who have resorted to these colors to create interesting and balanced monochromatic paintings. Now we will begin by using and mixing some of these earth tones, like burnt umber, burnt sienna, ochre, and white, to paint a very simple seascape with oils. In this scene the strong waves in an agitated sea take center stage.

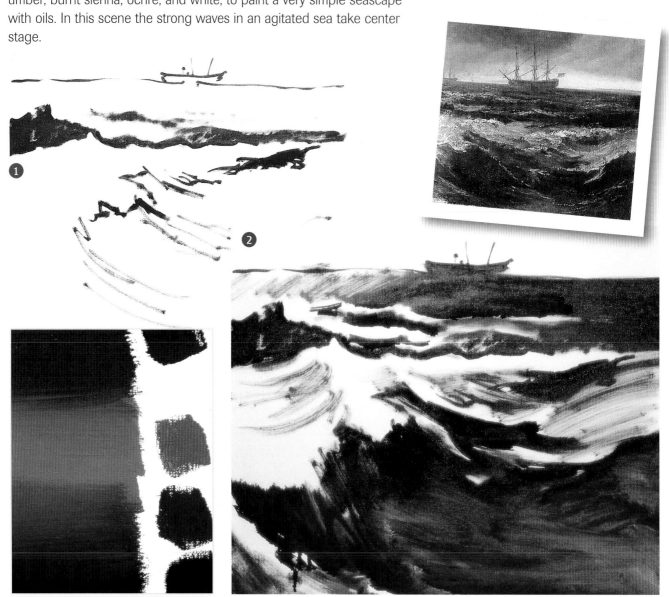

Be Careful with Imitations

Brown itself is a mixture of colors where reds and greens are predominant. But it can also be obtained by reducing the saturation of orange or by mixing it with black.

❶ We laid out a simple foundation with a brush charged with burnt umber very diluted with solvent. This establishes the placement of forms in the space: the boat in the distance and the direction of the waves.

❷ Using the same color, we modeled the volumes diluting the paint as much as needed to create forms with the paint. We reserved the areas for the foam, leaving them unpainted.

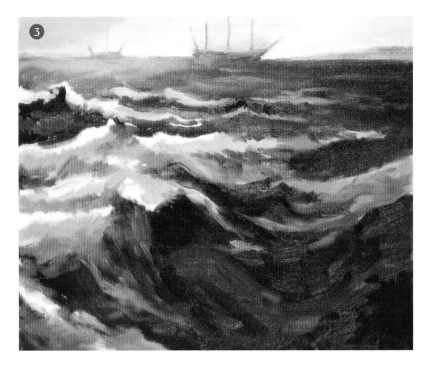

❸ We added white and ochre to burnt sienna to paint the lightest areas of the waves, while avoiding touching the crests of the waves with the brush, which are the splashes of light that will be painted white.

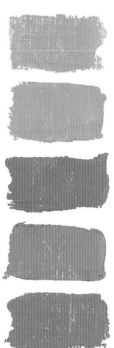

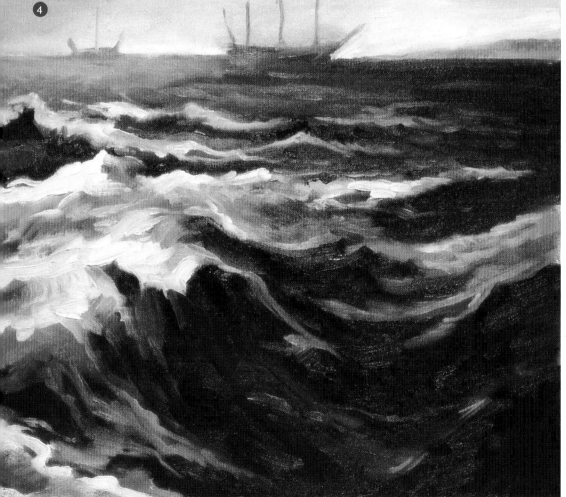

The white that is added to earth tones can be somewhat gray to better harmonize and neutralize the colors.

❹ To finish the work, we added the pertinent touches of pure white to the foam of the waves and included a few nuances with a dab of ochre mixed with orange.

Black, the Deep Dark

Black, together with red, green, yellow, dark blue, cyan, magenta, and white, is one of the eight basic colors, a classification that corresponds with the extremes of light reception of the human eye. Many artists consider it a secondary color that can be produced by mixing all the other colors. In any case, choosing black means giving up joyful colors and decorative elements in favor of strong contrasts and sobriety.

Black or "Noncolor"

Toward the end of the nineteenth century, black came to be known as the "noncolor" and was relegated from the painter's palette in favor of a more colorist palette. From that moment on, it could only be obtained from the mixture of several dark colors. Basically there are two deep blacks that can be obtained by combining two or three groups of colors. The first one is ultramarine blue, Venetian red, and sepia green; and the second with burnt umber, alizarin crimson, and emerald green, in such a way that the dark quality is not represented by a particular color but as a result of an optical effect achieved through the mixture of colors and the power of contrasts. A black color created with the mixture of these three colors is more interesting and harmonizes better with the rest of the colors in the painting than with black paint from a tube.

A Deep black resulting from mixing alizarin crimson, emerald green, and burnt umber.

B Black obtained from mixing alizarin crimson, burnt umber, and Prussian blue.

C Another way to achieve black is by mixing Venetian red, ultramarine blue, and sepia green.

■ The painter's palette contains all the colors and resources that cover all his needs, **replacing even black**, which is absolutely necessary.

Violet is one of the few colors that can be darkened with black and still provide a more or less natural result.

Hard to Combine

Black mixes very poorly with other colors, especially with light ones. This means that it should never be used for darkening because it changes the colors too much, muddying the mixture greatly. However, there are combinations that react better, like black and violet, because it is a natural occurrence in the environment: violet blends with black in the night sky. For this reason, black is normally not used for mixtures; it is only used when it is very justified, for example, to represent darkness.

It is not very common to use black when working with watercolors; it is usually replaced by Payne's gray.

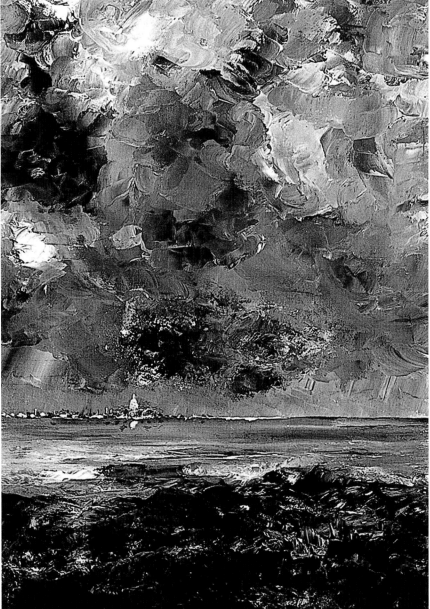

Black responds well to a wide range of gradations with white.

In night scenes, the presence of black, in pure form or mixed with other colors, is very justified.

White Is Light

White is, according to symbolism, the most perfect color. As with black, the question that it always prompts people to ask is: Is it a color? In the physical sense, in optical theory, white is more than a color; it is the sum of all the colors of light. But if we refer to pigments, white represents the absence of any color paint, because most artists work over a white background. That is why the Impressionists considered it a "noncolor." However, this color is essential in any palette because, unlike black, it cannot be obtained from the mixture of other colors. It would not be unreasonable to say that white is the forth primary color.

No other color is as light as white.

The Two Most Common Whites

White is part of many mixed colors, especially if the painting includes very light tones. The two most common whites that artists work with are zinc white and titanium white. The one derived from zinc is transparent and has low pigmentation strength; it is only recommended for glazes. Titanium white is opaque and is very resistant to light. When introduced into the mixture, in addition to lightening it, it reduces the saturation of the colors and allows the artist to enrich the harmony of the colors. You should be aware that white paints (if they are oil based) dry much slower than most of the other standard colors.

■ Whenever you need to work with light tones, **white** will undoubtedly be part of the mixture.

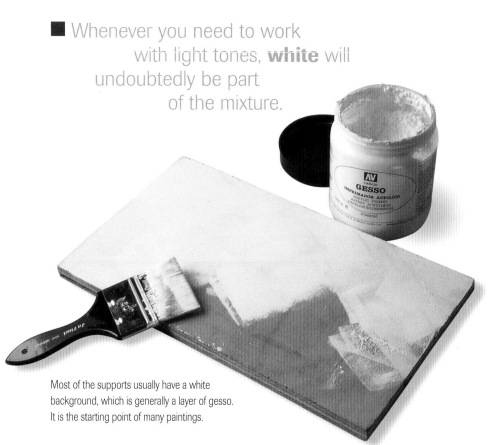

Most of the supports usually have a white background, which is generally a layer of gesso. It is the starting point of many paintings.

There are different variations of broken white colors, which are only perceptible when placed next to each other. A minute amount of another color is what differentiates them.

It Both Warms and Cools

Adding white to any color has a cooling effect for warm colors and a warming effect for cool colors. It forms part of the process of desaturation that white brings to the mixture and that alters the temperature of every color.

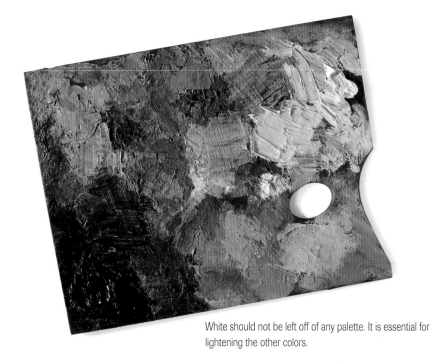

White should not be left off of any palette. It is essential for lightening the other colors.

With subtle dabs of gray and crimson we have painted this simple composition where a blinding white light bathes everything, creating a very peculiar scene.

Still Life with Earth Tones, Black, and White

Little by little, the level of complexity of the exercises is increasing. The idea now is to combine earth tones with the addition of white, black, and a range of grays that results from mixing all of them. The medium tones are mainly represented with earth tones, greatly impacted by the use of ochre; the most illuminated areas are highlighted with the addition of white; while black, which is more limited, is used only sparingly in the very dark areas and in the form of dabs or lines to add definition to the contours.

This still life, seemingly simple and sparse, is the perfect excuse for an exercise done with a limited range of earth tones, black, and white.

Before we begin to paint we test the colors that are going to be used in the exercise. They are a series of earth tones that will be lightened with yellow, ochre, and white, and darkened with burnt umber and black.

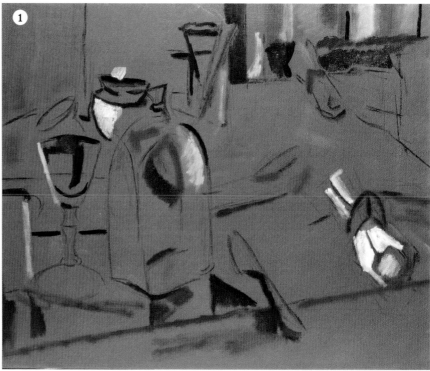

❶ We painted the background with very saturated iron oxide red, which will provide a deep and velvety color.

To strengthen the unity of the color range, many artists use color backgrounds. By doing this, harmony is almost guaranteed from the start.

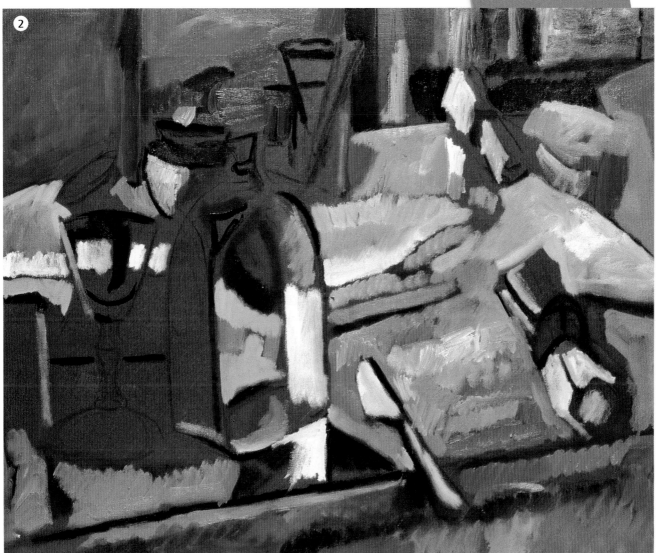

It is a good idea to develop different varieties of ochre. To do this, you can lighten the painting with yellow and white, which should cover the most illuminated areas of the tablecloth.

❷ The ochre and the areas of shadow will form a puzzle on the tablecloth surface. It respects the background color as an element of the chromatic harmony.

❸ In a composition dominated by earth tones, grays and blacks are very important for breaking up the chromatic monotony. We applied the first strokes of white paint on the bottle.

❹ The role of black and white is to define the shapes of the objects and to enhance the contrasts against the background. The treatment of the areas of color continues to be very stylized and the modeling minimal.

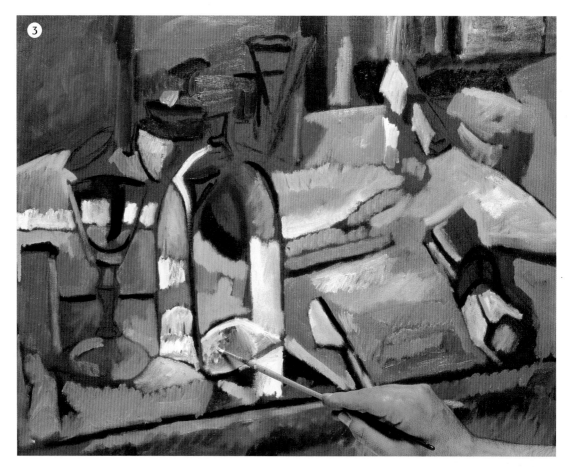

Line and Color

Black spaces appear much smaller than white ones. Because it contrasts strongly with the rest, black appears angular and harsh. The white color shines brightly, which creates an optical illusion that makes the space look larger, while black shapes and defines the outlines of the objects.

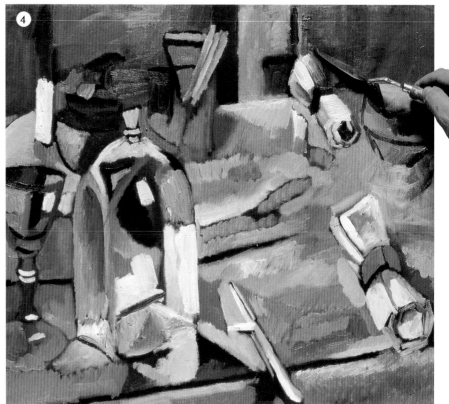

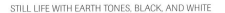

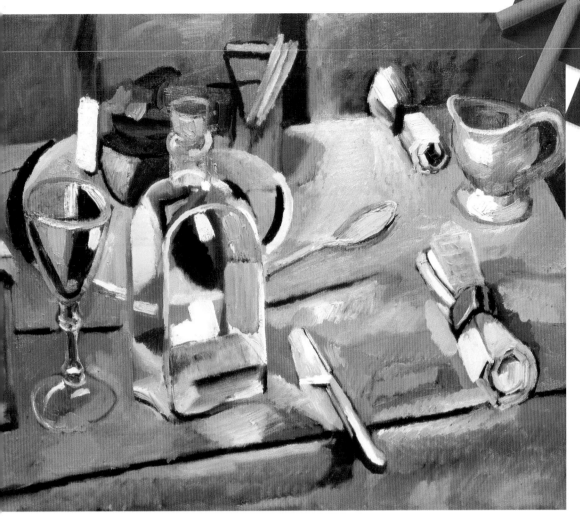

For grays to better harmonize with the earth tones, they must be combined with them. Simply add a dab of brown to make the gray brown or pink.

5 We added a few details and applied the last white reflections on the metal and glass objects. The color coherence, the variety of forms, and the free treatment of the areas of color provide an interesting result.

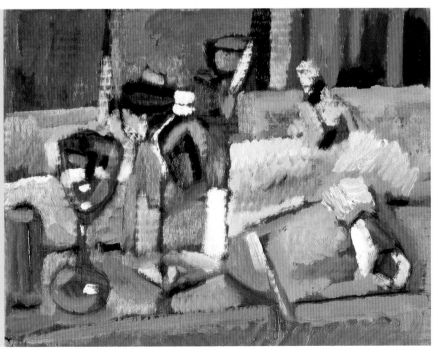

You can paint the same still life, but this time on a board and with larger brushes. Although the model is the same, the result will surely be different. To this end, simply take away a few objects and treat certain areas of the painting differently.

Special Colors: Golds and Iridescents

Oils, acrylics, and gouache not only provide a variety of traditional colors but also offer different variations that are related to the way light reflects on the pigment particles. Such is the case of gold, silver, and pearly colors. Certainly, gold, silver, and pearly white are present in nature, but they are not considered common colors, that is why they tend to be viewed as artificial colors and are associated with current painting styles, a product related to technology.

Pearly colors present a very characteristic pearly shine that varies according to the position of the viewer with respect to the painting.

Golds and Silvers

Gold is related to yellow, and it is always associated with the sun. It has an attractive shine, but it appears distant. It is not commonly used to cover large surfaces but for small details. This is because in daily life, gold is present as a decorative color on certain details.

Like gold, silver is a noble metal. The silver color has a more modern look, and it is associated with the luster of modern objects, although it is less outstanding and ostentatious than gold. Gold and silver tones add a great deal of warmth to paintings and are associated with wealth and with precious metals. Gold combined with browns and violets, favors harmony; and it looks festive and sophisticated next to fuchsia and orange. Silver, on the other hand, relates better with a variety of cool colors.

Golds and silvers are usually combined with other traditional colors to produce more solid and brilliant combinations.

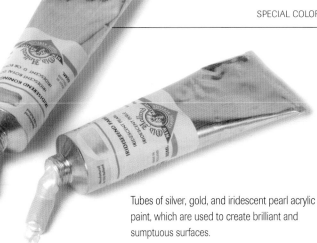

Tubes of silver, gold, and iridescent pearl acrylic paint, which are used to create brilliant and sumptuous surfaces.

Iridescent Pearl Colors

These paints provide a pearly reflection that changes according to the way light falls on the painting and the angle of the view. They are produced with flakes of mica mixed with titanium. The drawback is that the range of colors that is commercially available is very limited. The best approach for working with iridescent pearl colors is to buy an iridescent medium and mix it with any color as needed. Some artists purchase tubes of gold, silver, and iridescent paint to add highlights to the traditional colors.

Finished modern painting that includes areas accented with gold paint. This is a color that should be applied sparingly, without overdoing it.

Contemporary work that includes silver paint in the drawing of the church's door and front steps combined with other traditional oil paints.

■ Gold and silver paints

are recent arrivals, which is the reason why they are usually associated with contemporary and current works.

Fluorescent Colors

Besides a range of traditional colors, acrylics offer a range of luminous varieties that are closely related to the way light affects their particles. Fluorescent light produces extremely brilliant and flashy colors that are very suitable for commercial art; but for painting, this spectrum can look unnatural. For this reason, fluorescent paint is usually associated with modern and current techniques.

Emitting Their Own Light

Pigments emit a particular color as a result of the selective absorption of light rays. This physical process is different in fluorescent and luminescent colors, where the pigment appears to emit its own light. In other words, the rays absorbed by these colors are transformed into light with a wavelength that is greater than the incoming light. Conventional pigments reflect back part of the light and absorb the rest in the form of heat. Fluorescent pigments, on the other hand, absorb light on a spectral beam and reflect it back as light that is visible on other bands of the spectrum. A particular characteristic is that they can be illuminated with black light or ultraviolet light.

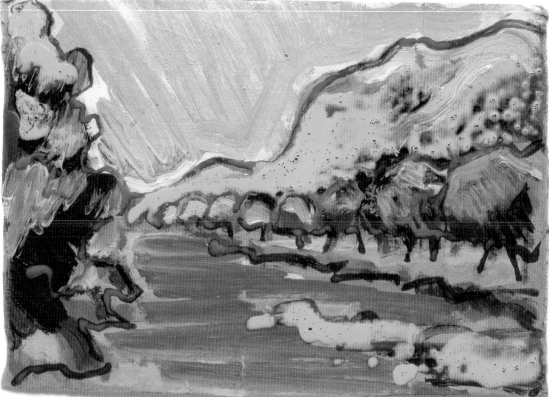

Generally fluorescent paints are acrylic and can be used in pure form or mixed with other colors.

They produce an overwhelmingly uplifting visual effect, as if the paint had its own light source.

Bright Paint

The more recently developed fluorescent and iridescent paints are used more commonly for commercial applications rather than artistic. They are extremely bright, as if they had their own light source. Since they reflect back more light than expected, it appears as if the pigments shine by themselves. This has its advantages, because fluorescent colors can be seen faster than conventional colors; therefore a painting made with these tones will attract the viewer's attention. Used sparingly in any painting, fluorescent colors can create contrasts or areas of focus. Therefore, they can be useful if the artist wishes to draw the viewer's attention to a particular area of the painting.

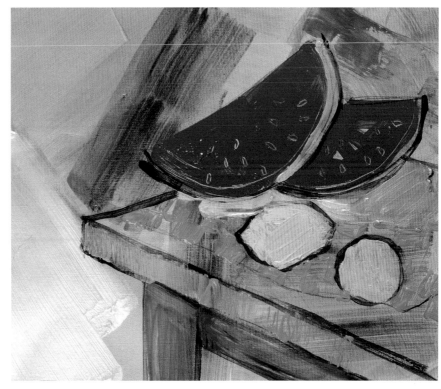

Fluorescent colors not only draw the attention of the viewer but they are also able to hold it longer.

Taking advantage of the fascination that new fluorescent colors suggest, artists can experiment with abstract compositions.

Boats with Fluorescent Paint

Here, we propose a simple subject that requires mixing traditional acrylic paints with fluorescent colors. The idea is to experiment with unusual colors, to figure out how they interact with other acrylics, and to learn their values and how to take advantage of their impact. Before we begin, keep in mind that the visual power conveyed by fluorescent paints on images printed with four colors is difficult to evaluate. To better appreciate the results of the exercise, the printing dyes should have been fluorescent as well, but unfortunately that is not the case. Therefore, we wanted to make these limitations clear.

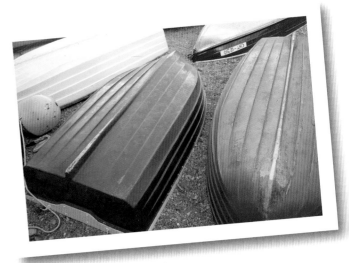

These small boats represent a very simple theme. They become interesting masses of color against the sand of the beach.

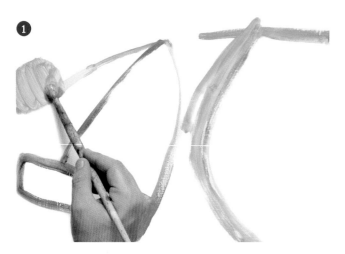

❶ Without a preliminary drawing, we charged a brush with heavily diluted lemon yellow and cyan blue acrylic paint, and we applied the first lines. The goal is to capture the main forms with simple rounded lines and areas of color.

A porcelain plate becomes an improvised palette where the most strident fluorescent paints are combined with traditional acrylics.

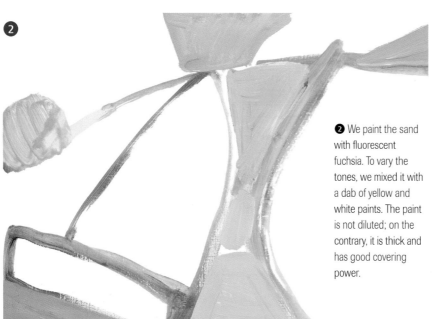

❷ We paint the sand with fluorescent fuchsia. To vary the tones, we mixed it with a dab of yellow and white paints. The paint is not diluted; on the contrary, it is thick and has good covering power.

3

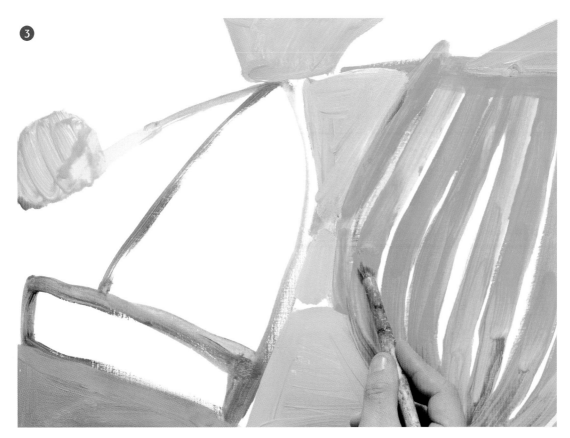

5 We paint the boat's hull lines and the relief of the boards with fluorescent green, using very long brushstrokes. We have added a small amount of cyan blue to the fluorescent green.

4 With fluorescent fuchsia tinted with a dab of red, white, and violet we do the same on the other boat. We leave small spaces unpainted between the colors of the planks.

4

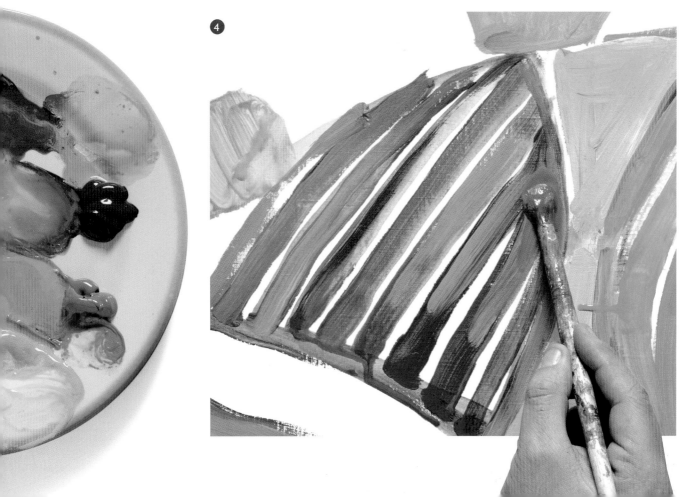

Several at the Same Time

When you experiment with a new medium or with colors that you are not familiar with, it is a good idea to do several paintings of the same subject at the same time to test different interpretations, applications, and possible combinations.

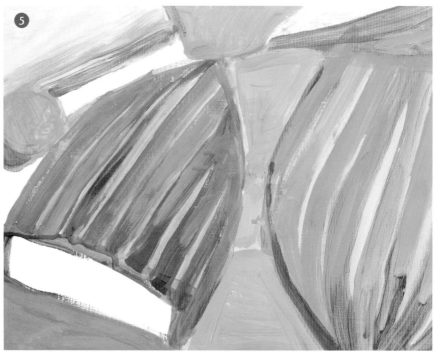

❺ When the layer of paint is completely dry, we paint the lines left unpainted with slightly diluted fluorescent orange.

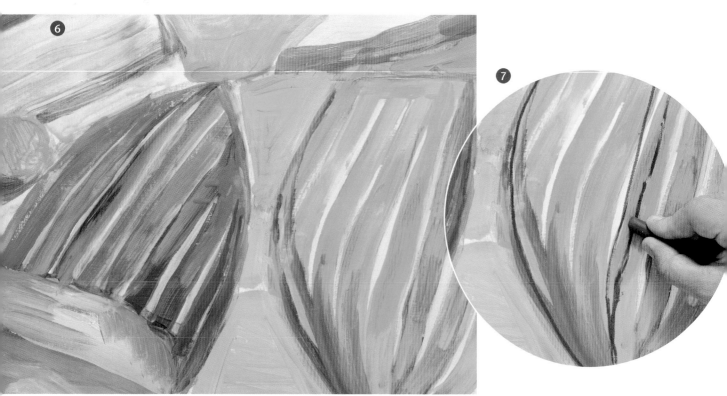

❻ With cyan blue we finish painting the boats. With the same color lightened with white, we paint the boats cut off on the upper area of the painting, letting the paint dry for a few minutes.

❼ Using wax sticks, also called oil pastels, we add a few lines and features. We used a red stick for the green boat, for the greatest possible contrast between the two colors.

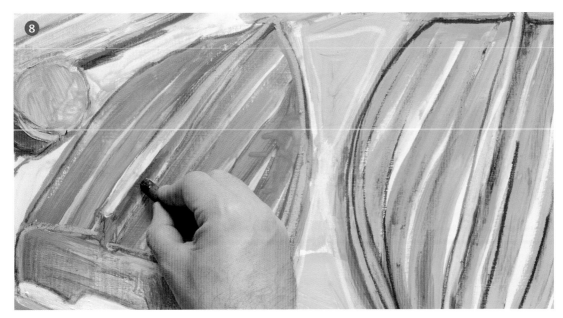

8 We do the same for the fuchsia boat, alternating cyan blue wax with cobalt blue. The lines should not be perfect but rather irregular and casual, which will provide a greater whimsical effect.

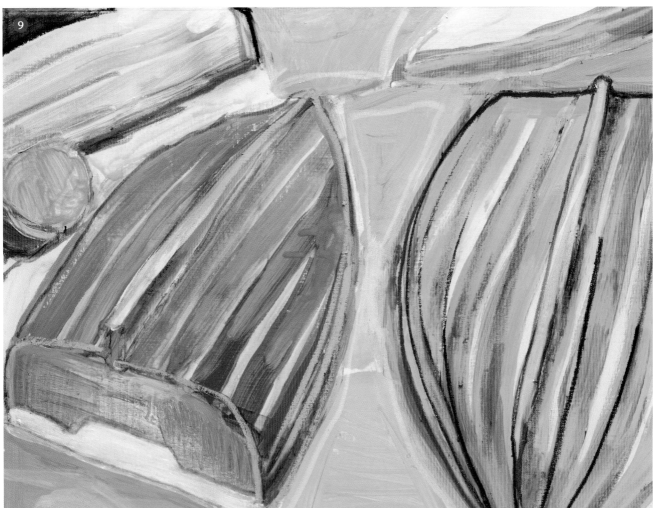

9 If you compare the final image with the initial model, you will see that the fluorescent colors have turned the representation into an explosion of color. Everything is covered with a generous amount of light and avid contrasts.

MIXING COLORS ON THE PALETTE

Very rarely does the artist apply the paint on the paper as it comes out of the tube or the cake. Generally, the mixtures are prepared and the tones are adjusted lightly by adding small amounts of other colors. In this section, we are going to study a few basic important concepts that beginners should learn and the more advanced should not dismiss. Manipulating and blending colors are not easy tasks, but it is necessary to have a few clear essential notions. The study and control of the mixtures is a very important resource for any artist, because it makes the work easier and provides greater control of the painting's final look.

Pads of disposable paper palettes are commercially available. They are very useful for oil and acrylic paints, and they eliminate the cleaning process.

Mixing Is Basic

Every artist needs a practical knowledge of color, and the only effective way to learn about it is by mixing colors on the palette, to experiment by trial and error. To learn how to mix is fundamental to understanding how the colors influence each other, affect each other, and interact with each other; in addition, it also teaches the artist how to predict the color phenomena and effects as well as how to create new colors from basic ones.

■ By mixing on the palette, **the artist creates new colors** and attempts to suggest those that he sees on the model.

A watercolor palette should be white and have a large surface for mixing.

Choosing a Palette

Palettes come in different shapes and sizes, but they are all designed to adapt to the characteristics of each painting process and to each artist. A large palette is more practical than a small one because it provides a larger surface for mixing colors. Whenever possible, it is a good idea to choose a palette whose color resembles the color of the painting's background, that way you will have a better idea of how the colors will look on the canvas. For example, a wood palette will be ideal for a red or brown background, and a white one if you are working over a light background. However, since wood is brown, it has an effect over the color applied over it and disguises its true appearance. A color surrounded by dark brown can appear much lighter than it is in reality.

Mixing on the palette should be carried out with a comparative approach, evaluating the base color against the tones obtained.

The mixing of colors iis one of the most important aspects of the painting process, much more even than their application on the canvas.

Palettes for oil paints should be rectangular or oval. The ones that are made of light-colored wood are better than the dark brown ones.

What Colors Do We Begin With?

A palette with many colors may not necessarily represent an advantage for the artist, no matter what process he or she uses. Professional artists tend to work with a range of 25 colors; however, with a palette of 10 or 15 colors you can obtain an infinite variety of possibilities as well. The colors selected should be opaque, resilient to light, and versatile, to be able to tackle a range of subjects.

Selecting Colors

Begin with a restricted range of multipurpose colors that will be able to produce a wide variety of tones and nuances when mixed together. Here we provide a list of the colors that you should buy to begin painting with a minimum guarantee of success: white, cadmium yellow, cadmium orange, yellow ochre, burnt sienna, burnt umber, cadmium red, alizarin crimson, cerulean blue, ultramarine blue, titanium green, sap green, and black. It is possible to make a different selection with slight variations or to widen the range with one or more colors depending on the subject that you are going to paint. For example, if you are painting a sunset, you can add medium violet, and if the theme is a seascape you can add cobalt blue or Prussian blue.

The basic colors from the palette that we proposed are shown in the center, and surrounding them we displayed the many mixtures that you can obtain from mixing them.

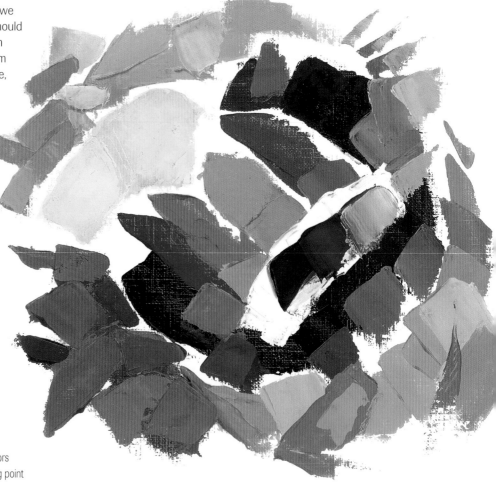

Here is a proposed palette with additional colors from the basic one suggested. A good starting point is to obtain a wide range of variations.

| White | Cadmium yellow | Cadmium orange | Cadmium red | Alizarin crimson | Yellow ochre | Burnt umber |

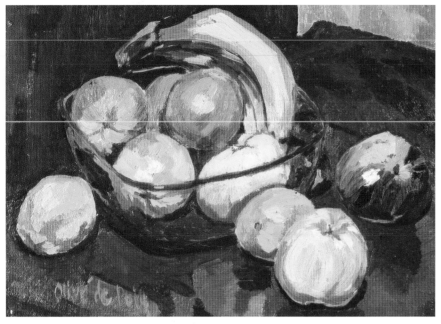

By mixing yellow, red, burnt umber, and a couple of greens, we have obtained the many tones iincluded in this picture.

Do Not Spare Paint

Do not spare any paint. Squirt generous amounts on the palette, otherwise you will be constantly opening the tops of the tubes and mixing new batches of paint, which can be time consuming.

Preparing the Colors on the Palette

You should not fill up the palette gratuitously with paint; the best approach is to have the necessary amount of only the colors that you plan to use. To be able to work coherently and quickly, we recommend placing the colors on the palette in a specific order. You can organize them by temperature and arrange them from warm to cool (begin with white, followed by yellows, oranges, reds, earth tones, greens, blues, and blacks). If you want, you can also arrange them according to the color spectrum. Avoid placing the very dark colors next to the very light ones, like violet next to yellow, because a small spill or accidental touch with the brush can result in an unwanted mixture.

There are many ways of arranging the paint on the palette, one of them is grouping them by temperature, warm colors on one side and cool ones on the other.

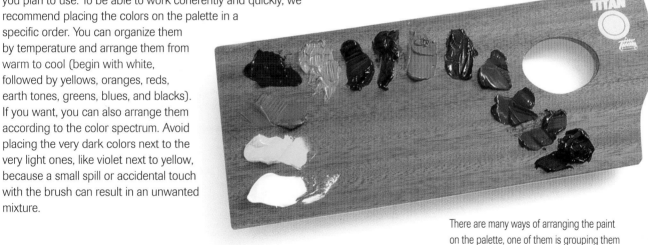

| Sepia brown | Cobalt blue | Titanium blue | Ultramarine blue | Permanent green | Emerald green | Ivory black |

First Mixtures

With the first mixtures we learn how to create secondary colors by mixing two primary ones.

F ew artists apply paint directly from the tube; the best way to do it is by mixing colors partially on the palette and then to finish adjusting them on the canvas until you have achieved the desired combination. Therefore, the palette should become your testing ground, a tool where you can experiment mixing and combining colors before they are applied on the canvas or on paper. A word of advice before you begin: when you mix oil or acrylic paste on the palette, you should not add any diluting substances. With watercolors, however, it is completely the opposite, because without water you would not be able to blend the colors.

First Mixtures for Beginners

Before you begin, place the three primary colors (cyan blue, magenta, and cadmium yellow) on the upper part of the palette or in their respective wells (depending on the type of palette), leaving ample space between them. This is a good way to experiment how secondary colors result from mixing primary colors and how easy it is to create a range of neutral tones through the subsequent combination of these three colors. The complete mixture of two colors produces a third solid color; on the other hand, their partial mixture allows the two original colors to be visible in this mixture.

It is important to press with the brush when mixing colors so the resulting color is smooth.

Do not apply too much pressure with the brush; the dragging action should be gentle.

The best way of mixing colors with the brush is with circular motions.

Little by little begin to mix two colors unevenly to create a greater tonal range.

When to Use the Brush or the Spatula

To mix oil paints on the palette, we use a brush or a spatula. The spatula is more practical because with it you can mix a large amount of paint and prevent the brushes from wearing out. However, to work fast and to mix small amounts of paint, a brush is more practical. Old and worn-out brushes can be useful for this as well; however, never mix paint (except for watercolors) with sable-hair brushes because they wear out quickly. Mix paint with a brush using dragging and rotating movements to minimize excessive wearing of the bristles.

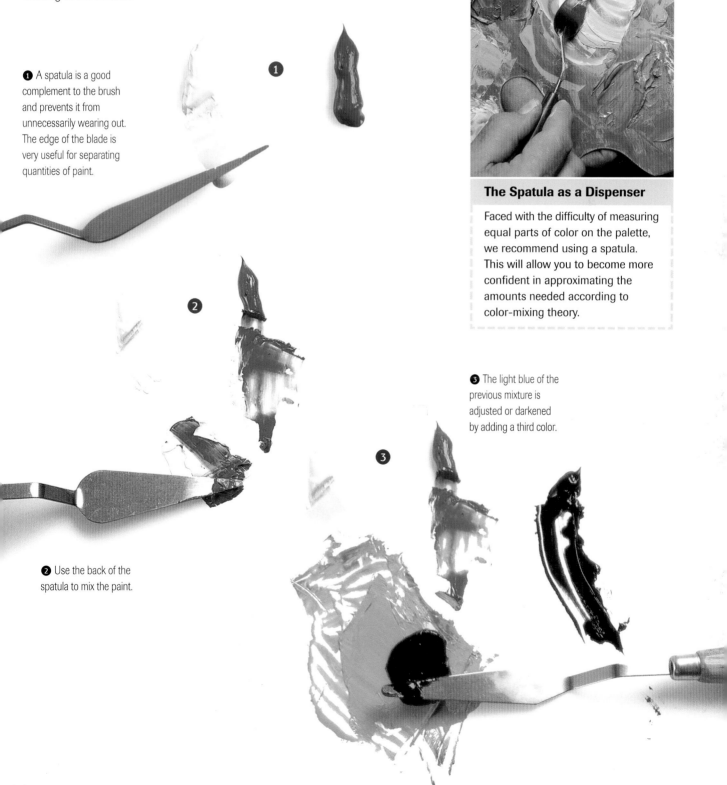

❶ A spatula is a good complement to the brush and prevents it from unnecessarily wearing out. The edge of the blade is very useful for separating quantities of paint.

The Spatula as a Dispenser

Faced with the difficulty of measuring equal parts of color on the palette, we recommend using a spatula. This will allow you to become more confident in approximating the amounts needed according to color-mixing theory.

❸ The light blue of the previous mixture is adjusted or darkened by adding a third color.

❷ Use the back of the spatula to mix the paint.

Mixtures of Two and Three Colors

You can paint using only two contrasting colors or three basic colors: crimson, yellow, and blue. But in these cases, except with watercolors, you have to add a fourth color, white, which is incorporated to the mixture to add nuances and to lighten the colors. Both approaches are very useful for experimenting with mixing colors on the palette. However, with the three-basic-color combination it is obvious that mixing colors this way has certain limitations.

The most common approach is to use the tip of the brush to pick up the colors that are to be combined.

Mix them by dragging each color toward the center of the palette until the desired tone is achieved.

Combining Two Colors

To mix two colors we pick up part of the paint with the tip of the spatula and place it in the middle of the palette, the lightest color first. Then, pick up a small amount of the second color. Combine both colors by pressing the second one over the first. If you want to combine two colors in a way that one overwhelmingly dominates the other, first spread the least predominant color on the palette, and then add the dominant one gradually until you achieve the desired tone. This allows greater control of the mixture, and it helps conserve paint. A two-color combination, whichever the colors may be, always results in the darkening of the lightest color, because it draws light away from it.

Normally, three colors take part in the mixture: two main colors and a third one for lightening, darkening, or for adding nuances to the two previous ones.

■ You can paint
any model with
**three primary colors
and white**.

Combining Three or Four Colors: Defining

This time we are using the brush to mix colors. First, we mix two colors; in this case it will be yellow and vermillion to get orange. Then, we add the third color, white, to define the mixture and to give the color more luminosity. The final touch is applied with a small amount of ochre to adjust the result. It is important not to overdo the mixtures, so avoid combining more than four colors at a time; otherwise the final color can have a muddied look. When you mix three or four colors, the result is a series of neutral or broken colors of medium or dark value.

❶ First, separate the colors that you will be using in the mixture: white, yellow, and vermillion.

❷ Vermillion and yellow are combined to get orange.

❸ Add white to lighten the previous mixture, and define the color with a small amount of ochre.

❹ Finally, check the resulting combination by testing it on the canvas.

Mixtures of Three Colors

To experiment with the paint, always begin by doing very simple exercises, for example, a theme that only uses three colors and white. Always choose the three primary colors because they respond better to the practical application of the theory and because they are the colors that produce the sharpest results. Therefore, the next step is to paint a simple still life with red, yellow, blue, and white acrylic paints.

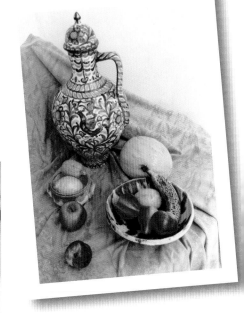

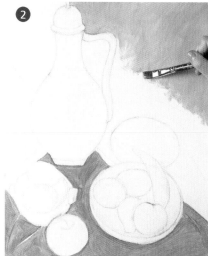

This still life has all the required elements for making a painting with the three basic colors and white.

❶ We begin with a well-defined pencil drawing. All the outlines should be very precisely drawn with a soft and clean line.

❷ With a flat-bristle brush, cover all the background with ultramarine blue diluted with water, not mixed with white.

By mixing the primary colors yellow, crimson, and blue on the palette you can create a wide range of colors.

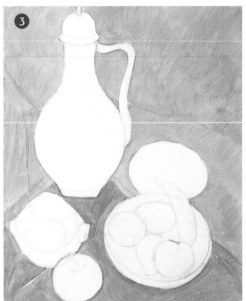

③ The blue of the background makes the objects stand out clearly. Later we will get back to it to paint additional darker tones.

④ We add a very light gradation of blue on the vase. It is very important for the mass of blue that covers the background not to look completely flat. The different blues suggest the folds.

⑤ We left a few areas of the vase unpainted. We outlined the contours and edges of the objects with blue again before we began painting them, using a thinner brush.

Thick and Opaque

Acrylic paint should be applied thick and opaque; if it is diluted, it will look too transparent and the colors will end up overlapping and mixing accidentally.

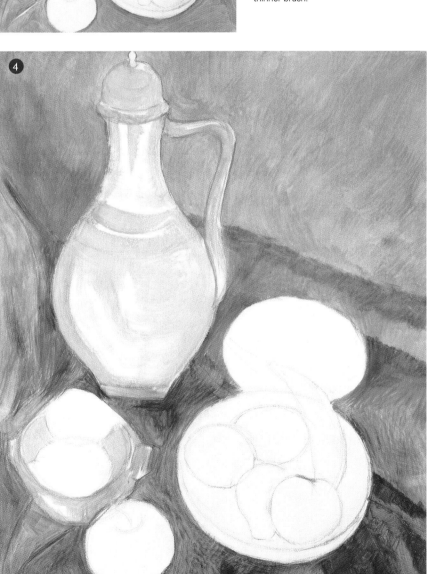

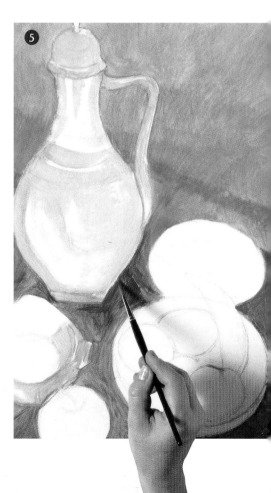

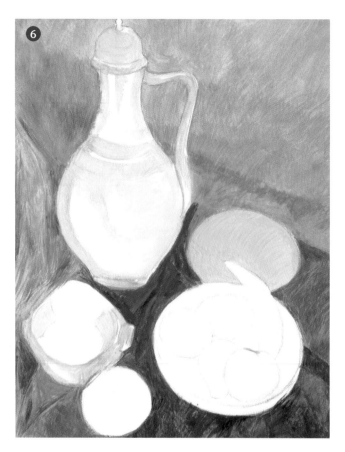

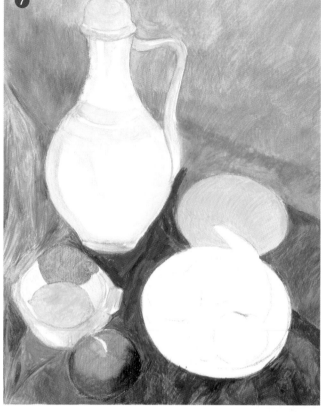

6 We painted the melon with pure yellow. Just next to it we added a few touches of very diluted blue mixed with red to create a violet undertone.

7 The yellow for the lemons was adjusted with a touch of red and a very small amount of blue. With yellow and red combined in different proportions, we mixed the orange for the peach.

8 With red lightened with cadmium yellow, we painted the peaches in the fruit bowl with rounded brushstrokes to represent the shape of the fruit.

9 We painted the fruit bowl with yellow mixed with white, and the lemon with the yellow mixture and a small amount of blue. The plate's decorative motif was painted very carefully, with green resulting from mixing a larger proportion of blue and a small amount of yellow.

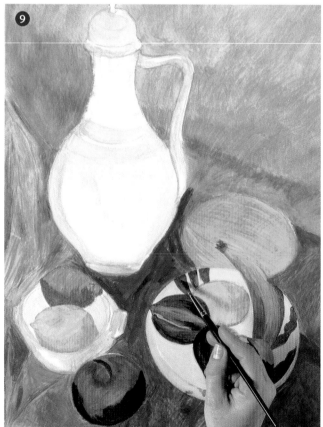

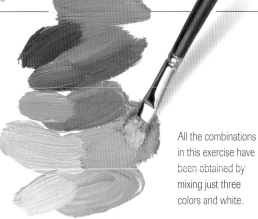

10 Finally, we applied a glaze with blue paint highly diluted with water, over the already dry vase. With this, we conclude this beautiful painting with three basic colors and white.

All the combinations in this exercise have been obtained by mixing just three colors and white.

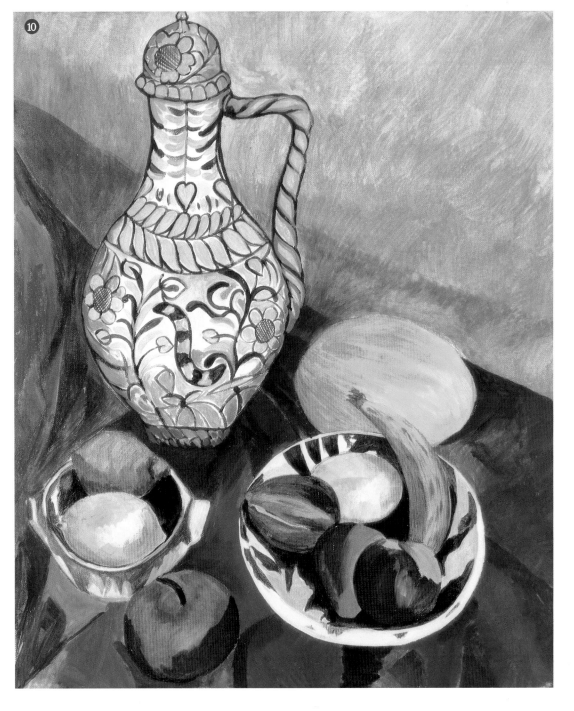

How to Lighten Colors

Beginner painters tend to use white to lighten colors, but it is important to keep in mind that white, in addition to lightening the colors, also makes them more pastel-like and takes away the chromatic vitality of the composition. White tends to make the colors look gray, diminishing their saturation to the point that colors mixed with white look dull. The best approach is to lighten the colors by using similar tones from the same range, that are lighter than the color you want to lighten. Only this way can you maintain both their luminosity and their saturation.

Lightening with Related Colors

It is better to use lighter related colors from the same range to maintain the brightness and luminosity of the color. Every color has several related colors that go from lightest to darkest. Use only the lightest ones. For example, if you wish to lighten alizarin crimson, you can resort to vermillion, to light cadmium red, and even to other lighter tones, because yellow and orange also lighten crimson and dark red.

Using white in excess to lighten colors tends to reduce saturation and to minimize the intensity of the colors. Notice here how the reds of the jar, with the white, appear pinker and look grayish.

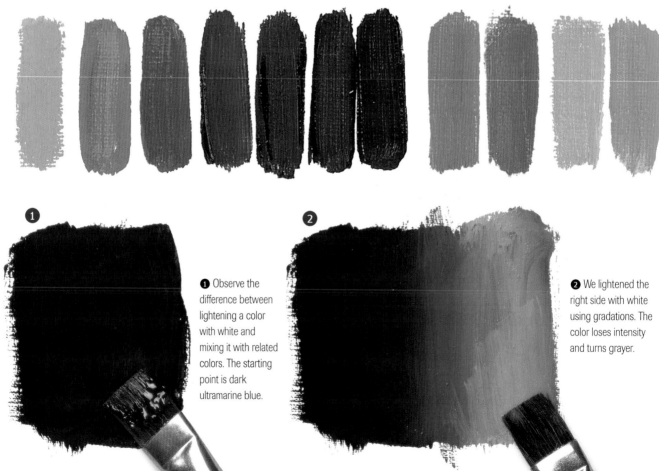

❶ Observe the difference between lightening a color with white and mixing it with related colors. The starting point is dark ultramarine blue.

❷ We lightened the right side with white using gradations. The color loses intensity and turns grayer.

Adding white is only justified when you need to lighten a color that is naturally light, for example, yellow. In this case, we have used green to darken it.

Justified Use of White

To lighten a color you should mix it with other colors that make it more luminous. Does that mean that you should never use white? Absolutely not; white can be used especially to lighten the lightest colors from each range. It can be added after the color has been lightened with like colors to improve the tone, even in very small quantities. However, if you are using paint that is soluble in water, like watercolors, they can be lightened by adding water. There are other soluble mediums as well that can be used instead of water. Since they are thicker, they add consistency to the paint and lighten it at the same time without minimizing the intensity and vitality of the color.

A tomato painted with oil paints using alizarin crimson lightened with light cadmium red. White is only used for the reflections.

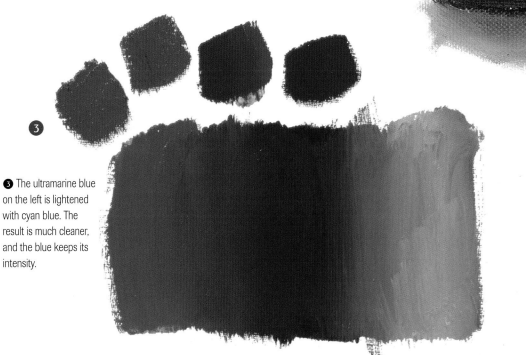

❸ The ultramarine blue on the left is lightened with cyan blue. The result is much cleaner, and the blue keeps its intensity.

How to Darken Colors

The cleanest way to darken colors is to use the darkest shade of the same group or to use earth tones. With some color ranges you can even use blue for this purpose, because to darken colors you should use tones that cool them gradually. For areas that are in the shadow, blue should always be present in the mixture because it is the coolest of the three basic colors.

The Dangers of Black

Within a color group, you can use any darker shade to darken lighter colors. Once you have exhausted the possibilities of a group, you should use colors (even if they belong to other ranges) that continue with the darkening effect. You should avoid black, however, since it changes the vitality and the character of certain colors. You can resort to it when its use is well justified, such as in the case of a night scene.

This is a representation of the same jar we used previously, with cadmium red darkened with like colors: crimson and cobalt violet.

Black is the most commonly used color for the darkening of almost any color.

Compare the two extremes of this orange color. On the right, the color has been darkened with black, the result is very muddied. On the left, we have used burnt sienna, which can be considered a related color.

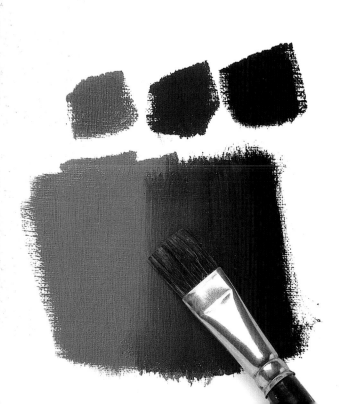

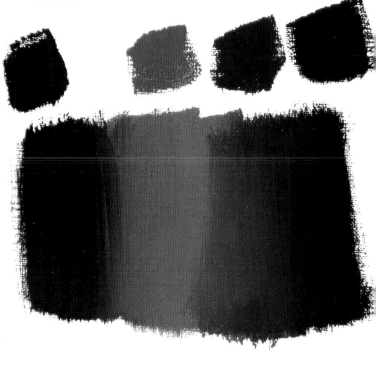

Darkening with Brown and Gray

To darken a mixture you should use the colors that are present in the model itself, but a darker shade. This is achieved by adding brown or dark gray to almost any color. Brown is the result of mixing green and red, or violet and yellow, in equal proportions, which tells us that you can produce brown by combining two complementary colors. Gray, on the other hand, is a little more complex because you need to mix that brown color with dark blue. The resulting mixture is very dark, but when you add a small amount of white the gray is more clearly seen.

An apple painted with oils. The shaded areas were darkened by adding a small amount of ochre and burnt sienna to the original yellow.

The different amounts of light in a color are applied with gradations. In both cases here, orange and red are lightened and darkened with related colors. Black and white are used as a last resort.

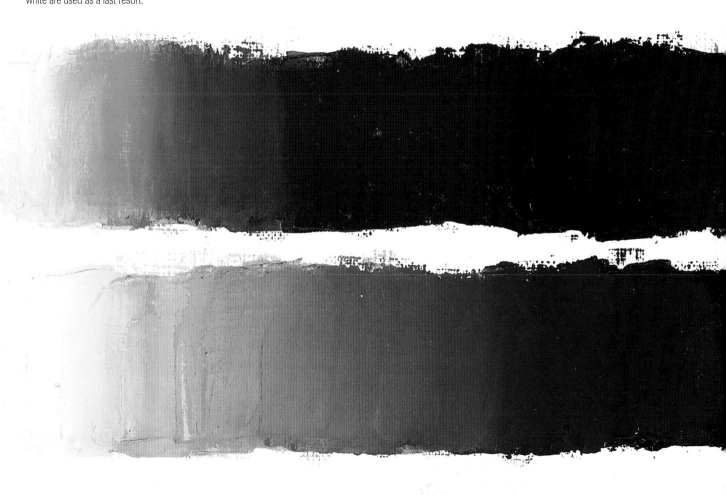

High-Key and Low-Key Colors

The terms high key and low key refer to the glossiness and saturation of colors. In low-key paintings, the vitality of the contrasts is its main characteristic. The painting is full of expressive colors that have not been overly mixed, which provides an excellent opportunity for working with values that are much more saturated. In high-key paintings, the intensity of the colors and the contrasts become lighter with the addition of white, resulting in a very harmonious composition.

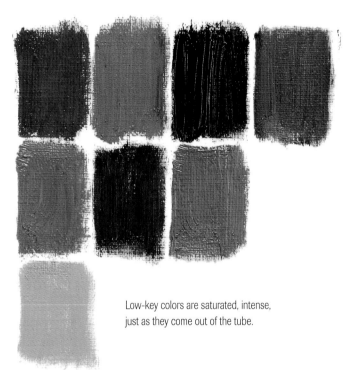

Low-key colors are saturated, intense, just as they come out of the tube.

Color at Its Best

In low-key ranges, the colors involved are usually pure and luminous. To saturate means to use pure colors, to capture the attention of the viewer through the glossiness and the exaggeration of color contrasts. It responds to an exalted color representation that creates a colorist euphoria. The color combinations are reminiscent of the works by the great Fauvist artists, full of contrasts that activate the perception of the colors. In this chromatic category there are no light tones, or if any, they are not very prevalent. The light and shadow contrasts are achieved by making light and dark colors stand out against each other.

■ A **high key** is used
for delicate and charming
representations, completely the
opposite of **low key**, which produces
paintings of great impact,
with a certain aggressive tone.

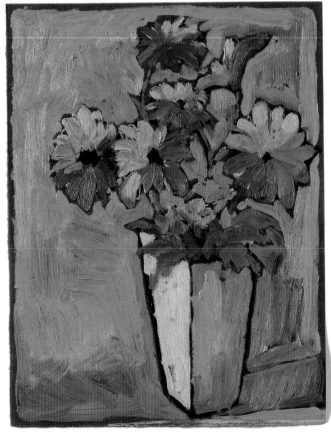

A work painted with low-key colors is full of strong contrasts and very bright colors.

Making a Color Less Saturated

In a high-key painting, the values of the colors used contain large amounts of white. For example, for a landscape with snow or immersed in heavy fog, the artist is forced to use a range of high-key colors, which means that every mixture will be combined with white. The neutrality that white confers to colors makes them harmonious and gives them extraordinary power. High-key paintings appear more subdued, but they can also be delicate and subtle.

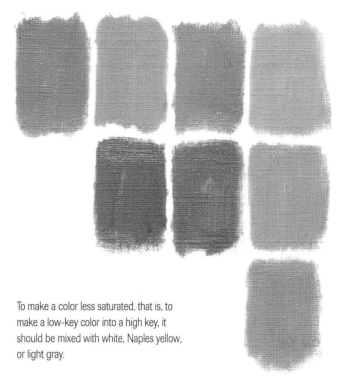

To make a color less saturated, that is, to make a low-key color into a high key, it should be mixed with white, Naples yellow, or light gray.

In high-key paintings, white and gray are added to the colors to mitigate their contrast and saturation. The result is very harmonious.

A bright color like blue will become less saturated when white is gradually added to it, which will make it very light blue, a high-key color.

Vase of Flowers with High-Key Colors

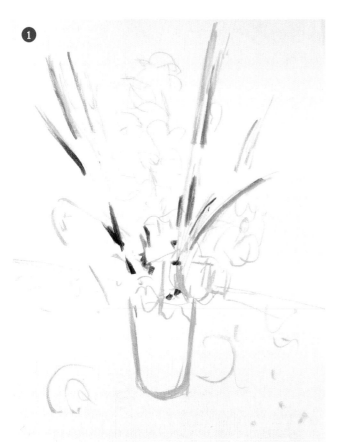

In high-key paintings there is no black, instead there are soft grays and whites, while the rest of the colors are usually lightened or softened with white. Light colors are the dominant range, and there are only soft grays, no pure black. In the language of photography, it would be said that these paintings have a lot of light with white as the predominant color, paintings that appear overexposed but whose final result is very interesting. This treatment is common in models where the artist wants to create an unusual, soft, and harmonious effect. To better understand this, we are going to demonstrate it below by painting a simple vase with flowers and oil paints.

❶ The drawing is laid out with very soft lines of diluted brown. With only a few strokes, the model is recognizable already.

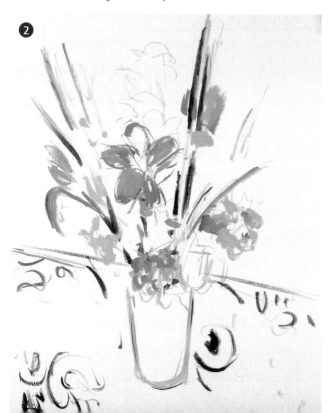

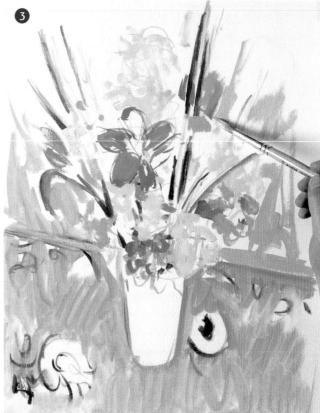

❸ We applied the colors of the flowers. Crimson and violet are painted in combination with a generous amount of white. A proper high-key image has texture and includes a wide variety of tones.

❷ The paint should have the right consistency for the colors to be opaque and covering but without making them too pasty.

■ If you are going to paint a high-key
model **with natural light**,
it is important to make it
soft and subdued.

Almost all the combinations should include gray or white to soften the colors.

❹ The final result has white or grayish colors that are not too bright but that are well integrated and relate to each other very well. It is important to include a few darker colors to achieve the desired contrast.

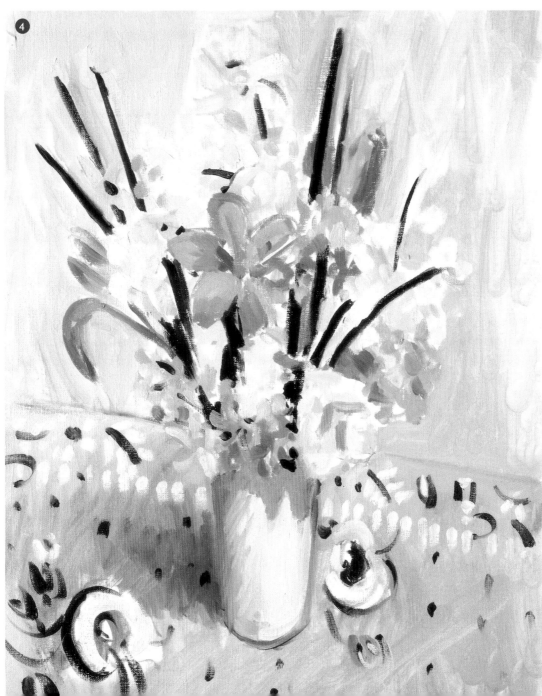

MIXING COLORS ON THE PAINTING

U p to now we have seen how colors can be mixed on the palette to produce uniform tones. On the following pages, we are going to explore how certain nuances, combinations, and gradations can be created directly on the surface of the painting, mixing fresh colors with the brush or by spreading them with the spatula. Applying the combined colors directly on the painting, even in pure form, is a very common approach when working with oils or acrylics and absolutely necessary with watercolors; however, there are other methods. We are referring to optical mixtures. In this case, color is not blended on the painting but in the eye of the viewer or through glazes, thin layers of translucent paint that let light come through.

White Frost. Camille Pissarro (1830–1903). Impressionist artists mixed paint directly on the canvas by dragging part of the paint that was underneath.

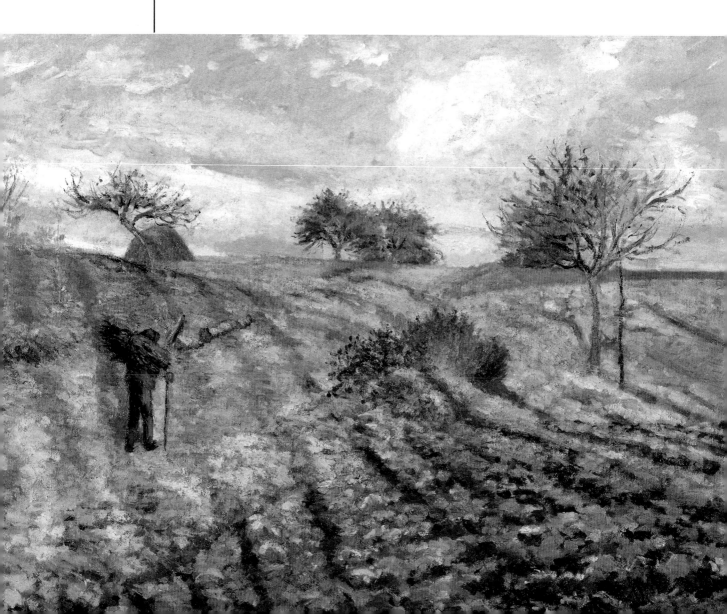

Knowing the Colors

It is important for any artist to know the properties of all the colors and how they can be used to one's advantage; for example, cadmium and titanium colors are suitable for opaque paintings, and lacquers for working with glazes. It is not a matter of analyzing the characteristics of the colors but of observing how they react in practice: their ability to affect other colors when mixed directly on the surface of the painting, their possible change of structure when combined with other colors, which colors go well together, their drying time, their potential for fading after drying—anything that has to be kept in mind for greater control of the result of any mixture.

Painting Over Wet Color

When mixing colors directly on the support over fresh paint, it is important to have an idea of the color that will result from the combination. If you use Prussian blue, it turns green when combined with yellow. The same is true for crimson, which provides an orange undertone. The more you brush a color, the more homogeneous it will become.

With watercolors, the paint has to be mixed on the support. You will achieve very characteristic results by doing so.

■ "It is better **to work with small brushstrokes** and to try to represent your own perceptions immediately. Not to act according to rules and principles, but to paint what one sees and feels."

Luis Le Bail,
disciple of Camille Pissarro

A professional artist usually prepares the mixtures on the palette, although the final touches, blending, and gradations are normally done on the canvas.

The First Brushstrokes

Applying large areas of color makes the subsequent work much easier for the painter. This is done to provide a base color, to define the theme, and at the same time to use it as a sketch or a first color and tonal impression for the composition. Cover the entire surface of the painting, laying out the areas of color as if they were the pieces of a puzzle. These areas of color, placed in their context, will help you visualize how the work will look in the end.

In watercolors, the first color applications are much more subtle and tend to appear more monochromatic and gray than with other techniques.

Distribution of the Main Areas of Color

During the painting process it is important to define the distribution of the specific large areas of color. The idea is to simplify and decide the general areas of color, the most important ones. In other words, a color or color mixture is assigned to each one of these areas that corresponds to the chromatic undertone of the real model.

Sudden color changes and contrasts should respond to compositional demands, to light and color, for example, because they represent a transition from an area of light to shadow, or to differentiate two areas that are located far from each other.

Example of the first strokes of color with acrylic paint. It is a simplified approach, without the details of the colors of the real model.

Adjusting the Colors

The first colors will be used to lay out the model with wide brushstrokes that will make it look more like an abstract painting than the real theme. These areas of color are the foundation, the base that provides the dominant tone of all the mixtures and additions that will be applied over it. Although the preparation of the definite colors is done on the palette, it is on the canvas that they are blended together with the first layer of paint until it reaches its final appearance.

❶ When you work with oil or acrylic paint, it is best to apply the first colors over a base of diluted color.

During the initial approach, the paint should be somewhat diluted so it can be extended easily and the brush will slide easily on the surface.

❷ The first colors will define the main chromatic areas that the artist has in mind.

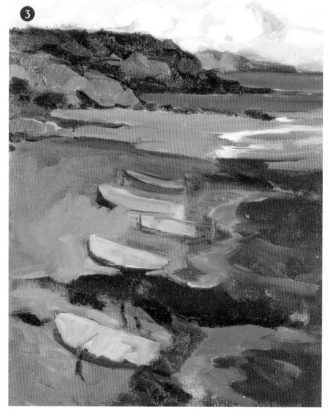

❸ New colors are blended with the previous ones until the desired effect for each area is achieved, thus giving you a glimpse into its final appearance.

Painting with Short Brushstrokes

With a group of small brushstrokes or lines, you can achieve, even on small surfaces, a great variety of colors and tones that give a painting a vibrant appearance. To take the most advantage of the colors it is important to use only light and saturated colors, primary and secondary in their original state or mixed with white. Avoid black and the tones that are too dark. Painting with small brushstrokes is especially important for themes with rich and contrasting colors.

Impressionist Technique

Impressionist painters are known for their fast technique: small brushstrokes charged with paint. They use juxtaposition, very bright colored lines or brushstrokes, to their limit to create a vibrant base and to make visual impressions of light and color. The difference between these optical mixtures and those that are done on the palette is that with the broken color approach you can achieve an intense feeling that cannot be re-created by applying color evenly, so the paintings done with this technique are bright, full of energy, luminous, and fresh.

To achieve the desired effect with impacts of color it is fundamental to master the technique and to control the direction as well as the superimposition of the lines.

■ Impressionist painters dispense the paint on the canvas directly from the tube to **create voluminous impacts** of saturated color.

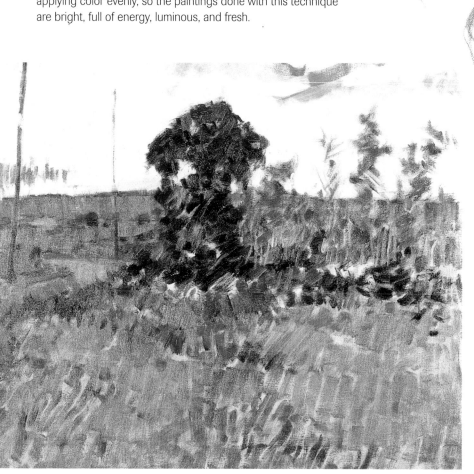

The short brushstrokes or color splashes often add to the texture of the vegetation in outdoor scenes.

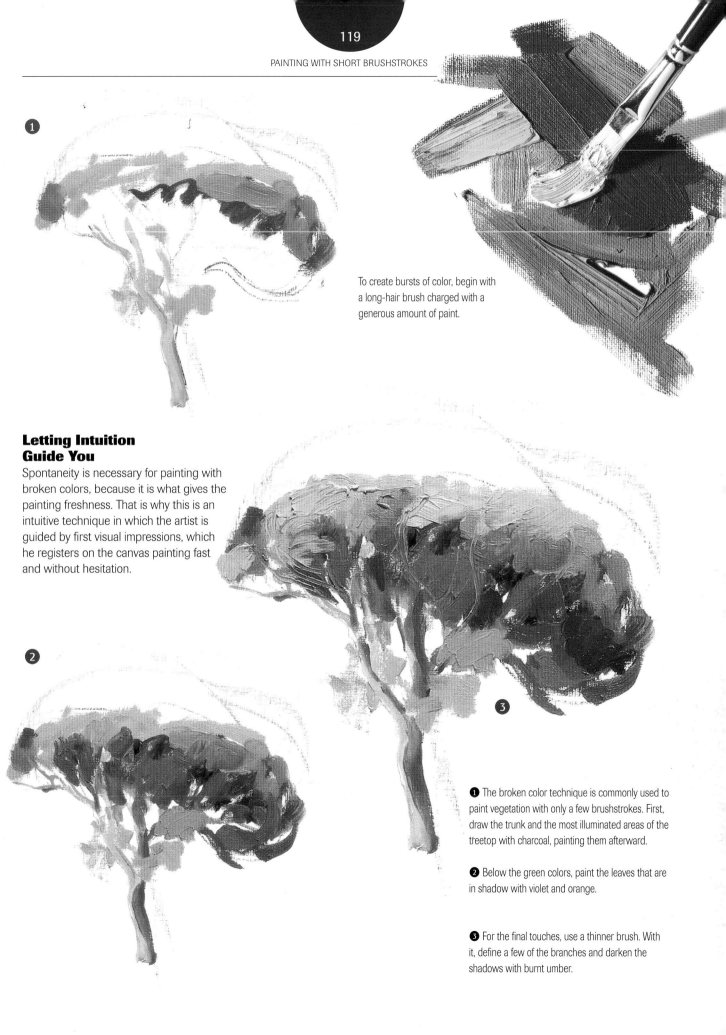

①

To create bursts of color, begin with a long-hair brush charged with a generous amount of paint.

Letting Intuition Guide You

Spontaneity is necessary for painting with broken colors, because it is what gives the painting freshness. That is why this is an intuitive technique in which the artist is guided by first visual impressions, which he registers on the canvas painting fast and without hesitation.

②

③

❶ The broken color technique is commonly used to paint vegetation with only a few brushstrokes. First, draw the trunk and the most illuminated areas of the treetop with charcoal, painting them afterward.

❷ Below the green colors, paint the leaves that are in shadow with violet and orange.

❸ For the final touches, use a thinner brush. With it, define a few of the branches and darken the shadows with burnt umber.

Rural Scene with Superimposed Brushstrokes

The broken color technique is also very effective when done with pastels or color pencils. It calls for the juxtaposition of superimposed lines of color that are very saturated and distant on the color wheel, even many complementary colors together. The goal is to let the eye of the viewer blend them together, forming new colors that play and interact with the base color. The theme of the following exercise is an interesting rural scene. The drawing is developed with a daring range of colors that plays with contrasts of warm tones on the roof and cooler tones on the shaded façades.

❶ On yellow paper we block in the theme using a violet color pencil because it is the complementary of the yellow background.

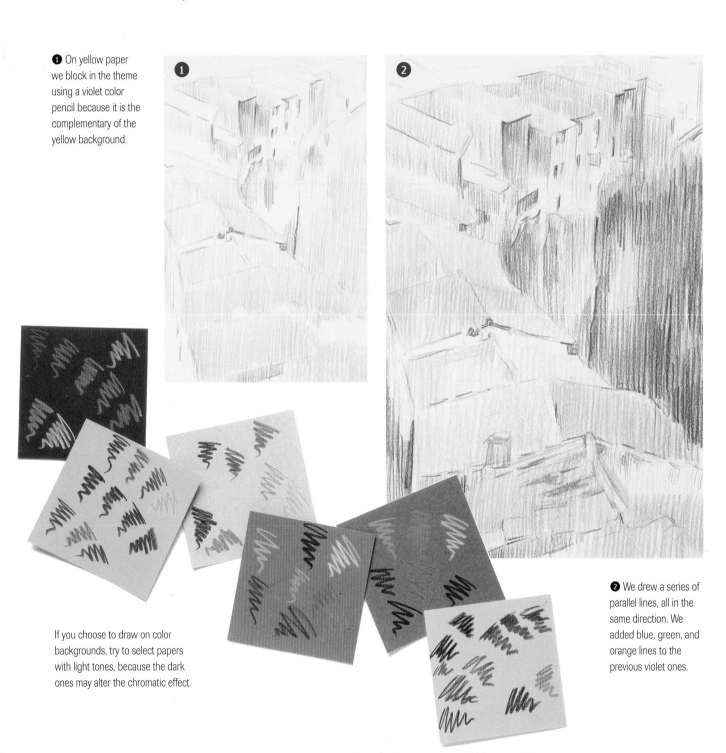

If you choose to draw on color backgrounds, try to select papers with light tones, because the dark ones may alter the chromatic effect.

❷ We drew a series of parallel lines, all in the same direction. We added blue, green, and orange lines to the previous violet ones.

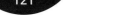

❸ We worked the roofs with saturated colors, pressing hard with the tip of the brush. Keep in mind the contrast between complementary colors like orange and blue or violet.

❹ To create the effect of depth, we worked with intense colors on the foreground and soft lines on the façades in the background.

With an assortment of only 12 color pencils it is possible to create interesting color studies. It is preferable to use watercolor pencils, that way you have the option of turning them into washes.

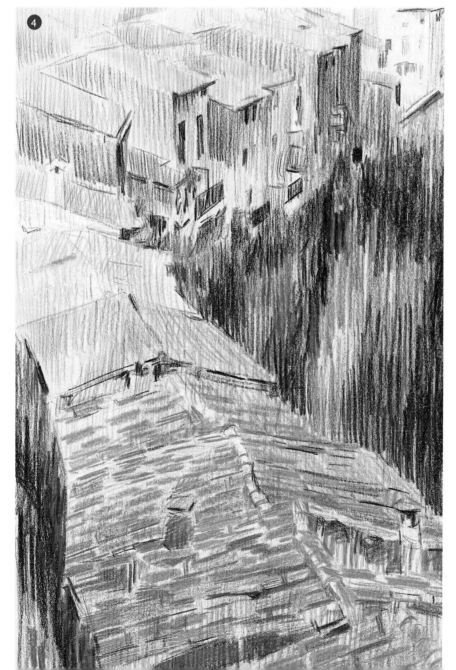

Painting *Alla Prima*

With traditional techniques, the colors, almost all of them, can be prepared on the palette, but with *alla prima* (at the first) most of the mixtures are done directly on the canvas. This is achieved by modeling and blending colors together while they are being applied with the brush, dragging and mixing them while they are still fresh. Following this procedure, the mark of the brushstrokes is more visible, and the colors blend together spontaneously.

❶ When you paint *alla prima* with acrylics you do not have to tackle all the areas of the painting at the same time. The quick drying time of the paint forces you to work by area. You can begin with the sky, for example, combining white, yellow, and blue.

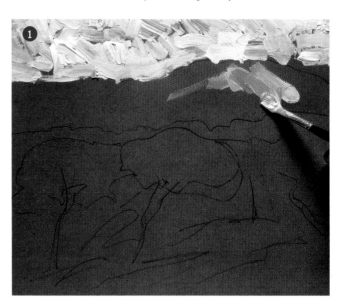

Alla Prima for Oils

This technique makes use of the natural consistency of oil paint, its thickness and creaminess, to build up a large amount of paint on the surface of the support. The paint should not be very diluted so that the brush marks will be clearly visible. The brush should always be full of paint. The paint should be concentrated in the tip of the brush and the strokes applied surely and firmly to avoid muddying the colors. Brushes with round tips are best for use with this technique.

■ Quick painting
is a very appropriate approach when painting **outdoors**.

Alla Prima for Acrylics

The main challenge for painting *alla prima* with acrylics is their quick drying time; the thicker the layer of paint, the longer it will stay fresh, and the easier it will be to blend colors. To lengthen the drying time you can add a small amount of drying retardant to each mixture. This will give you additional time to handle the paint and to blend and combine the colors on the canvas.

❷ If you apply new colors over the areas of the landscape that are still wet, drag part of the color underneath, in such a way that any new color addition will become integrated with the previous ones.

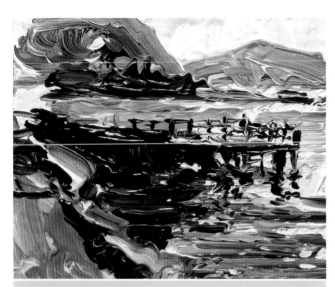

Greater Expressivity

Many artists take advantage of the fact that colors can be mixed directly on the support to achieve a more expressive finish.

Retardant gels are transparent and can be purchased in tubes or jars. Added to the paint, they will lengthen the drying time.

3 The finished painting has an expressive appearance of great vitality. It has been worked following two procedures: using the palette for mixing colors to a minimum, and mixing and blending at the end directly on the canvas. We added retardant gel to work at a more comfortable pace.

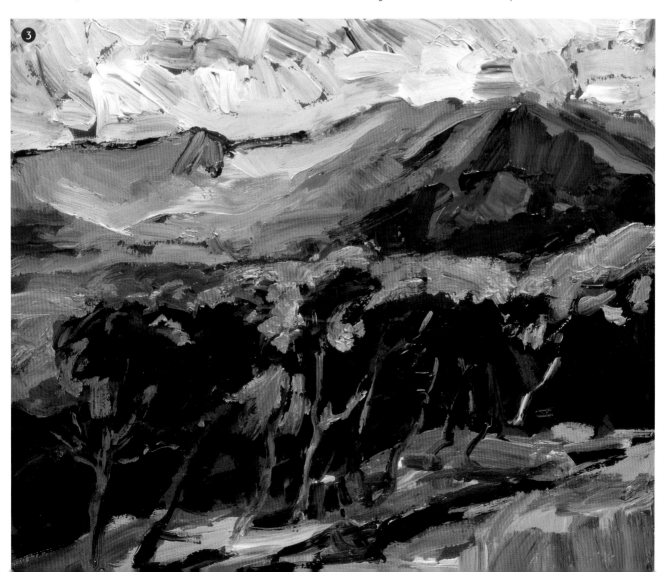

Mixing Watercolors on Wet Paper

The *alla prima* technique with watercolors is called "painting on wet." When the colors are applied over wet paper or over an area of wet paint, they blend together on the support, forming soft contours and gradations. The exercise shown below was painted with three primary colors only: cerulean blue, crimson, and yellow.

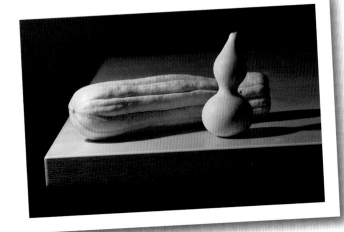

A very simple still life with a light source that creates a strong chiaroscuro.

1

❶ We did a line drawing in pencil of the model without paying too much attention to details. We began painting the squash that is resting on its side with yellow. The shadows were painted on wet with a mixture of crimson and blue.

❷ We painted the base for the squash that is standing up with yellow. Next, with violet we applied soft tonal transitions to make it look round.

2

❶ Apply the base yellow.
❷ Add a brushstroke of blue with a small touch of crimson over wet.
❸ Immediately after, apply the third brushstroke with crimson. Notice how all the colors blend together.

❹ With the brush charged with water, blend the crimson, which turns brown.
❺ Do the same over the other end, again with crimson and blue.
❻ We recommend experimenting with several tests like these to observe how the colors react with this technique.

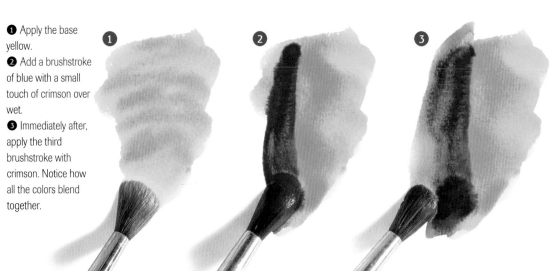

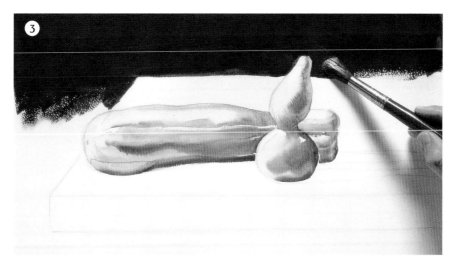

❸ At this point we tackle the background with a more intense and covering color. This dark color is the result of combining the three primary colors in equal parts.

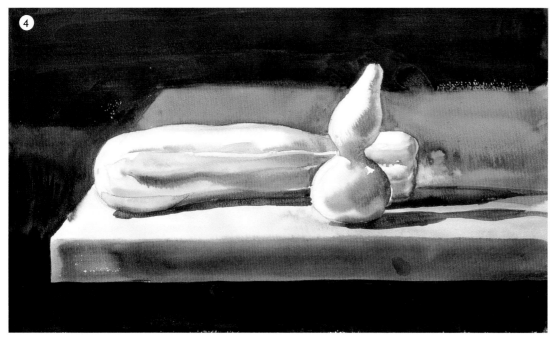

❹ Now, to finish the exercise, we only need to paint the dark background of the table and the shadows projected by the vegetables using the same color.

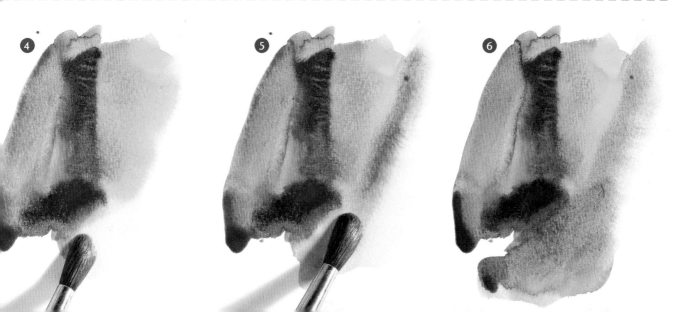

Mixing with Dots

The surface of the painting can be covered with many different colored dots that are perceived by the eye simultaneously. This simultaneity makes the small colored dots, first, disappear and then be replaced by a perception resulting from optical mixing. This means that instead of using orange paint, which results from combining yellow and red by hand, you can apply those same colors with small dots side by side, in such a way that the human eye will blend them together, like an impression. This discovery led in the last century not only to a new pictorial technique but also to the invention of new photomechanical techniques.

We have chosen a landscape with a few trees on the foreground. The proposed view is reminiscent of Japanese scenes.

With pointillism the mixtures are done directly on the canvas with minute color dots. Their intensity depends on the color combinations and the consistency of the dots.

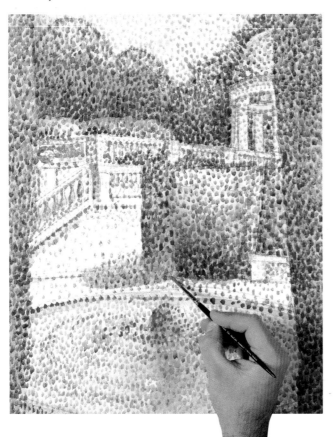

Pointillist Paintings

With the pointillism technique the brushstroke marks left by the brushes are almost nonexistent. The subject is represented with light vibrations by accumulating small photons of shiny and clear colors. This way, colors create an optical mixture instead of the traditional chemical one, and the eye of the spectator does not perceive the colors individually but the sum of all of them. The colors blend together as wide gradations or unified areas when they are viewed from a particular distance.

❶ With blue and brown washes we break up the white surface of the paper.

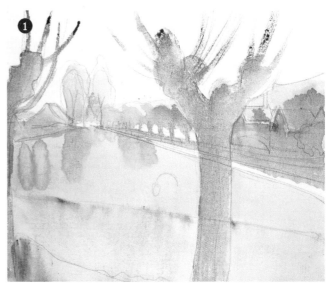

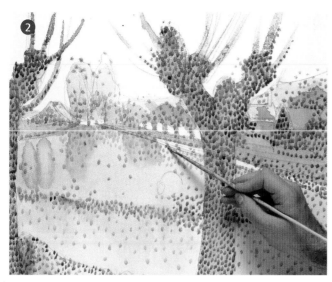

2 When the washes are dry we apply the first color brushstrokes over them with a thin brush. First, we cover the more shaded areas with blue.

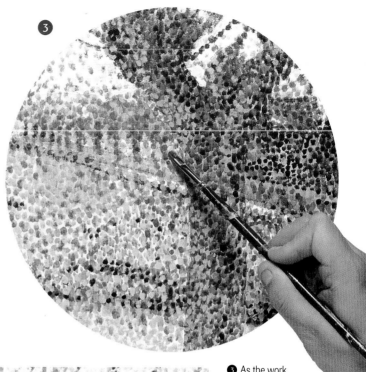

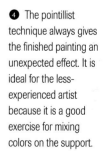

3 As the work progresses, we combine the color dots more daringly by adding touches of red and yellow in the areas where such colors do not really exist normally to make the overall composition more vibrant in the end.

4 The pointillist technique always gives the finished painting an unexpected effect. It is ideal for the less-experienced artist because it is a good exercise for mixing colors on the support.

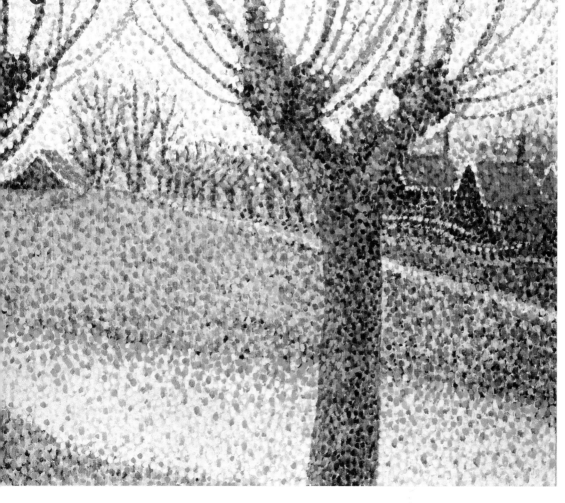

Overlaying Glazes

Working with glazes basically consists of superimposing layers of semitransparent colors through which the color below can be seen. When you add a translucent layer of paint over another, the color that you see is the result of the mixture of the two, the glaze and the color underneath. The resulting optical mixing produced by this technique creates deep and well-balanced colors. Traditionally, glazes are done with watercolors; however, here we are going to add gum arabic to produce more vibrant and intense colors.

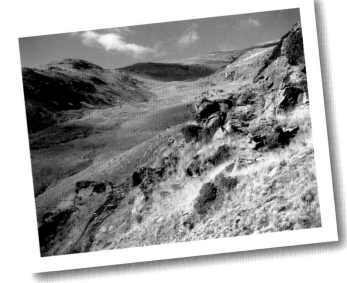

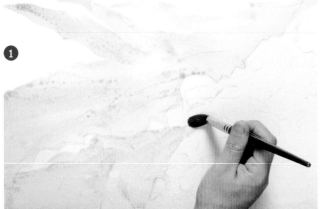

The model is very simple and bright and presents many color nuances. There are hardly any features on the foreground.

❶ We begin with a pencil drawing. A wash of ochre is prepared and thickened by adding a brushstroke of gum arabic. Then we apply it very widely.

❷ With green and a very transparent blue gray, we finish painting the closest areas. The first layers are very transparent.

To obtain a deeper blue, superimpose a glaze of a color that belongs to the same range or one that is very close to it.

3

Before a new glaze is applied, it is important for the previous ones to be completely dry.

❸ After letting the previous layers dry, we apply a new transparent glaze of medium gray to emphasize the shadows. The puddles that are visible are characteristic of gum arabic.

❹ While the rest of the paper dries, we paint the sky with cyan blue diluted with gum arabic, trying to keep the area for the clouds free of paint.

4

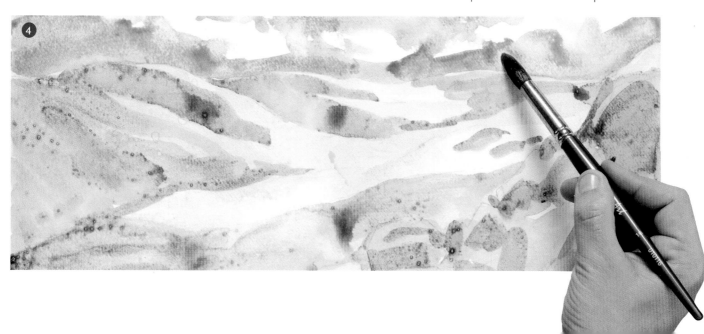

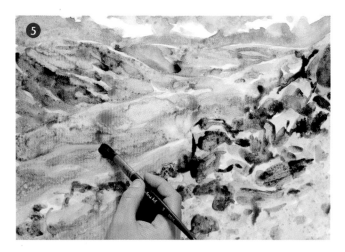

5 We are going to darken the colors gradually with new translucent layers. The lightest areas should have fewer layers.

6 When the paint is dry we outline the profiles of the rocks with black chalk. The line should be very thin and fine.

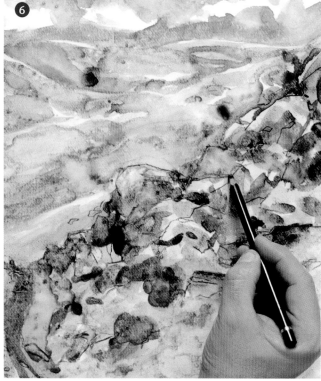

7 We darken the mountains with new gray, ochre, and sienna glazes, and we paint the darkest shadows on the foreground with Payne's gray.

In glazing, colors are mixed by overlaying color filters. Therefore, yellow over a blue base produces green.

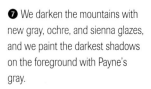

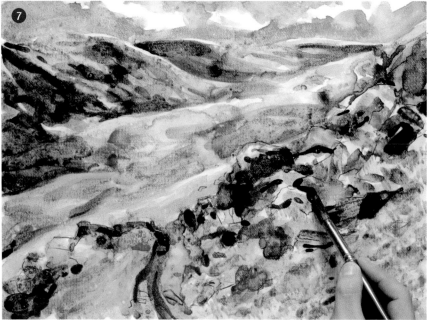

Three at Most

It is not a good idea to superimpose too many colors. Three glazes are the maximum recommended; if you apply more, the last layer will make the color more subdued and muddy it.

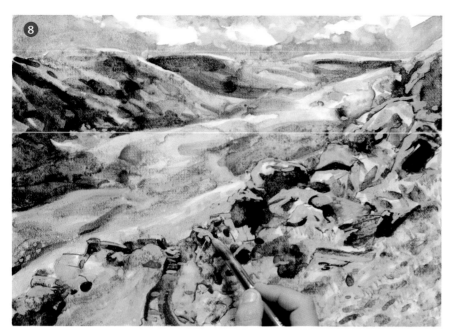

8 We mix Payne's gray with a small amount of white gouache on the palette, and with the resulting color we paint the most illuminated areas of the rocks. Of all the colors applied, this will be the only opaque one.

9 When we add gum arabic to the watercolors, the glazes at the end are not too dim. Despite the subdued nature of the color, the final painting is rich in nuances.

Blending with Pastels

Diffused lines and blended colors are very common resources with the pastel technique. Unlike other pictorial mediums, pastels are not mixed on a palette but applied directly on the support where the needed blending is done, whether by superimposing shadows or by combining several colors and rubbing with the hand or with a blending stick. This way, you can achieve gradation effects and very attractive subtle colors. This exercise is a good opportunity to learn how pastel colors are mixed and adjusted by rubbing with your fingertips.

This vast meadow with an alpine background is a motif full of technical inspirations for pastel artists.

❶ The initial drawing is done with an ochre pastel pencil. The thin line of the pencil makes it easier to draw in more detail than when we use white pastel sticks.

❷ The first areas of color establish the sky and the mountains. After painting a few areas with blue and gray, we blend and diffuse the colors by simply rubbing the hand over them.

When we blend the areas of color with the fingers, the pigment spreads over the chosen area.

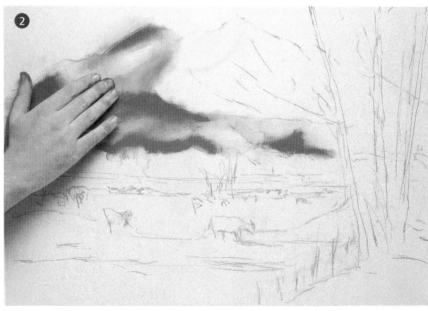

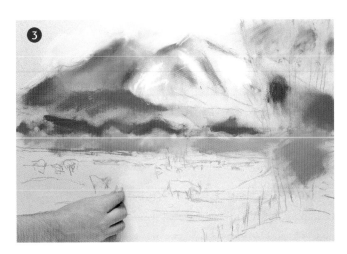

The pressure applied with the pastel stick, whether the tip or the side, determines the amount of color transferred.

③ The gray colors of the background have been blended with greens and pinks. With the side of the stick we apply the color of the flat areas, where ochre and yellow tones are dominant.

④ We go over the warm colors of the foreground with orange, yellow green, and reddish brown to create a darker contrast against the cold colors of the background. We blended everything with the hand to finish the foreground.

⑤ Blending with your hand helps highlight the nuances of the larger areas, partially erasing the borders between them. We finished by drawing the trees on the foreground with pastel pencils.

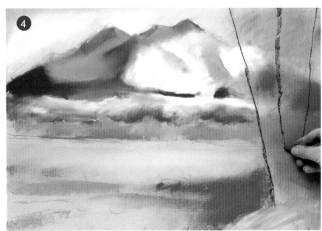

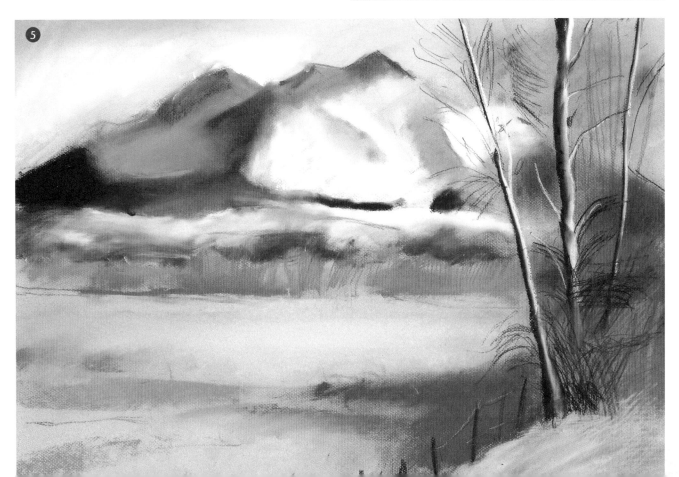

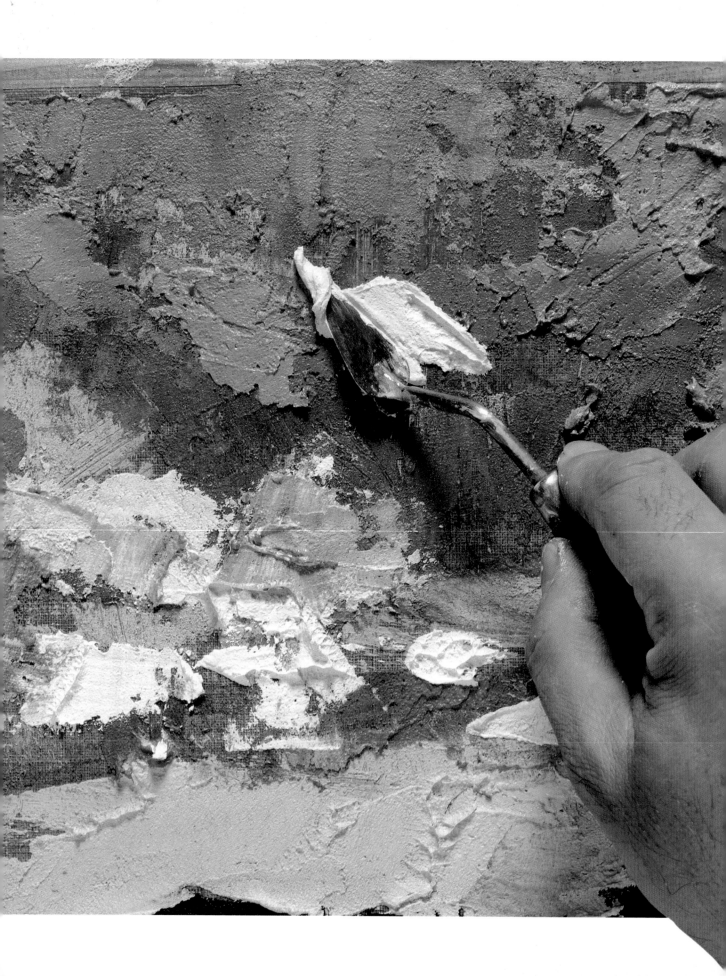

CONSTRUCTING AN IMAGE WITH COLORS

Color and form are the two main elements of visual perception: they provide information to make the objects recognizable, and they convey expression. The use of colors, the different levels of saturation, and the contrasts they provide are valuable resources that help identify and place the elements on a composition. They give more or less relevance to each component. The limits determined by forms are based on the capacity of the eye to distinguish between areas of different clarities and colors.

In this section, we are going to show how the placement of colors on the painting can be diverse and different. Each one offers a different character to the model, changing the relationship that exists between the objects, even their spatial configuration.

COLORS IN THE COMPOSITION

Color, strictly speaking, is not used only to paint objects but also to make them stand out, to identify them, and to indicate to the spectator the proper order in which to view them. The formal order conveyed by colors is called chromatic composition. The composition is the balanced and orderly placement of the elements that make up the image to facilitate their reading or to convey specific feelings to the viewer. In this process, colors are a powerful compositional tool, and their distribution must be approached in a way that offers a clear meaning and an intention that corresponds to the message that the artist wishes to convey.

The Red Room. Felix Vallotton (1865–1925). In this painting, the range of reds plays a fundamental role in the composition and helps distinguish between the elements that form part of it, while re-creating the space.

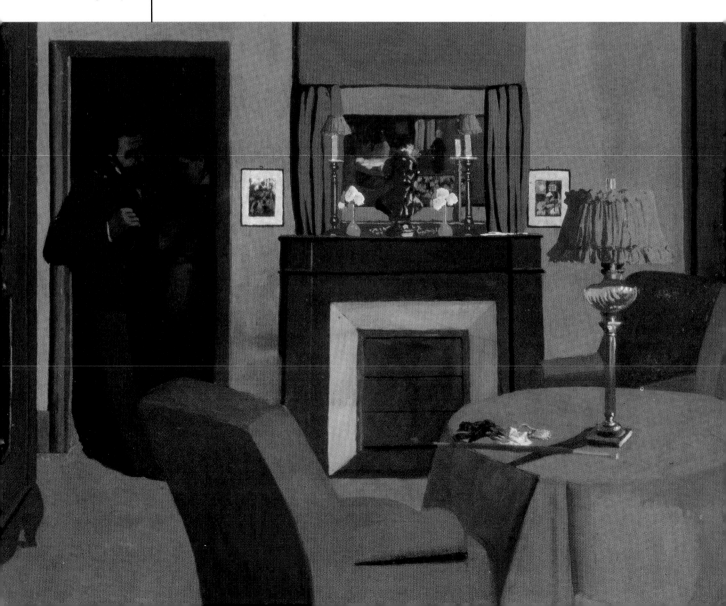

Compositional Schemes

A very effective way to compose with colors is by using compositional schemes, which are a series of imaginary lines with which you can construct the chosen theme. These imaginary lines are references used to distribute the elements of the painting and are the ones that indicate the trajectory of the viewer's eye. In a way, they underline the points where the focus should be placed. Compositional schemes usually consist of geometric shapes or simple organic forms.

■ **"Every movement of human life is affected by form and color.** When the artist uses these elements freely and creatively, they can become an enormously powerful influence in our lives."

Ben Nicholson

Composing with colors requires planning and unifying the areas of color to check their tendency in the representation of the model.

Composing Means Choosing

Before applying color it is important to think about the reasons for emphasizing an object, to focus on the most striking colors in a single area, displacing some of the other elements… Then, it is important to distribute the colors to support the goal. When you plan a composition it is important to keep in mind the following concepts: the view, the format, the focal points, the angles, the contrast between colors, the light, the context, and the structure itself, which is derived from the combination of the previous elements.

The geometric scheme is an imaginary line that distributes the elements and the colors in a scene.

People prefer compositions based on geometric schemes. All the elements of the painting usually respond to it.

Creative Composition with Colors

The treatment of colors is one of the most important matters that an artist must resolve. In this exercise, we propose an interesting color experiment together with a particular understanding of the forms in search of an original and daring composition. The objects are composed with primary colors, saturated and minimally blended. The objects with warm colors are placed over a blue and greenish background; on the other hand, the green and blue objects have yellow contours. We used oils in this case.

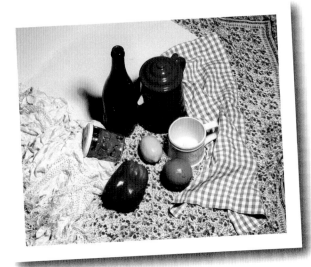

The model presents a whimsical composition: the objects are arranged like the color wheel.

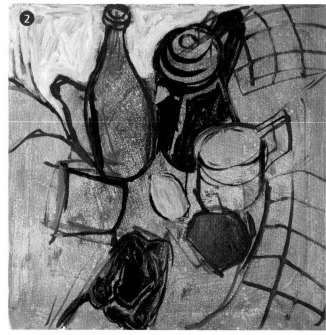

With a flat brush charged with oil paint, we apply short brushstrokes in the center of the painting.

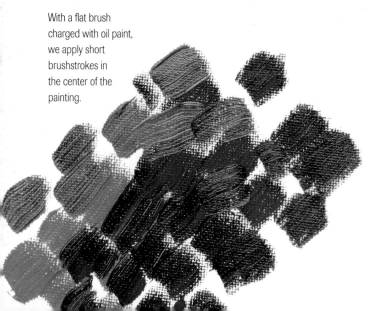

❶ The background has been painted with a mixture of brown, green, and ochre. When it is completely dry, we lay out the overall form of the composition by painting quick lines with blue and black paint mixed with solvent.

❷ We paint the background with yellow, and the red tones of the model with a small amount of English red; the orange is painted with a flat and even layer.

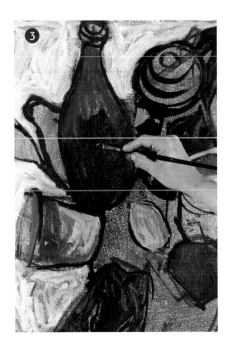

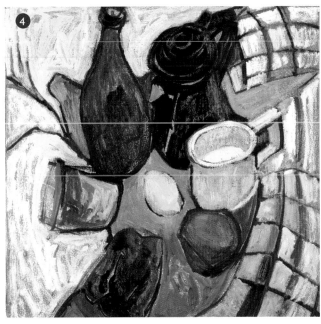

❸ Within each one of the forms outlined by the blue lines, we develop the colors of the forms: each color presents a variety of tones from within its own range.

❹ Over the initial tones we add a few brushstrokes that are more opaque, covering, saturated, and luminous. We use a dry brush to make the brush marks clearly visible.

The color wheel served as inspiration for painting this daring composition with objects.

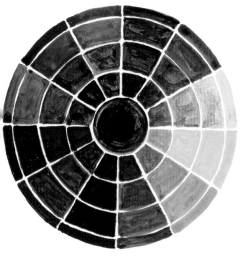

❺ We alternate dry brushstrokes with thick paint impastos and add highlights on the objects that until now had been treated with flat colors. On these last brushstrokes we used thick paint.

Chromatic Patterns

Apattern consists of a more or less predictable repetition of color units that make it possible to evaluate the role that each unit plays in the overall composition. This repetition of colors becomes a dynamic element on the painting, a repetitive rhythm that gives focus to the painting. In every rhythm there are always two components: repetitiveness, which means that identical individual elements or groups of elements are repeated systematically, and structuring, which varies considerably and can include from repetitive groups of elements to what is known as free grouping.

Introducing Rhythm

Rhythm can become a key factor in the composition, especially when units of colors are repeated systematically, forming a pattern made of visual units with regular forms, which is known as modular rhythm. Rhythm also appears when you introduce an element of tension, of contrasting color, that crosses the entire surface of the painting in a zigzag pattern or forming pronounced curls or curves. A third option is to apply repetitive brushstrokes of color in the same direction. The latter makes the color surface appear more dynamic, more rhythmic.

The color patterns are the more or less predictable repetitions of forms and colors that give more emphasis and rhythm to the painting.

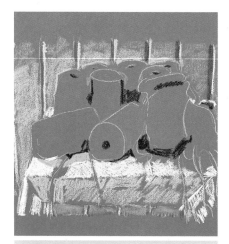

Relativity of Color

The most determining property of color is perhaps its relative character. No color can be judged by itself without taking the environment around it into consideration. Besides the tonal differences, colors are influenced by factors that affect its light and darkness, warmth and coolness, glossiness and shadows, as well as by surrounding colors.

Repetitive brushstrokes that are applied in the same direction create a rhythmic surface that gives the appearance of movements to the forms.

The orange colored road introduces a strong compositional rhythm into a landscape where blues and greens are dominant.

Tessellations

A tessellation is a repetition in the distribution of colors or a pattern that covers or paves a flat surface in its entirety, minimizing gaps or the superimposition or layering of the various forms. This technique is used to create floors or walls of decorative mosaic. It is a way to create a composition in which everything is filled up and everything has form, making the background virtually disappear. The resulting compositions are dynamic and charged due to the number and variety of elements and colors involved.

A tessellation covers the entire surface of the painting, with patterns minimizing the presence of gaps.

This painting, with a black and white monochromatic theme, done with a color pattern provides a stunning effect.

Cloisonné as a Chromatic Pattern

The next theme consists of painting a nocturnal cityscape by dividing each plane into individual color shapes, small color areas of various sizes that will cover the entire surface of the paper. To make them stand out these areas are separated from each other by small spaces, or cloisonné pieces, which surround the latter as white spaces. This technique does not seek optical mixing of the color but a general effect or order within a large geometric pattern, encasing each color area within its particular shape. The work is developed with watercolors on fine-grain paper.

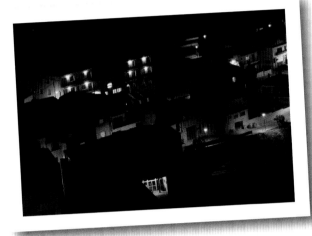

Even though the photographic model is very dark, we did not paint it with black colors, instead we used lighter colors and greater contrast.

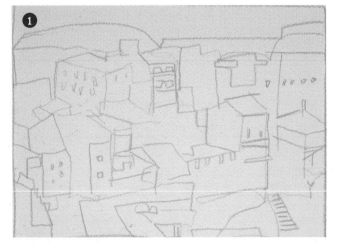

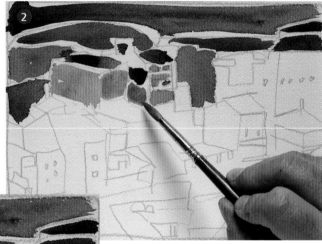

❶ Before we began painting we divided the areas of color with blue pencil. We chose this color because the line will still be visible after the work is finished.

❷ With Payne's gray we painted the darkest area of the sky. The colors get lighter as we near the houses. Then, we painted carefully, leaving an area unpainted between the blocks of color.

❸ It is important to invent colors to overcome the darkness of the model, interjecting cool and warm tones. Both ranges should be distributed regularly and with enough space in between.

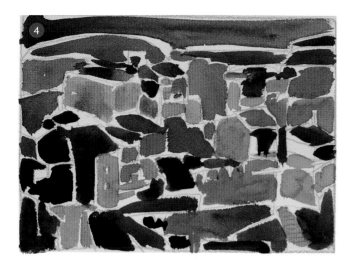

❹ We paint all the areas, changing the nuance of their colors, interjecting light and dark tones, to build up the composition as if it were a large puzzle.

❺ We add the final touch by reinforcing the borders of the cloisonné pieces. To make them richer we went over a few of the lines with a reed pen charged with black watercolor.

Anticerne Effect

The cloisonné effect can also be created over backgrounds covered with saturated colors. This way, the contrast will be very intense and striking. This effect of the color background is called the anticerne effect.

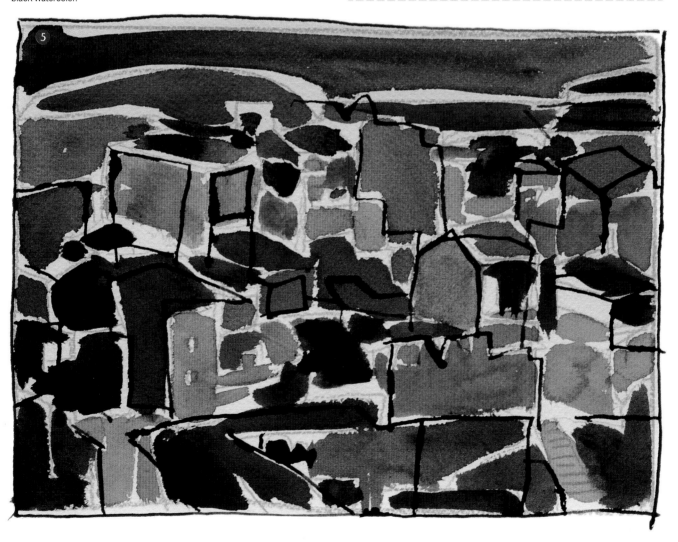

Chromatic Tension

If color harmony leads to compositional static and balance, tension is achieved by doing exactly the opposite: disturbing that color balance with strong and bewildering contrasts. In every color composition, it is better to have tension, an imbalance that activates the forms and breaks up monotony. The dynamic placement of the colors or the inclusion of a very striking and contrasting area of color creates color tension by itself, a focal point that disrupts and breaks up the apparent stillness of a harmonious range of colors.

Overlapping geometric shapes of various tones and colors produces compositional tension.

Forms That Create Tension

Tension is a feeling produced when the color elements are distributed over a background. The effect achieved is the result of the partial tension that each individual form contributes to the overall composition. There are several types of tension: dynamic, static, balanced, unbalanced, and unstable. When you include certain elements in the composition of one form or another, it can give the impression that they are subjective, like visual tricks created by the composition. You can use simple geometric or other irregular shapes to establish formal tension. Regular geometric shapes (triangles, circles, squares) are less dynamic than irregular ones. The greater the difference between simple shapes, the greater the tension will be.

Color tension is achieved by repeating the same color element, in this case a group of flowers, in a rhythmic way.

The conflict between two color ranges (reds and blues) that differ in temperature and intensity are the main elements of tension. The triangle is a shape that provides greater tension and dynamism than a circle or a square.

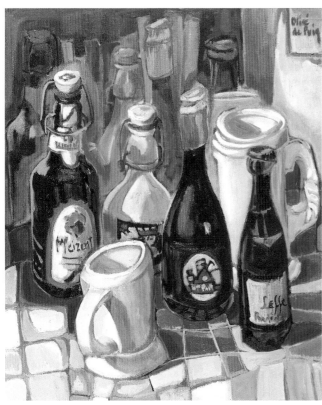

A focal point is used to break up the monotony or to attract the eye of the spectator with a bright and very localized contrast.

In this painting it is obvious where the focal point is. The red bottle is the element that breaks up the monotony and creates color tension.

The Focal Point as a Discordant Element

When a painting presents a similar, homogeneous color range, you can create chromatic tension by introducing a focal point, that is, a note of color that is overly contrasted. For the focal point to be effective it cannot be too large, it must be limited to a very small area of the model.

■ "Harmoniously established **forms and colors** produce poetry in themselves."
Paul Gauguin

Here, the angular shapes of the plant against a background of square shapes, and the lively contrast between greens and magentas, heighten the tension of the painting, making it very dynamic and agitated.

The Strength of Complementary Colors

The most striking contrasts are those produced between complementary colors. When they are placed together on a painting it looks like they are fighting each other because each one of them has a unique color that the other lacks. From the communicative and expressive point of view, the contrast between complementary colors can be used to guide the spectator through the different elements of the image—from one color to its complementary and vice versa—or to structure the image in successive pair partitions.

The most striking contrast possible is produced when two pure complementary colors are placed together.

The Most Striking Contrast

Two complementary colors placed together offer better contrast options, although visually it may seem very disturbing to combine them if they are in their pure state. Contrast between pure complementary colors is very beautiful, but it is considered too elementary and it is not given high value; it looks like the colors do not go well with the rest, especially with the mixtures. When they are together, it is difficult to know which one is the most striking; they transform any painting into a color feast, but they destroy the tonal variety and richness of the painting.

■ The goal of **contrasting complementary colors** is to convey energy, vitality, and power.

The contrast between pure complementary colors may appear very aggressive because they are too saturated; however, very rarely can we convey so much energy and vitality.

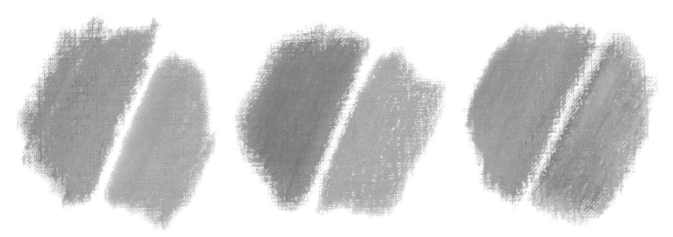

Colors that are adjacent to complementary colors may produce a false complementary contrast against them, which can be lively, although somewhat more subdued.

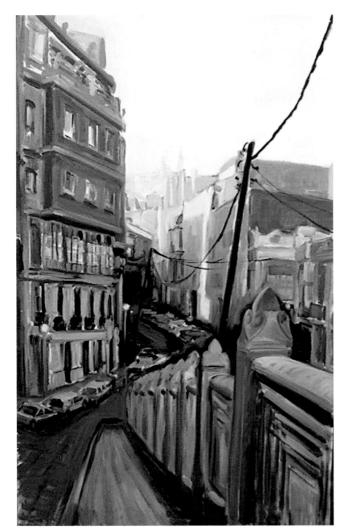

The contrast between complementary colors can be subdued when lightened with white, or even when mixing together, as in this pumpkin.

Subdued Contrast Between Complementary Colors

If you wish to achieve a subdued contrast between complementary colors, you should try to limit the pure color to a very small area, because the extension of a color in a composition should be proportionally opposite to its saturation. Then, it is important for the complementary colors that are opposite the pure one to be a little more subdued. The brightness of complementary colors can be reduced first by making them equal in luminosity and then by reducing their outstanding saturation, mixing them a little between themselves or by adding white or gray. This way they will go better together with adjacent colors.

In this urban scene the contrast between complementary colors has been reduced with white, ochre, and blue gray. The scene appears more harmonious but without losing the colorist intention.

Nude with Subdued Complementary Colors

It is more interesting to use less saturated complementary colors than very saturated ones to create more subtle contrasts and a much greater range of shades and nuances. We are going to put this into practice in the next exercise: a nude figure worked with contrasts between the complementary colors orange and blue. We begin with these two opposite colors, keeping in mind that each one of them can be combined with its respective adjacent complementary colors and with white to mitigate the contrast and to achieve a wide range of values. We used oil paints.

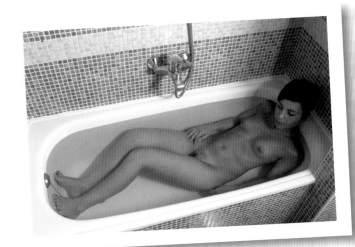

Grooming scenes and female figures in the bath were recurring subjects among Impressionists.

1

2

❶ The initial drawing has been drawn with a few simple lines using the tip of the brush. It is a good idea to establish the position of the figure and its placement in the bathtub beforehand.

❷ We painted the body of the figure with purple pink made from combining crimson, white, and a touch of blue. We begin painting the walls with grayish blue.

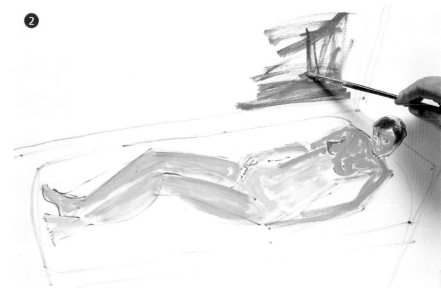

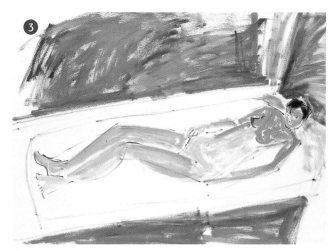

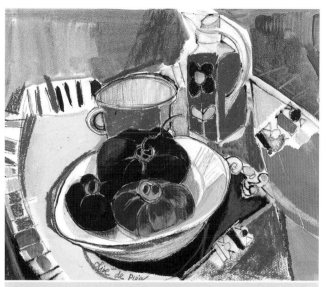

3 The two complementary colors are introduced. We have switched the logical placement order: orange covers the darker area while the blue is painted over the areas with more light.

4 We paint the water in the tub with the same blue color. The purple undertone of the figure now appears even cooler due to the chromatic dominance of the blue that surrounds it.

Start with Saturated Complementary Colors

If you are using subdued complementary colors, it is a good idea to begin with the purest complementary colors, leaving some areas unpainted, which later can be painted with other tones and shades.

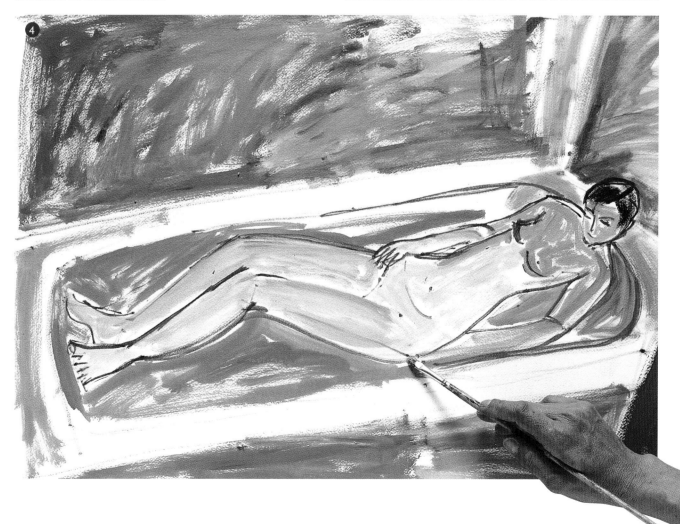

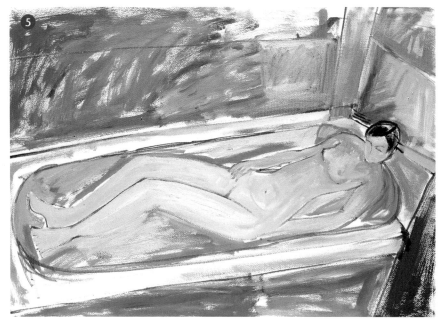

To produce a variety of nuances and rich colors, it is important to work with different shades of blues and oranges.

5 There are many color variations present in the composition: a variety of blues, modified oranges, and the color of the skin, which has acquired a denser and warmer color with a yellowish undertone.

6 The water in the tub needs to be defined to give it a feeling of transparency. For this purpose, we introduce white, which will be combined with blue or yellow to make it less saturated.

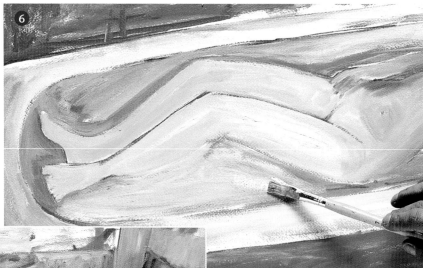

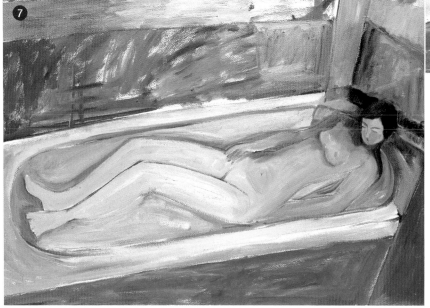

7 The orange and the blue are placed opposite each other at both ends of the painting. The orange has an effect on the skin of the upper half of the body, while the blue, mixed with yellowish orange and white, creates new green nuances.

8 To tie in the color areas of the wall we take advantage of the mosaic pattern on it. By doing this we try to construct a grid of lines that will change colors according to the color that is underneath.

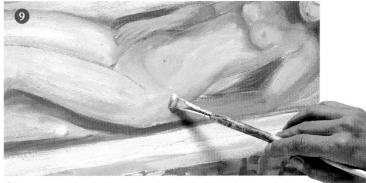

9 Oranges and blues become predominant on the right half of the painting and have an effect even on the mosaic of the walls. We add a few shadows on the skin to prevent the body from looking flat against the color of the tub.

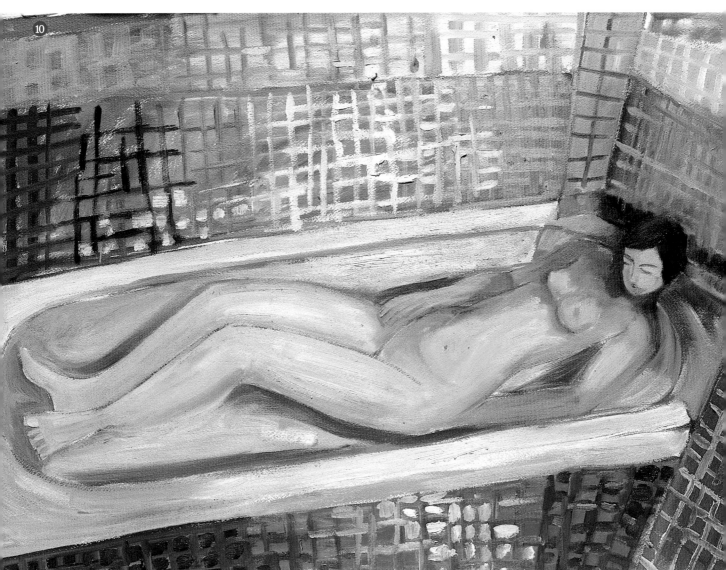

10 Here is the finished work. The figure and the space are separated by the unifying clash between blues and oranges, which provides a very rich harmony full of light and multicolor reflections.

Color and Space

You can use color to manipulate the space by tricking the mind into seeing objects larger and closer or smaller and farther away, to see depth where there is none, or to make a composition look flat, devoid of space. The natural order of the spatial composition goes from warm to cool, and not the other way around; therefore, a good approach for creating space and to achieve an illusion of depth is to use colors following these basic rules. This effect can be enhanced by saturating the colors of the objects located near the viewer and diluting the colors used to paint elements that are farther away.

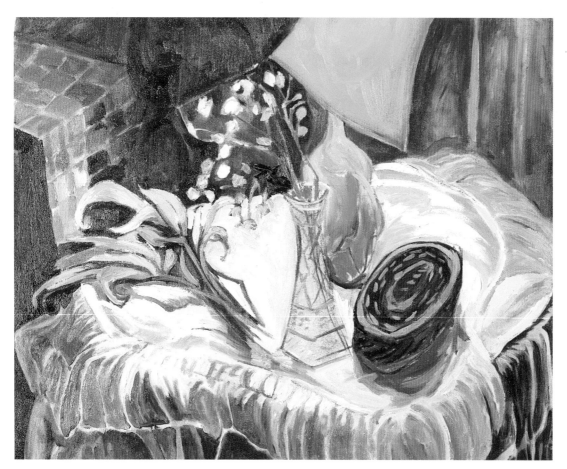

The most intense and warmest areas of light tend to appear closer, while a background of dark blues and greens gives the painting a feeling of depth.

A black background makes the objects stand out and look more luminous, as if projected to the foreground.

Intensity and Light Affect Size

By changing the saturation, the light, and the dimension of the area of color, you can change the feeling of depth in the space, of the objects and of their size. A bright color can make us perceive an object larger and closer, while a soft color makes it look smaller and farther away. Lighter areas are seen first against a dark background, and they appear projected forward; they look closer depending on their degree of luminosity, with yellow being the color that stands out the most. On a light or white background, the darker objects are seen first; the colors are projected forward opposite to their luminosity, with violet being the one that stands out the most.

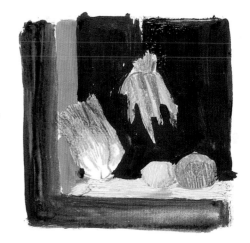

Warm colors are projected forward and appear closer to the viewer. Cool colors produce the opposite effect; they tend to recede.

Manipulating Space with Color

You can experiment with the optical effect of colors by painting an interior theme. You can make a high ceiling appear lower if you use warm colors, like yellow and red, which the eye sees as projecting forward. To test the effect, sketch out an interior and paint its walls with warm colors to make the space look smaller. Painting them with cool colors will make the room look bigger. The same applies to height. A ceiling painted with cool colors appears higher than one painted with orange, red, or yellow.

Green and blue tones convey depth and make the previous space look larger.

Warm colors on the floor, which have an effect on the white walls, make the space look smaller and project it forward toward the viewer.

Cool colors on the walls tend to give a room the feeling of space.

The same approach can be used for the ceiling to make it appear higher or lower.

If you paint the walls of a room with warm colors, the space looks smaller.

Near and Far Colors in a Landscape

You can create different planes in a landscape by using warm colors that advance visually and others that create a receding feeling. This means that the superimposition of planes can be enhanced by painting the areas located in the foreground with warm colors and the ones in the background with cool colors. This way, the mountains that are farther away in the distance will have bluish tones, while the green ones will gradually become yellow as they get closer. Next, we are going to show in this exercise painted with oils the order in which the colors should be painted and how to increase the effect of depth by following this simple chromatic rule.

Applying a Color Scheme

In the color scheme shown here we indicate the order of the colors and how they function showing distance: yellow and red on the foreground, browns and greens on the middle planes, and blues and violets on the background. This does not mean that you have to paint a landscape with the same order of colors—this range of colors may not always be suitable for a particular theme—but you should try to add the colors mentioned, even if subtly, into the color mixtures for each area. In other words, if the colors of the landscape do not match the ones in the color scheme, you can change them to resemble the proposed range.

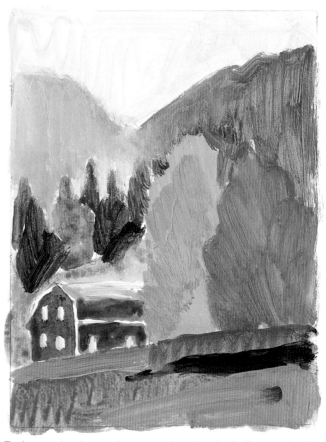

The foreground tends to stand out more, so it can be painted with warm colors. The more saturated the color the more the main theme of the painting will stand out.

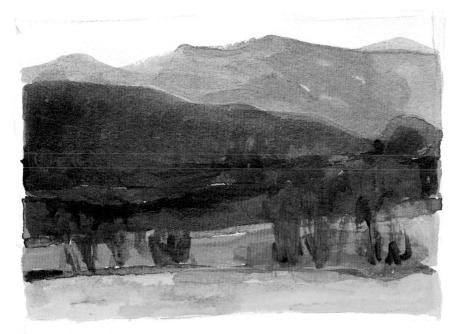

Warm colors dominate the foreground, while cool colors describe the areas that are farther away.

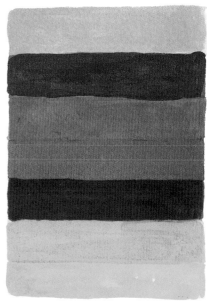

In this scheme we show the order of the colors and how they function showing distance.

The effect of depth can also be reinforced by blending different bands of color to create a gradation.

The garden is like a stage where a real explosion of colors takes place. It has enough depth to experiment with near and distant colors.

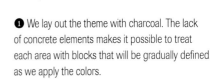

❶ We lay out the theme with charcoal. The lack of concrete elements makes it possible to treat each area with blocks that will be gradually defined as we apply the colors.

❷ With a thin brush charged with a generous amount of blue and violet diluted with turpentine, we begin to define a few of the forms. We apply a generous amount of turpentine, because it is easier to cover large areas with thinner paint and because thick paint will ruin the effect of other colors applied over it.

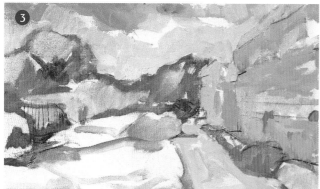

❸ We paint the sky with cerulean blue mixed with white, followed by the clouds, which we paint with a wide brush. Areas of orange paint are added on the right wall.

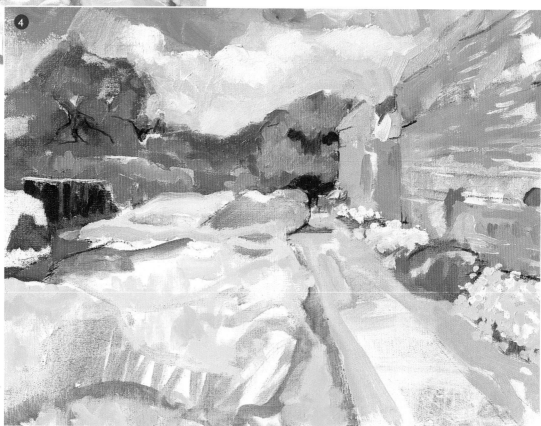

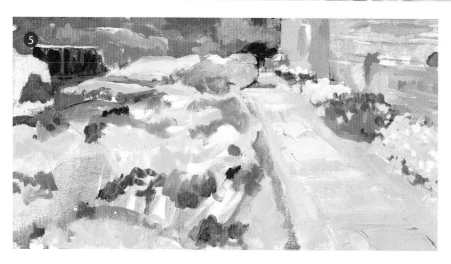

❹ On the background, the violet tones blend with different mixtures of green. On the closer planes, between the flowering bushes we apply pure yellow tones to represent the sunlight.

❺ We added touches of red on the flower beds with wide and spontaneous brushstrokes and without defining each flower in detail but giving them a feeling of abundance.

Color Schemes

Before you begin painting the landscape, lay out a simple color scheme to assess the overall effect of the colors based on their placement.

❻ With a stick of dark wax reinforce the contrasts of the trees. This oily medium goes very well with oil paints. The stick is a good tool for drawing lines very easily.

❼ We have finished the painting. When we compare it to the original model it is obvious that we have made some colors brighter to match the orderly succession of colors recommended for enhancing the effect of depth.

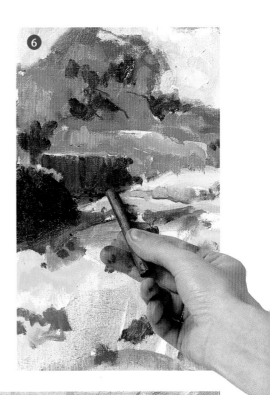

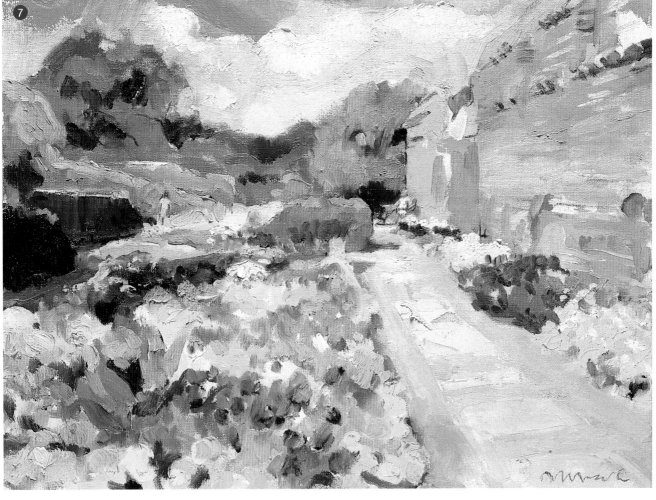

The Color of Shadows

A shadow can be interpreted as a negative space or as a projection of an object on the surface. Traditionally the difference between light and shadow is approached by darkening the colors with brown, black, or gray. But, as you can see, it can also be achieved by combining bright colors. The Impressionists were the first ones to represent changes in light by substituting shading and its function with contrasting complementary colors or with others that appear to be opposite. Therefore, color replaces the traditional shading in chiaroscuro, making the shadow the protagonist and turning it into an active element in the chromatic balance of the painting.

Blue Shadows
When light is not very bright, colors look cooler, and as a result the overall color scheme becomes blue or violet, which is what happens with the colors of a landscape at sunrise and sunset. For this reason, many artists represent the shaded areas of the model with blue colors. This technique can be used for establishing and laying out the shaded areas as well before applying the other colors. In addition to making the overall layout easier, it provides the correct distribution of light. Watercolor artists very commonly use this technique.

A creative and colorist approach to the model requires the use of bright tones to paint the shadows, which are able to replicate the colors in the illuminated areas.

■ When the painting includes bright light, **the lighted areas** are painted with a warm color scheme. **The shaded areas**, on the other hand, are interpreted with cool colors.

Many watercolor artists paint the shadows of the landscape with blue washes. It is a good way to establish the base of the drawing.

Divisionism

Also called chromoluminarism, this is the name given to a method of representing light and shadow with color. It stems from the premise that if the most illuminated area is represented with yellow, darkness does not have to be brown, gray, or black but a color that is its opposite on the color wheel, violet. Based on that idea, many colorist artists paint shadows with the complementary of the colors used in the areas of light. The contrast between complementary colors tends to be more assertive with projected shadows whose profiles are not well defined than with shadows painted with gradations and diffused profiles.

Green, violet, and blue colors are usually associated with shadows.

It is not a good idea to paint the shadows with warm colors, because they look more like sun rays than shadows.

A In a value-based painting shadows are usually represented with brown or grayish colors.

B The shadows projected by orange and red objects can be painted with their complementary color, green.

C Colorist painters believe that blue should always be part of any shadow.

The Collage: A Number of Approaches

You can use color papers to experiment, to try out compositions, and to plan a color base. They provide an interesting surface to work from, very different from the traditional white background. The opportunity to play with forms and with blocks of color without the strong figurative constraints allows artists to delve into the multiple possibilities of simplification. In this process, the artist must rely on his intuition and perception to simplify the main forms of the model.

Synthesis with Colors

The best way to simplify a model is to try to see it as if it were made up of flat shapes with large areas of color, as pieces of a collage. Working with flat colors makes simplification easier because you can rely on a single color to explain a surface full of values and nuances. Contrast is a powerful tool for expression and for simplifying an element, allowing you to enhance the meaning of the image so the viewer can visually interpret it more quickly.

It is a good idea to have a wide range of papers available of different contrasting colors.

❶ With scraps of color paper you can lay out areas for any model, in this case we used a still life.

❷ Then, you can adapt or change the outlines with drawn lines to make the objects more recognizable.

The Tension in Collage

When you synthesize the forms of any model with a few paper cutouts, color plays a greater role. The contrast between the various pieces of paper creates tension, which needs paint to strongly capture the attention of the viewer. When the collage is finished, the paint helps modify and complete it with new colors and forms and by laying out its contours. The graphic contrast between the paint and the background gives the painting a very striking finish.

■ A collage with **color papers** is a good way to synthesize the forms of the model.

The color paper and newspaper cutouts are glued to the support with acrylic latex. Spread the glue with a brush, applying pressure with the bristles to make sure that they adhere properly.

Various Textures

If you combine collage with oil or acrylic paints do not settle for a single type of paper, instead combine several of them to create not only a variety of colors but of textures as well.

You do not have to cover the color paper completely with paint. The paint should interact with the color underneath.

A Colorist Composition with Collage

This exercise is especially for those artists who are interested in learning and knowing how to work with the expressive possibilities of collage and its validation as a tool for the creative production of colorist and attractive images that can then be completed with oil and acrylic paints. First, it is important to begin with very simple compositions that have strong colorist elements, like this group of toy boats. Once you have overcome the first small challenges, you can venture into more complex and involved themes, like an urban landscape or a human figure. We have used oil paints for this exercise.

The inspiration for this exercise is a still life with several toy boats that have colorful sails.

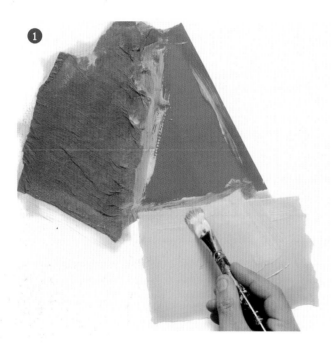

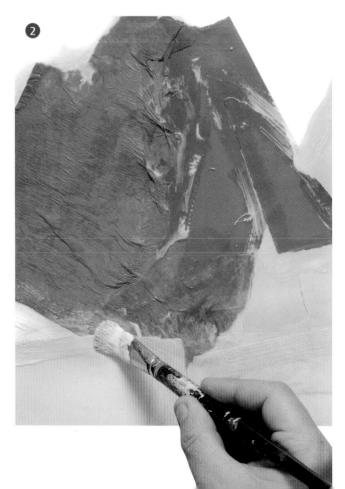

❶ First, we chose different color papers that go well with the colorist composition of the real model, and we glued them to the support with latex.

❷ We tear up the papers by hand to create irregular contours, and we cover the surface of the support with them as if it were a puzzle.

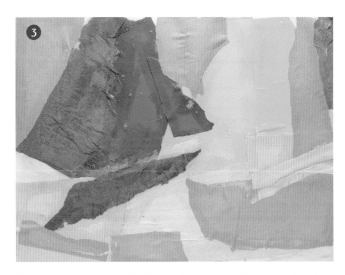

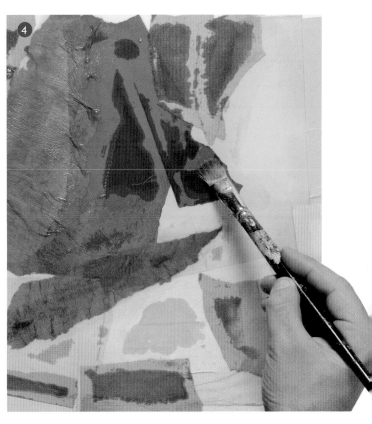

3 The arrangement of the color papers should respond to the placement of the elements on the model. The papers begin to show the first bright color contrasts.

4 We soaked the surface with purified linseed oil to add intensity and richness to the color papers. You can also use varnish if you wish.

5 We soaked up the excess oil with blotting paper. We defined the model over the shiny surface with charcoal. The lines should be very simple and should be drawn pressing gently on the stick.

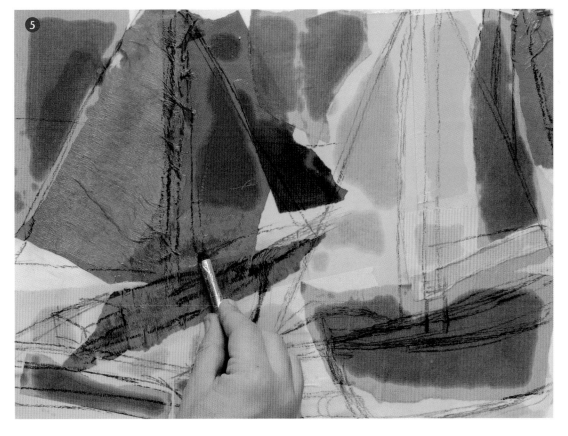

The wrinkled tissue paper that we used in this exercise has a very interesting texture.

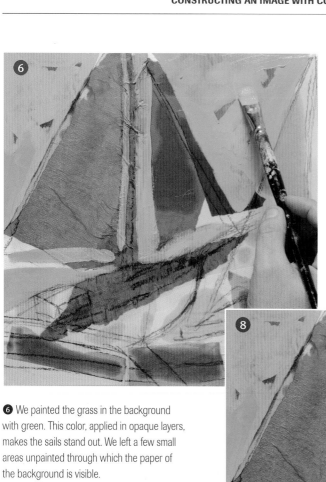

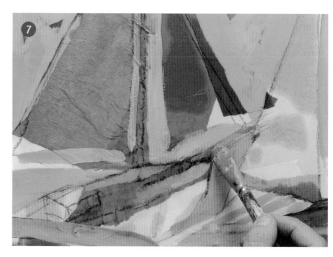

6 We painted the grass in the background with green. This color, applied in opaque layers, makes the sails stand out. We left a few small areas unpainted through which the paper of the background is visible.

7 With blue and orange we modify the forms laid out with the paper. The goal is to make the painting resemble the real model. But the additions should be minimal to prevent covering completely the color effect of the paper.

8 At this point, decisions are crucial: for example, leave the sails fuchsia or pink instead of painting them white as they are on the model.

9 The last phase is carried out with a smaller round brush. Now it is a matter of adding a few spontaneous patterns to the sails to make their colors and textures richer.

10 With the same thin brush we add the last details: the thin lines for the ropes, a mast here and there, and more definition to the shadows of the oars below.

11 We have made the background lighter by adding green mixed with much more yellow than before. The charcoal lines, still visible against the color paper, provide information about the process while adding graphic interest.

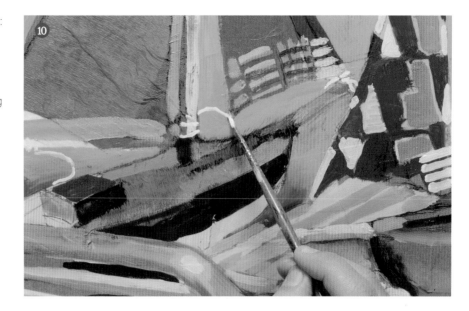

The Plasticity of Relief

Oil and acrylic paints can be easily combined with other mediums to change their composition and texture to make them thicker. This physical property provides a wide range of textures that cannot be matched by any other art medium. The goal for incorporating relief effects to the surface of the painting is to change the way the colors look at the end, as if the artist were trying to defy the viewers' common sense or to surprise them with effects other than the purely chromatic ones.

Texture and Color

Texture consists of the addition of effects that are perceived as surface variations or irregularities that enhance the thickness and relief of the paint. Texture is added to achieve greater graphic richness and for the color to acquire a tactile quality. The most common ways to work colors with texture is by applying thick paint with a brush or with a spatula accumulating greater amounts of paint on the support to form peaks and valleys through which light travels in unusual ways.

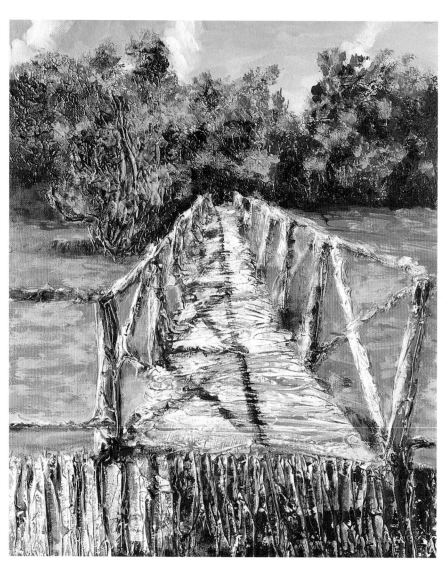

Texture applied with modeling paste and painted over with acrylic paint. The realism of the wood bridge is striking.

When texture is added, the color surfaces no longer look flat and show light and shadow differences that stem from the relief.

Fillers consist of solid materials and fine dust that add consistency to the paint and texture to the surface.

Gel is an oily substance that is added to the paint to give it more volume and viscosity.

Mediums, Fillers, and Their Effect on Colors

Mediums are modeling paste and creamy substances that are added to the paint to give it more volume and to change its consistency. Mediums change the color slightly, add luster and luminosity, and reduce the drying time. Fillers are finely ground materials that can be added to the paint to alter its texture and viscosity. They provide the surface with very abrasive mottled and textured surfaces. They are usually gray, very light brown, and even black; therefore they have a considerable effect on the original colors. When they dry, the small shadows of the microgranules extend evenly over the surface of the painting, giving a variety of nuances to each area of color.

A study of a landscape painted with acrylics and fillers made of marble dust.

The paint mixed with fillers gives the surface an even grainy texture that casts shadows and creates light effects.

A Seascape with Gesso and Spatula

This seascape has been done with acrylics and a spatula. Gesso or modeling paste has been added to the acrylic paint to give it more volume and consistency. This has its pros and cons: it is a fact that gesso adds body to the paint, making it easier to work with a spatula; however, it also changes its color. Since gesso is a white paste, when mixed with acrylics it tends to whiten them, making the color less saturated, reducing its chromatic power. We have chosen a very simple theme on purpose, because it is less complicated and therefore does not require a drawing. We use acrylic paint.

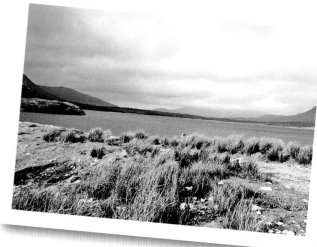

This seascape emphasizes a prominent foreground full of vegetation, which divides the scene into two areas.

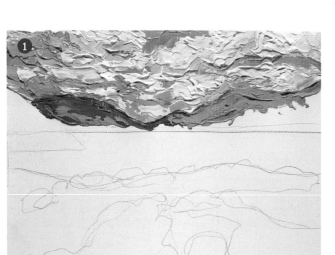

❶ We begin with the sky where we alternate pink, violet, and white tones. To give them more volume we add a small amount of gesso to the color mixture.

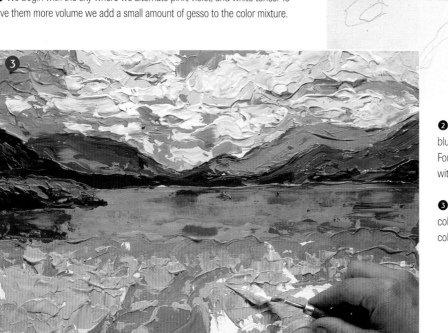

❷ The mountains in the distance are covered with blue colors and the closer ones with medium brown. For the water we applied ultramarine blue mixed with the gray from the sky.

❸ We paint the foreground with an orange base color. Without waiting we superimpose a second color, yellow green.

The quick drying time of gesso forces us to work fast because we need to act when the paint is still wet.

❹ We finish the vegetation with touches of orange paint applied with the tip of the spatula dragged vertically.

❺ Work done with paint and gesso always provides lively and luminous results. The overall white effect is quite visible, which forces us to apply a few last touches of pure paint to counteract this effect.

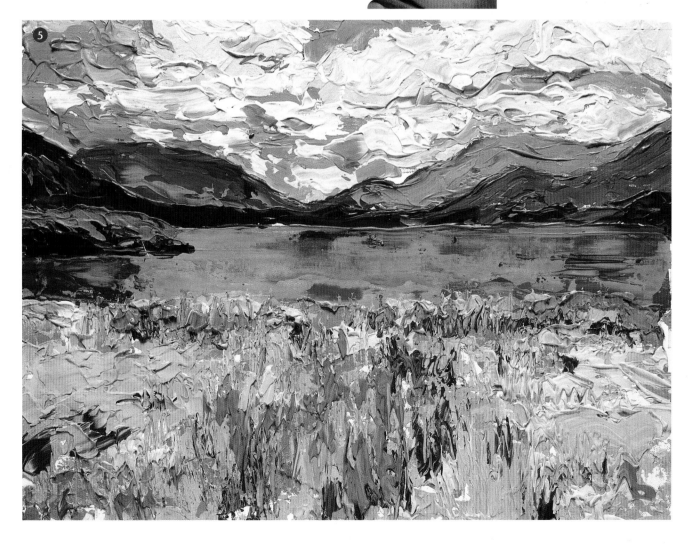

INTERPRETING REAL COLORS

It is not difficult to paint any subject matter with accurate and appealing colors, the only thing you need is to develop a good sense of interpretation. Interpreting means translating, identifying the real colors and bringing them to life on the painting. Therefore, a good interpretation depends on the color contrasts, the overall harmony, the convergence of the brushstrokes, and the perfect combination of forms and colors, as well as the rhythmic repetition of the elements. It is important not to forget that color is a medium for expressing and building ideas through images. The goal is to stay away from visual rigidity. Relying on different color proportions and combinations, the creative person chooses the combination, the impact, the strategy according to what he wants to convey. In the world of painting there are different premises and models, elements that constitute the subject being represented: the water, the green, the ground, the sky, the clouds. In this section we are going to review some of them, studying in depth the most appropriate color treatments according to the case.

House in the Suburbs with Laundry. Egon Schiele (1890–1918). First, the artist visualizes the model, and then he interprets it. By exaggerating the outlines and saturating the colors he creates a personal interpretation of the theme.

The basis for a correct interpretation relies on the selection of effects and colors for each situation.

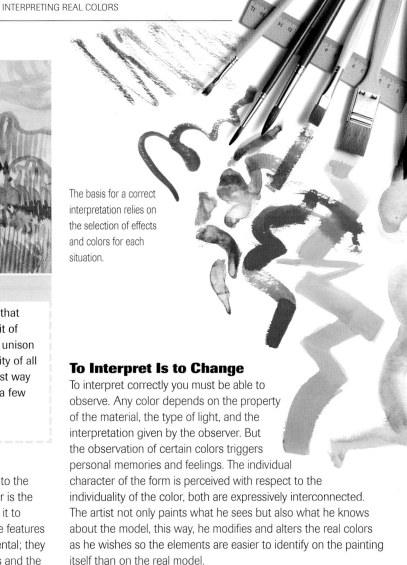

Expressive Impressions

The affective-emotive impressions and expressions that accompany the use of color are necessary. Each unit of color must make sense not only by itself but also in unison with the colors that surround it, enhancing the quality of all the elements that make up the composition. The best way to study this is to make quick color notes with only a few strokes of color, letting emotion be the guide.

To Interpret Is to Change

To interpret correctly you must be able to observe. Any color depends on the property of the material, the type of light, and the interpretation given by the observer. But the observation of certain colors triggers personal memories and feelings. The individual character of the form is perceived with respect to the individuality of the color, both are expressively interconnected. The artist not only paints what he sees but also what he knows about the model, this way, he modifies and alters the real colors as he wishes so the elements are easier to identify on the painting itself than on the real model.

Real Colors

Painting with colors that are too realistic and very close to the colors found in the real world can be boring. Since color is the transmitter of meaning and emotion, you should rely on it to create a more attractive and personal interpretation. The features that enhance the most important elements are fundamental; they mark the particular highlights of the surfaces, the colors and the forms that are being represented.

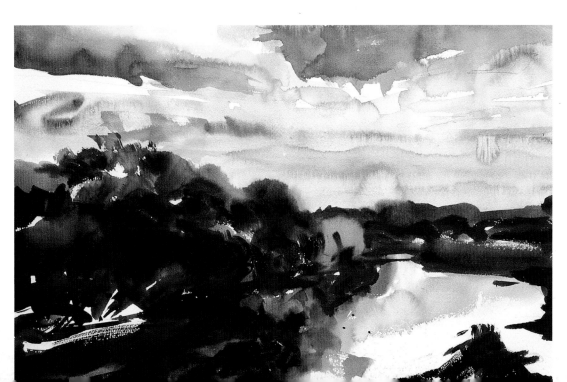

The first areas of color on the painting try to establish the first color impression, to capture the environment with an interpretation that focuses on the most significant features.

The Color of Vegetation

Vegetation constitutes a large part of many landscapes. It is important for the great variety of textures and nuances that it can offer. If you paint a close-up, vegetation can provide rich details and color variations that are not limited only to green but to the ability to discern between a yellow green, or blue or ochre green, and the same can be said about the colors of fruit, flowers, or the gray or brown tones of a tree trunk. The artist has to define the color and use the tone that can be achieved by mixing greens with other adjacent colors.

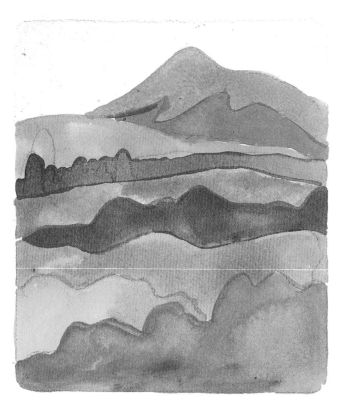

The Dominant Color

If you wish to paint a landscape with a lot of vegetation and lively colors, even creative colors, it is best to first determine a dominant color, which could be green, brown, red, or orange, depending on the type of vegetation, but especially depending on the season. Together with the dominant color you can lay out other secondary colors that add richness and variety to the basic color. For example, a dominant olive green goes perfectly together with the secondary color ochre. Compositions with a burnt sienna as the dominant color combine well with orange, green mixed on the palette, or yellow as secondary colors. Bright greens next to dark blues, the earth tones, oranges, and yellows also offer outstanding combination possibilities.

We have painted this landscape with flat planes of color according to the dominant color tendency of each area.

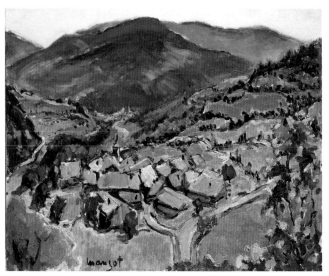

Lightening Greens

Mixing the colors of vegetation in landscapes with white yields tones that are too light and takes away the power of the landscape. Instead, mix with ochre and yellow to make them lighter. White should be used with caution.

Landscape painted basically with a palette of cool greens and blues. It has a touch of yellow to lighten the greens and a small amount of crimson on the violet tones of the background.

The use of green tones that are too much alike can make a landscape look boring and monotonous.

Shading Without Upsetting the Balance

When you paint vegetation make sure that the eye is not drawn to a green that is too homogeneous. Be open to color highlights to ensure that the different elements that form parts of the painting are discernable. A painting that only has green tones can be boring. It is important to introduce small details of other colors that contrast with the green to break up the balance. If you prefer to add more color, you can introduce pinks, oranges, yellows, and blues with the green to create different nuances.

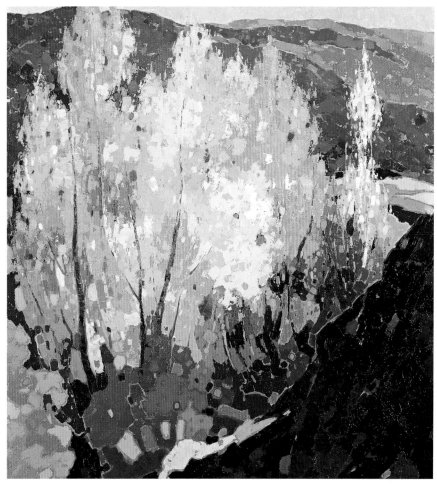

Here is an example of colorist vegetation. The dominant color of the trees is yellow, and the background is blue. Starting from these two references we have developed the different color nuances.

A clump of vegetation can be painted by combining different tones of green.

To achieve greater chromatic variation we have added other colors to the green in moderation to avoid disturbing the balance.

Painting Water

O ne of the most common constrictions of academic painting is the norm that advocates the use of a very limited color palette to represent water, a palette in which different hues of blue are dominant. Contrary to common belief, the palette for painting the sea, or rivers and lakes does not necessarily have to be made up of blues; it can include a wide chromatic range, which will make it possible for the color of water to break down into a prism of multicolor reflections. This ambiguity, so characteristic of water, has attracted painters from every time period, eager to find new solutions and suggestions and greater freedom in the approach to this medium.

To paint a blue surface, you can mix green, blue, and violet together directly on the support with firm brushstrokes.

What Color Is Water?

The greatest problem presented by the representation of water is that it does not have a specific color. Its appearance is the combination of its reflective surface and its translucence, that is, the color of the sky and of the objects that are reflected on it plus the tonalities of the objects in the water, which will depend on the depth at which they are found, an important factor. The color of water in itself does not exist, not even on a surface as vast as the sea. The large bodies of water act as mirrors that do not reflect back an exact color, except on very sunny and bright days, in which case the water can be a radiant blue. But often, according to different factors (the sand on the bottom, reflections, vegetation on the shore), this blue may appear green, or blue green, violet, and/or different hues of gray.

The colors that are associated with the color of the water are most commonly the blues.

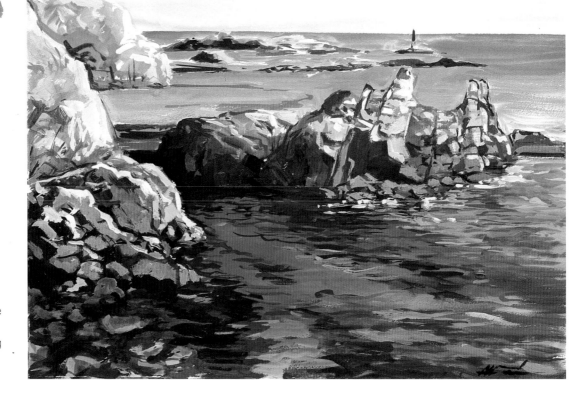

On sunny days the different color shades of the water explode into greens, violets, blues, and ochres, the latter as a result of its transparency showing the features at the bottom.

Moving Water

When the water of a river, or a lake or sea, is turbulent, it loses the transparency and luminosity of its reflections. The current of the water in the river breaks up the forms reflected on it and turns them into a blend of colors and shadows that tests the ability of the artist in the handling of the brush. In this case the palette is composed of broken and neutral colors. The colors of the illuminated areas should be lighter and more transparent than those that are near the shoreline. Therefore, regardless of the theme, the goal is to paint the water not according to established prescriptions but according to the light, the atmosphere, and the colors that surround it.

When painting a flowing river, the water can be represented by including dark colors to contrast with the light ones.

When the water is still, it does not have a specific color; it becomes a giant mirror that reflects all the colors of the sky.

A Pond with Color Pencils

In still water, the transparent surface makes it possible to perceive the colors on the bottom in the shallow areas with the surface acting as a mirror reflecting them. If we add to this a gray and overcast day the result is a surface made up of brown, gray, violet, and ochre colors. The subject for this exercise is very appropriate for working with color pencils. The detail and subtlety they can provide makes it possible to represent the variety of colors that occur on the surface of a body of still water.

The pictorial interest of this theme resides in the very unusual tones of the water that are made up of blues, grays, and violets.

❶ After the initial pencil drawing, we apply the color base of the bushes with a general yellow composition, which we will define later with additions of reddish brown and dark brown.

❷ The first lines are applied very softly, hardly pressing at all. On the water, we applied different tones of gray, leaving the areas that will represent the reflections unpainted.

❸ On the reflections of the clouds we add new green tones that modify the initial blue colors, which begin to add more density to the color of the water.

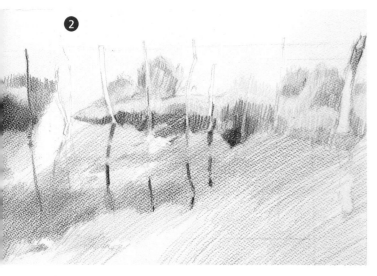

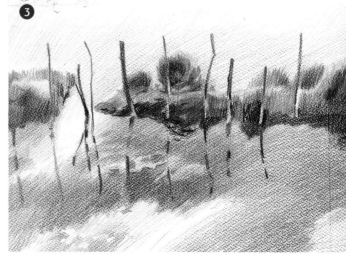

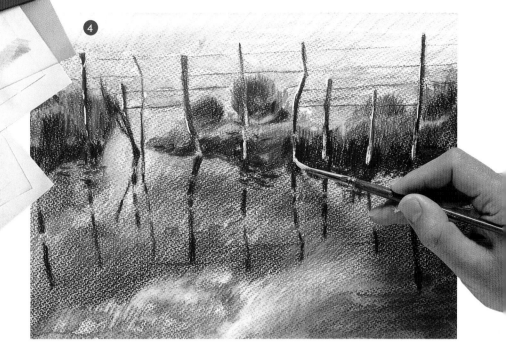

When drawing with color pencils, it is more common to use papers without texture, which make the lines appear cleaner.

❹ Ochre and yellow colors that are painted over the grays and violets are the result of the reflections of the plants on the bottom. The darker colors of the posts and their reflections on the water are blended with water as if it were a watercolor.

❺ This is the way the water looks at the end: very rich in color and very convincing in terms of the chromatic variations cast by the reflections or by the incidence of light from the sky, a water that is somewhat murky under an overcast sky.

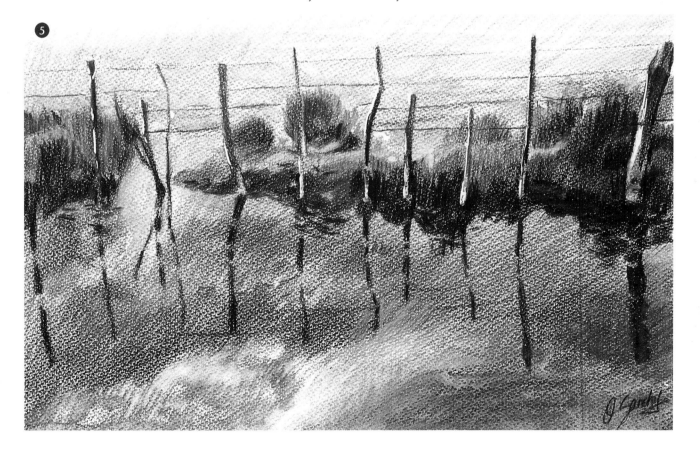

Flesh Tones

Achallenge that artists encounter when representing a human figure is how to paint the color of the skin. Many artistic works corroborate the idea that the color of the skin can encompass all the colors of the palette, and there are many variations because, depending on the style and the color range, the color of the skin can present unexpected tones. But it is important to abandon relative conjectures and to pinpoint some of the most common colors, the ones that can be used preferably and that can be adjusted later according to the particular light that affects the figure.

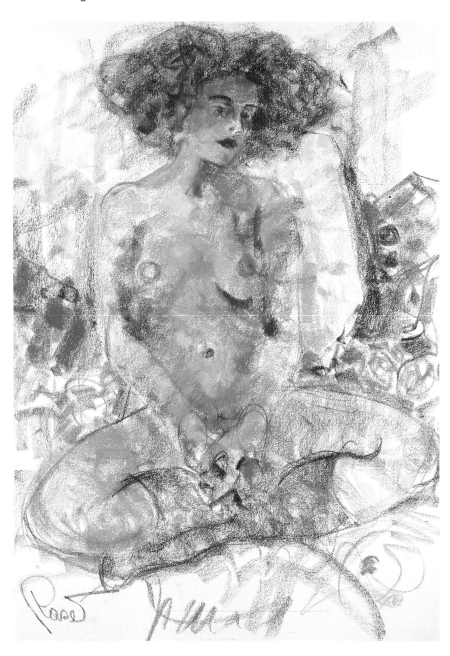

The color of the skin has multiple saturated tones, especially if the representation has a clearly colorist approach.

Skin Color

We are referring here to the color of human skin. Even though there is no single skin color, because it depends on characteristics, such as the light that bathes the figure, the most appropriate range of colors combines ochre, sienna, orange, and earth tones in general mixed with white for figures with tan or crimson skin, and vermillion with a touch of yellow combined with a generous amount of white for pinker skins. This is only a suggestion or a point of departure to begin experimenting with various possibilities, without forgetting that the darker colors should be used with caution to avoid too much contrast.

An example of the skin tone that you can obtain by mixing crimson, Naples yellow, and burnt sienna with a generous amount of white and a touch of blue.

A range of colors resulting from combining ochre, orange, yellow, burnt sienna, cadmium red, and white.

Three examples

We offer a few suggestions for experimenting with different possibilities for painting the skin. Skin colors can be achieved by mixing crimson, Naples yellow, raw sienna, and a touch of blue for the shadows. Depending on the surroundings, you can add orange directly. Other artists begin with orange ochre and darken it with burnt sienna or red, and then they make it lighter with white. A third possibility is skin color with a pink undertone, which is achieved by mixing crimson and white and a touch of yellow and then darkened with light greens or blues.

A This very warm skin color is created by darkening pink (white, crimson, yellow) with burnt sienna.

B Pink (crimson and white) that turns warmer after adding yellow ochre then darkened with a touch of green.

C The cooler skin tones are achieved by adding a touch of blue or more crimson to the initial pink. The skin tones therefore acquire a hint of violet.

Layering Colors

Flesh tones are created by superimposing colors without too much contrast, which prevents them from blending to achieve an interesting modeling effect.

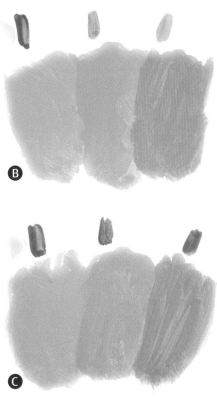

The skin tones present a variety of hues that are achieved by mixing a base skin color with a small amount of burnt sienna, orange, green, and white.

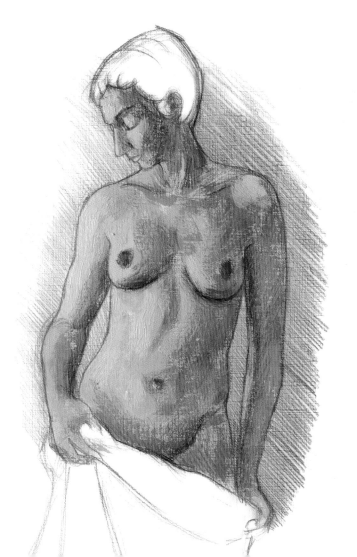

The Color of Light

Sometimes light unexpectedly takes center stage in some paintings, especially when it is manifested through sun rays that play an important role in the structure and composition of the painting. The quality and coloration of light can define a myriad of forms, and they undoubtedly condition the final result of the scene and, therefore, our perception of it. In this section we are going to try to give a chromatic solution to this phenomenon.

The use of small dots of color that are gradated in a radial direction is a good way to paint light.

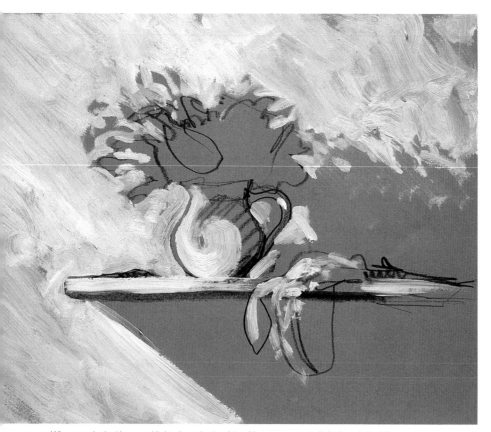

When we deal with natural light, the color is whiter. You can re-create light by painting with angled or diagonal brushstrokes to express the incidence of sun rays.

Light Can Be Painted

Light is an intangible element. When you paint a landscape, the bright and blinding sunlight almost always seems invisible, unless you paint the side effects from it: shadows, reflections, gradations, contrasts… But there is a graphic approach to representing it: try to show it as if it were small photons or color sparkles. Evidently, they are completely invisible, but an approach with very small brushstrokes helps explain this effect: photons that transmit light in different directions stemmed from the light source, dragging small particles that belonged to the lighted figure.

You can make lines with a craft knife on the fresh oil or acrylic base to mimic the dispersion of the sun rays.

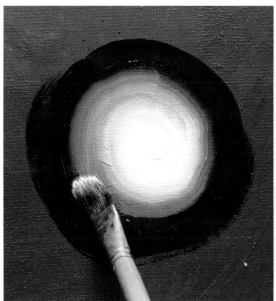

You can paint the beams of light with circular gradations that stem from the center of the light outward. Using the tip of the brush, paint with circular motions spreading and blending the white with the violet.

The beams of light are painted in the shape of small photons or brushstrokes that stem from the light source and extend throughout the entire painting.

Artificial Light

Artificial light comes from electric lighting. It is characterized by the intense illumination of all objects that are nearby, leaving in the dark the elements or planes that are far away. The shadows generated by artificial lighting are more distorted than the shadows created by sunlight. Artificial light alters the real appreciation of the object's color; even if it does not seem so, lightbulbs have a yellow, blue, or orange undertone (unlike daylight, which is whiter) that blends with the colors of nearby objects and alters their appearance.

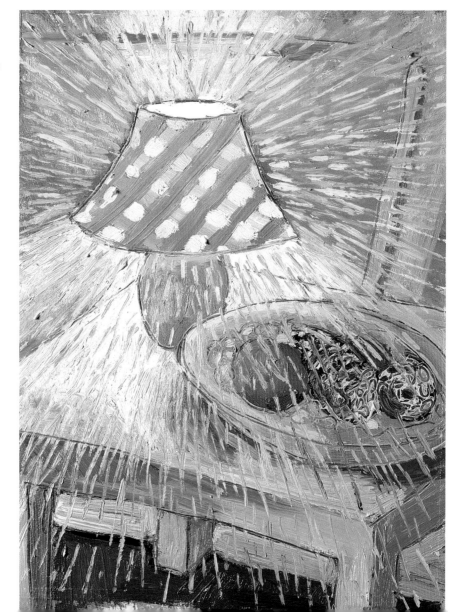

Painting Reflections on the Water

The impact of light on the water and its array of colors increase when the light hits the reflective surface, because the latter acts as a giant mirror that breaks down the white light into an array of colors. Water, like most liquids, captures light very well and distributes it in zigzag motions, which can be painted with contrasting colors. For reflections to be convincing, they must be colorful and firm and contain many more colors than the model on the photograph. We have done this exercise with oil paints.

A boat with reflections is a common theme among artists because it provides a striking effect.

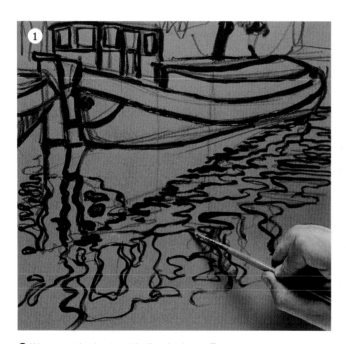

❶ We go over the drawing with diluted red paint. The reflections on the water are extended vertically with zigzag lines, which become more interspersed the farther they go from the object.

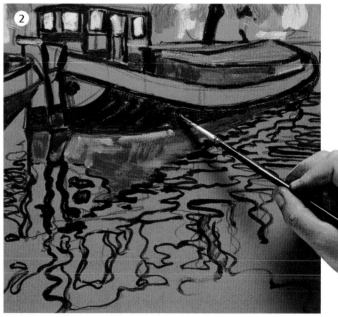

❷ We paint the boat itself with its characteristic colors using a schematic and simple approach and a Fauvist-like interpretation.

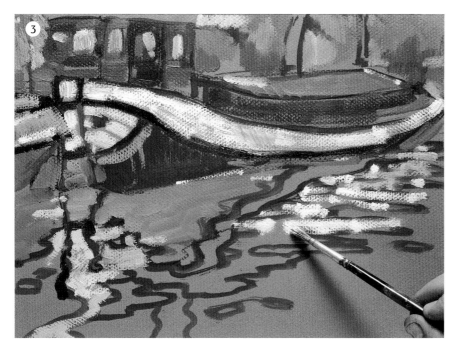

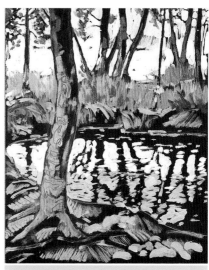

Background Reflections

It is much easier to paint the light of the reflections on medium- or dark-color surfaces. Colors should be applied only to the areas of light, leaving the shadows unpainted.

❸ The reflections on the water are covered with short and horizontal brushstrokes. We gave them a more colorist interpretation, and we lighten them with small touches of white paint.

❹ The greater the water movement, the lesser the definition of the image reflected, to the point that the reflected object and the light around it break down into a myriad of color flashes.

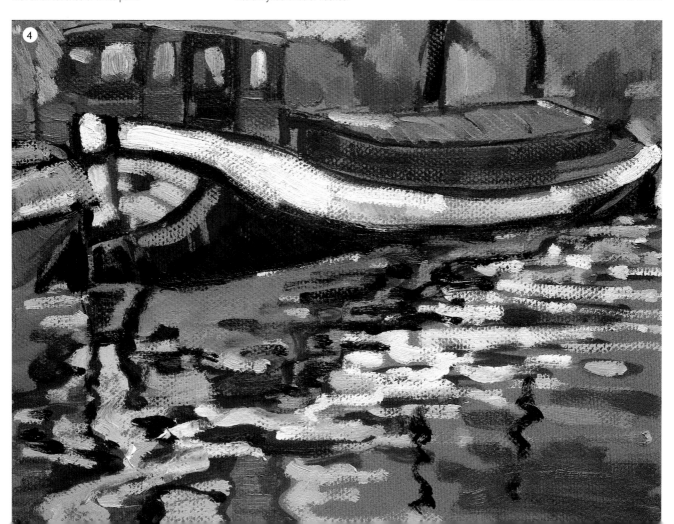

A Variety of Skies

A sky is a very attractive and very accessible theme for anyone; if you have a window or an open space, nature provides a wide range of colors and pictorial possibilities. The sky, because of its fleeting and changing nature, plays a very important role because it determines the overall chromatic tone of the landscape. It acts as a giant filter that floods everything with its color.

The Effect of the Color of the Sky

The color of landscapes changes throughout the day. At sunrise the atmosphere looks bluish, and the colors of the vegetation are dim; at midday the landscape acquires a saturated look with bright colors; and at sunset oranges and reds become the dominant hues. The sky, a great color screen, causes these changes projecting its color and affecting everything below. The sky is a fleeting and changing theme, and for that reason it is the first area of the landscape that should be painted because it conditions the entire color scheme of the work.

On a radiant day, with the sun at its highest point, the sky is bright ultramarine blue, which can be painted by blending cobalt or cyan blue.

■ The sky can present from **cold wintery scenes** with fog dominated by a range of grays to **warm evenings** full of oranges and reds.

This stormy scene is very typical of the tropics and of near and distant deserted places. The atmosphere fills up with sand, and the sky turns red. Here, we have mixed burnt sienna with English red.

A Variety of Clouds

A painting of skies often includes clouds. Therefore, it is important to learn how to paint them by establishing differences between them and by learning about the different types of clouds according to their density and thickness. Their characteristic shape can be painted by changing the type of brushstroke used and by establishing color contrasts between the clouds and the background, which will be the sky. As with the sky, clouds also change color according to where they are located, whiter when higher in the sky and much bluer and violet close to the horizon. And during sunsets, they act as screens that capture the last, but intense sun rays, which light up the sky as if on fire.

At sunset, the sky transforms and lights up with yellow and orange colors.

The clouds that are high in the sky are very white and have well-defined and sharp contours.

On a very foggy day, the sky covers the highest areas of the mountains with a thin gray veil.

Near the horizon, the clouds are thinner and their base turns bluer, more violet and yellow, depending on the time of day.

An Explosion of Colors in a Sunset

The light at sunset gives the artist a rich palette of colors, from very luminous yellows, oranges, and turquoise tones to deep blues and violets. In this case, we have the opportunity to experiment with the colors of a sunset. To this display of colors on the sky we can add the reflection of the surface of the water that multiplies its effects almost on the entire support. We have used watercolors. It is important to keep in mind that the brightest reflections and colors should be represented with the white of the support. The drying time of the different areas is also a factor to remember, so the colors do not mix together accidentally.

The view of a sunset by the sea cannot be ignored by a colorist painter.

■ In the evening, the combination of the **sun rays and the masses of clouds** can create very dramatic scenes.

❷ We wet the surface and begin painting the sky with blue, red, and yellow tones. The shape of the mountain is laid out with violet.

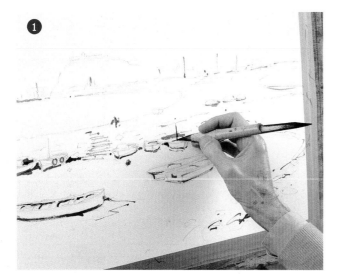

❶ We draw the theme with pencil and go over the lines with a reed pen and brown and black ink.

It is important to paint over a dampened surface and to wait a few minutes to let the colors blend by themselves.

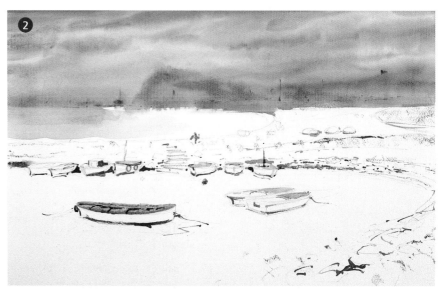

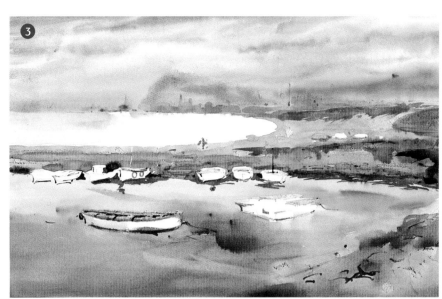

When you blend a variety of colors on wet, be generous with their intensity; when the watercolors dry they become less saturated naturally.

❸ We painted the mid-ground with brown. We wet the foreground and painted the most illuminated area of the water with an orange gradation, and the most shaded area with violet.

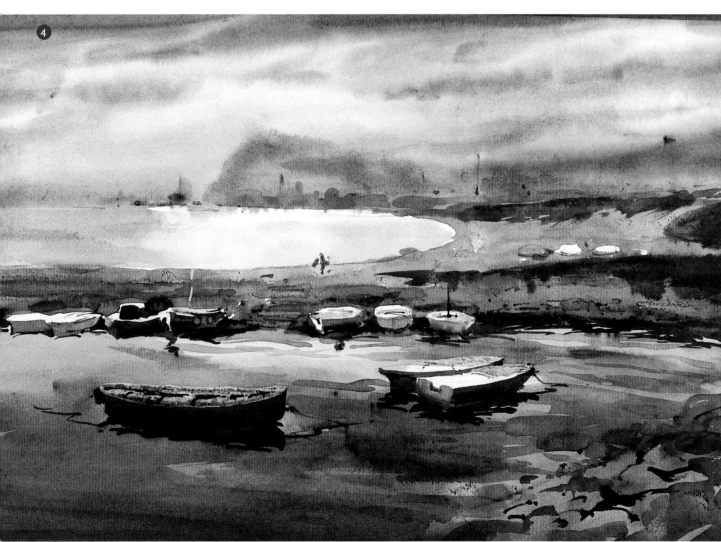

❹ Once the background is dry we begin painting the boats. It is important to prevent the new watercolor areas from mixing with the previous ones. We let the white of the paper represent the areas of more light.

Painting Grass: Overcoming the Monotony

When you paint vegetation that possesses very similar hues and values of green, it is important to approach it with a contrasted and varied palette to avoid chromatic monotony. The goal is not to paint the vegetation as it appears, limited to the real colors, but to be inspired by their vision and to plan a creative compositional and chromatic approach. See below how we have planned several studies with oils, which experiment with color and contrast to explain the texture of the grass. The first one we did by contrasting the greens with violet and pink colors, and the second, with yellow as the dominant color, showing less contrast and intensity, represents an area of grass that is farther away than the first one.

Study in Greens and Violets

The first study of grass has been done with colors that have a cool tendency. The main colors are cadmium yellow, yellow ochre, alizarin crimson, emerald green, permanent green, ultramarine blue, and a small amount of white. To add interest to the subject and to avoid monotony, we have painted the most illuminated areas of the grass with green, which has been softened with yellow, while the shadows were painted with pinks, violets, and blues. It would be very time consuming to paint each blade of grass; it is better to suggest only a few, the most outstanding ones, to be able to establish the different tonal areas easily.

The model is an expanse of grass dominated by the monotony of a homogenous green.

A study of grass in which the blues and violets are predominant and the goal is to achieve a contrast of colors and hues to create an interesting and appealing result.

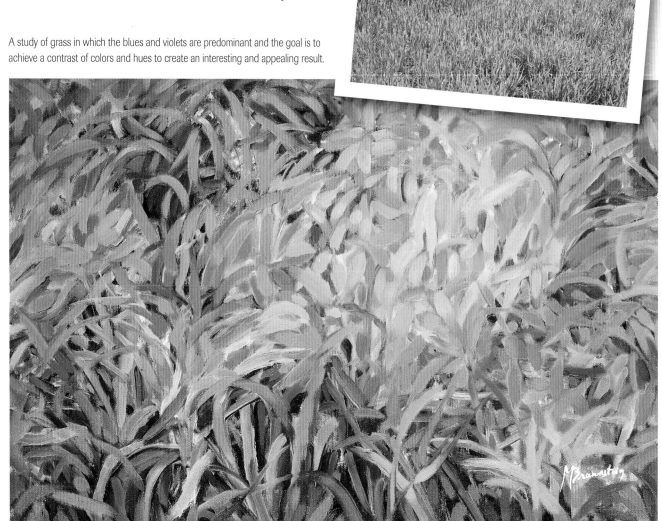

A Study with a Warmer Palette

We have painted the second study with a warmer array of colors. The palette contains cadmium yellow, crimson, emerald green, permanent green, cobalt blue, ultramarine blue, and a generous amount of white. The most illuminated areas were painted with yellow, the medium tones with yellow greens, and the areas in the shade with blue gray blended with a generous amount of white. The leaves should not all be pointing in the same direction: the visual play required variety and rhythm, showing how the stems bend from their own weight and the interplay between bent and upright stems.

Before you take on a painting of these characteristics it is very useful to prepare the canvas with a base of violet paint mixed with a generous amount of solvent. The yellow and green colors will stand out against this color background.

Although we used a much warmer green palette for this model, it is very similar to the one on the previous page, and it presents similar challenges.

Another version of a similar model, this time with more yellow, which almost covers the few remaining green colors.

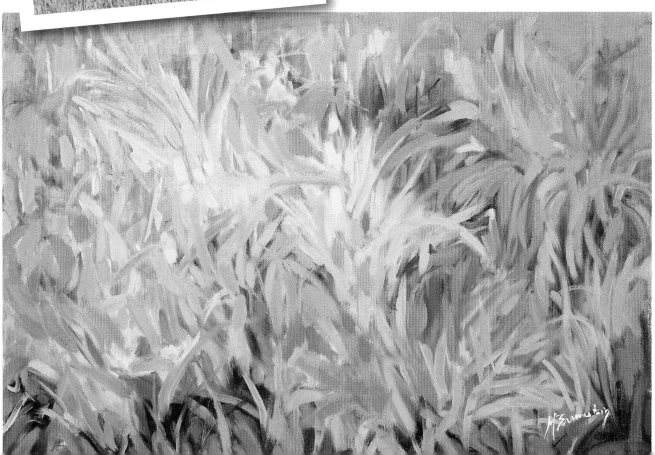

Flowers: The Best Colors

Many artists who paint still life resort to flower themes. The reason for this preference resides in the colorist nature of flowers and in the endless possibilities for color that they offer. Many artists resort to this genre as a medium from which to experiment with colors, texture, and new expressive approaches. The representation of flowers is not banal; it provides a good platform from which artists can project their most intimate feelings.

The details are ignored to focus on the power projected by the color contrasts.

Synthesis of Forms

From the pictorial point of view, the observation of flowers must be done with a single objective in mind: to find a way to express, with color, the shape of the flowers, that is, enough characteristics to help identify their particular features in a simple way. A flower has different parts. It is important to study the main features or each one of them, for example, the shape of its petals and their distribution around the crown. The observation of the peculiar shapes and of the particular colors of each component constitutes the first approach, which should be painted with bright colors and generous paint, more saturated than the way they appear in real life. Unlike vegetation on a landscape, floral compositions are painted as close-ups, which means that some petals often are cut out of the frame.

Pink colors contrast sharply against a green background and give this bouquet a vital and dynamic appearance.

■ "Few artists
are capable of
**capturing the
fragile nature**
of flowers."

John Ruskin

Flowers in a Colorist Style

Painting flowers with a colorist style means that the artist wholeheartedly believes that color can express everything, with very little use of volume or modeling. Shadows and light are represented by contrasting saturated colors. Color on its own diversifies, separates, and explains the shapes of the objects. It is best to paint flowers simply, without excessive realism. By simplifying the forms, it is easier to focus on colors.

With a few brushstrokes and strong contrasts on a solid-color background, we created a poetic and atmospheric view of a floral arrangement.

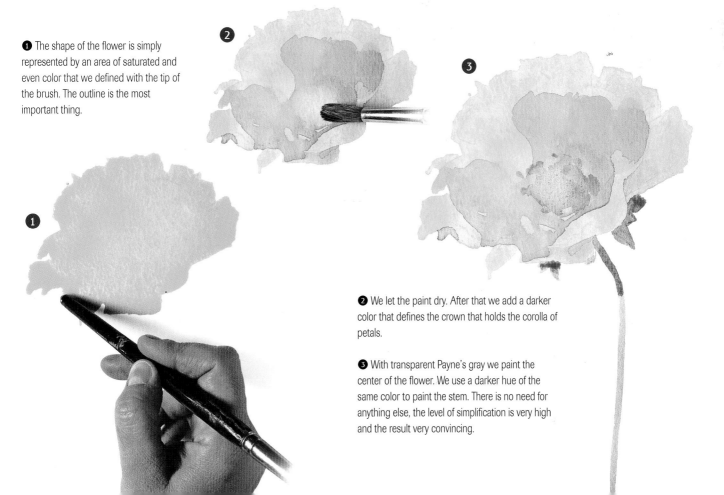

❶ The shape of the flower is simply represented by an area of saturated and even color that we defined with the tip of the brush. The outline is the most important thing.

❷ We let the paint dry. After that we add a darker color that defines the crown that holds the corolla of petals.

❸ With transparent Payne's gray we paint the center of the flower. We use a darker hue of the same color to paint the stem. There is no need for anything else, the level of simplification is very high and the result very convincing.

Nocturnes: Darkness and Artificial Light

A nighttime urban scene provides interesting color effects as a result of the dim lighting whose shadows give the theme a mysterious feeling. Here, the objects are illuminated by more than one light source and cast shadows of interesting and unusual forms, which superimpose each other with various colors. Romantic and symbolist artists were interested in the effects that artificial light provided in a city environment and in how it changed our perception and transformed everything into a theatrical-like atmosphere.

The painting on façades should be gradated to represent the dim artificial light. In both cases, the color of the sky will be a determining factor in defining the upper outline of the building by making it stand out.

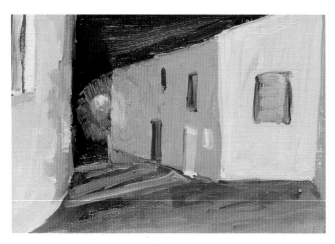

Here is a very simple note of color in a small street with white façades. We have added a light source by gradating yellow and orange.

The simple nature of color notes makes it possible to focus on the planes of color and the contrast between the illuminated areas and the darker ones.

Color Notes

The best way to begin painting night scenes and to study the chromatic effects depicted in this genre is through simple color notes that capture very quickly the color of the façades, the atmosphere, and the areas of absolute darkness, allowing the artist to identify the main points of light that produce these illuminated corners. It is a good idea to begin with small spaces (side streets, small plazas, courtyards…) that do not require a very elaborate drawing, themes in which architecture plays a fundamental role that can be worked with ease. Later you can tackle larger subjects like a city seen from a meandering river or from an elevation.

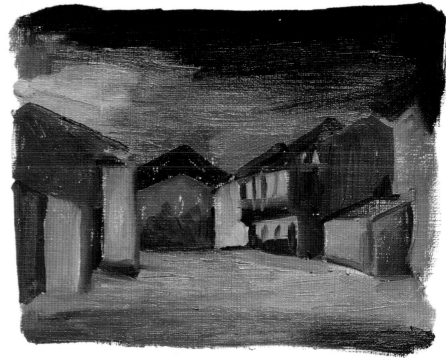

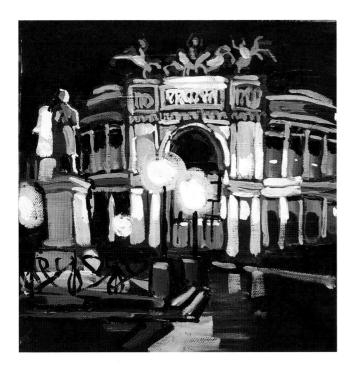

Three Basic Premises

When painting night scenes it is important to keep three basic premises in mind. Façades display gradations, where the bottom part is most illuminated and the upper part is darker, with small highlights on the windows whose lights are on. The shadows on the sidewalk or the asphalt are cast in different directions and even have different colors depending on the color undertone of the closest light source. Finally, if there are trees on the street, their lowest areas will be illuminated, making their lower branches visible, while the upper ones, which will blend with the night sky, disappear from view.

The night lends itself to unrealistic interpretations of forms and creative approaches to lighting on façades, like on this main entrance to a metropolitan theater.

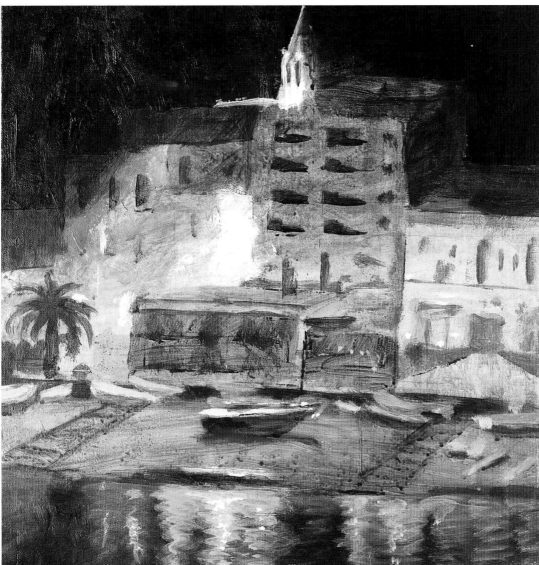

Night is not the negative result of the lack of light but the replacing of daylight with artificial light that changes the colors of the environment.

An Illuminated Alley on a Color Background

When the sun sets on the horizon, streetlights and the light from businesses replace it and light up the urban environment. In this exercise, we focus on the study of how light propagates in the gradations and on the strong contrasts that explain its incidence on façades and on the streets. We used ochre Canson paper, an appropriate support to develop a step-by-step demonstration with color pencils. The warm color background of this paper will help us balance and unify all the colors that take part in this exercise.

A night scene offers numerous artistic possibilities.

❶ With a dark brown color pencil that is very sharp, we draw the architectural features, planning this way a correct perspective of the windows, doors, and balconies.

❷ With black pencil we lay out the first shadows of the street's background. We do not paint the lamppost yet but its light beams, which are projected in the form of yellow and orange lines over the façade on the right.

To create the different shades in the drawing, we superimposed layers of colors very tightly. The combination with glazes does the rest.

A Mixture of Primary Colors

In nighttime urban scenes we do not use contrasting complementary colors for the shadows because the light from lampposts follows the principle of additive colors: red, green, and blue. This means that the shadow cast by the yellow light will have a reddish undertone, not blue.

❸ We finish by painting the lamppost with pure white. On the sky we paint a gradation that ranges from light blue to indigo. We emphasize the contrasts with the black of the windows and balconies and the borders of the sidewalk, as well as the large shadow on the lower part of the foreground.

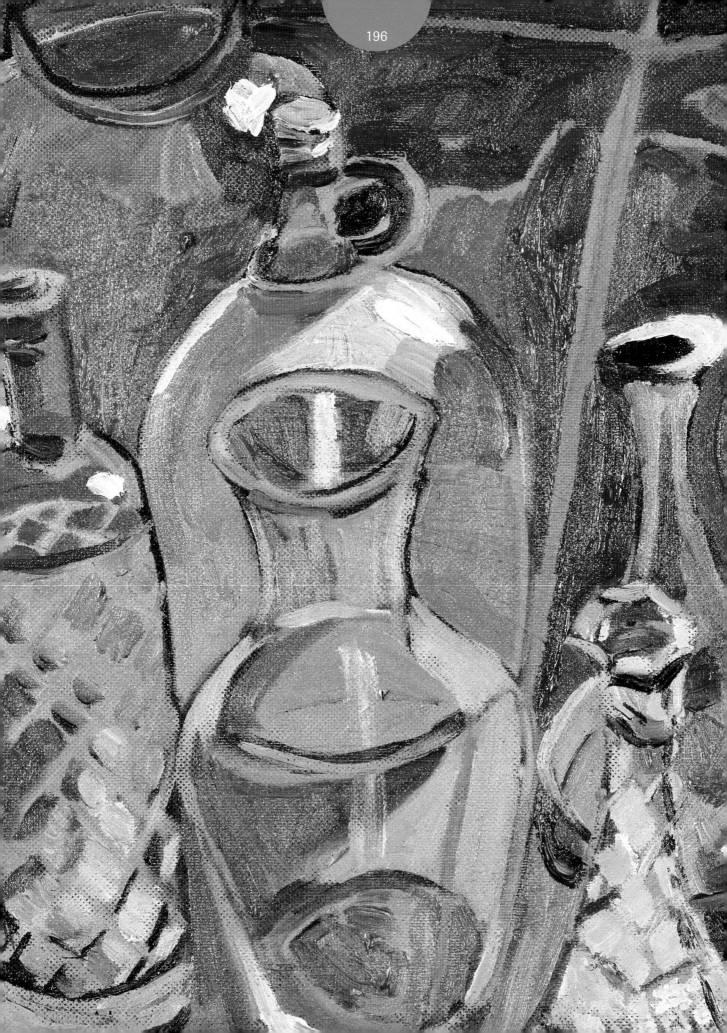

BEING CREATIVE WITH COLORS

There are many approaches and resources available to make paintings more appealing. The composition, an original point of view, an unusual interpretation…these are some of the elements that help achieve a creative and surprising painting. But color harmony is without a doubt the greatest determining factor, the ideal vehicle for transforming dull subject matter into a spectacle for the eyes, a creative masterpiece capable of moving the viewer. The basic principle of creative painting with color is to promote stimuli through color and contrast. The selection of colors and their distribution are fundamental for stimulating our senses, to accentuate the character of a painting and to find the path to interpretation and creativity. This section is for those who wish to study the use of colors in greater depth, to explore all the creative possibilities that they offer.

COLOR COMMUNICATES

Color affects our emotions much more than we think. It has a positive emotional effect that is key to the viewer's reactions, be it naturally or by association with other symbols, connecting them to an individual's daily life and emotions. Colors and feelings do not intertwine in an accidental manner; their association is not only a matter of taste but also a matter of universal experiences that are deeply rooted in our language and our thoughts from an early age. Colors can express any emotion in a strong or subtle way: joy, desperation, torment, uneasiness, calm, violence…

Wisteria. Claude Monet (1840–1926). The vegetation painted by Monet in his last years was an excuse for the development of creative color compositions that were nearly abstract.

■ **"Color possesses me.**
I don't have to pursue it. It will always possess me, I know it.
That is the meaning of this happy hour:
color and I are one. I am a painter." Paul Klee

Freedom to Paint

Fantasy and invention are not characteristics of abstract painting alone; artists can also transform any subject and change colors even when working from a life model to create an original and striking representation. Generally, chromatic creativity is accompanied by other elements, like the use of textures, more energetic lines, and a certain level of spontaneity. Drawing the model more freely responds to artistic license, to fulfill a visual effect that increases the interest of the representation.

Creativity can be the result of using different techniques for painting that depart from academic treatments.

Tendency and Style

When we look at works by the great masters of the twentieth century, it becomes obvious that there are many ways of being creative with colors. The interpretation tends to relate to the artist's subjectivity and freedom for combining colors in an original way; however, before you venture into it yourself it is important to examine some examples and to master some of the techniques, the styles, and the creative color combinations that contemporary artists use frequently. They have used the expressive qualities of color to achieve interesting representations with a personal touch.

Cubism calls for a very monochromatic color treatment and a greater level of distortion, even the breaking apart of the model.

In an Expressionist approach, gestural motions made with the brush become an expressive complement of the color.

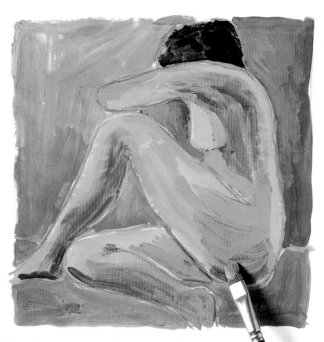

Fauvism promotes contrasts between very strident colors. The painted areas are represented with light gradations.

Color Sketches

Color sketches allow you to make small, quick notes about a particular model. This way, you can create a very personal interpretation of the theme with just a few brushstrokes. The sketches can become finished paintings in their own right or be used as notes for larger work. Painting color sketches frequently is essential for improving compositional techniques and color interpretation skills, and to test new creative ideas on any subject matter.

Painting Spontaneously

Whether you use oil paints, acrylics, watercolors, or gouache, it is important to work with abundant paint and without hesitation, even if the results are less than perfect. If it does not turn out great the first time, try it again. There is no room for trepidation or shyness; accept the risk of making mistakes. Limit the time for the color sketches to 10 or 15 minutes. In such a short time, colors will be applied very intuitively, in a way that may seem unreal, mixed quickly and applied hurriedly. This should be seen as something positive because it adds spontaneity to the final work.

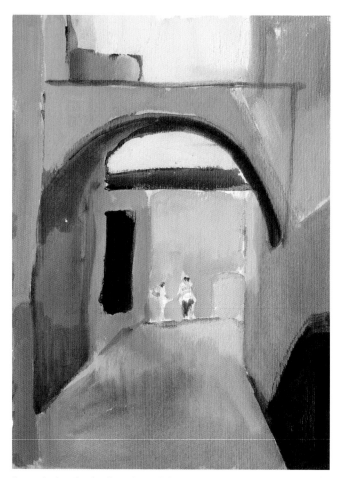

A very simple color sketch can be made by covering each area with flat and even colors. This approach provides a high level of synthesis.

Sketches of landscapes are ideal for capturing the most distinctive forms and colors of the model.

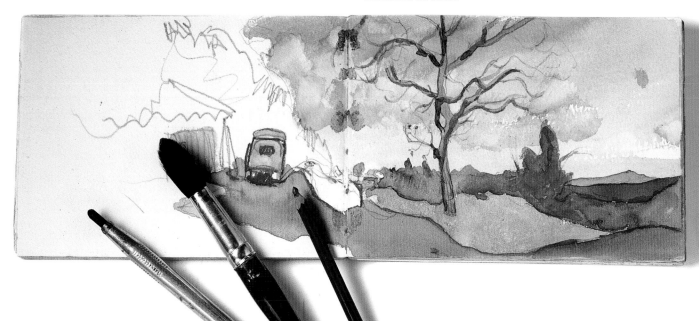

For color sketches, you should use a
generous amount of paint so the larger
areas of the support can be covered quickly.

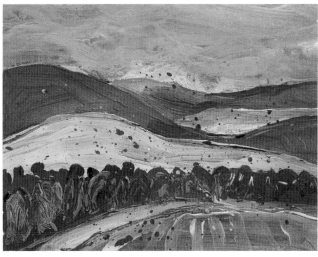

The use of this range of colors conditions the perception of the landscape,
which looks like it is burning under a scorching sun.

Working in Series

The best way to experiment with colors is by working in series,
painting the same model several times to explore all its chromatic
and expressive possibilities. Begin with the same model and give
it different interpretations to practice the different techniques
learned. For the different interpretations, choosing the level of
saturation and the range of colors is very important to convey a
specific feeling to the spectator.

The range of blue tones conveys a cooler feeling. The paint has been applied
with wide brushstrokes. The hurried approach produces tracks and drips.

The starting point
for the following
sketch is this mountain
landscape that has very
clearly defined areas.

Each note is done with different color combinations. Neither the accuracy
of the forms nor the details are important, only the succession of colors.

Deformation and Color

A painting is expressive when it has life, internal vitality, when the model conveys the idea of movement and does not look like a lifeless representation. The best way to achieve a lively representation is by distorting the structural elements combined with the use of unconventional and bold colors. When choosing colors, a quick intuitive selection may result in an unsuspected solution that did not seem obvious before. In this exercise with acrylics we lengthen the brushstroke and alternate highly contrasting colors to offer a modern and dynamic version of the figure.

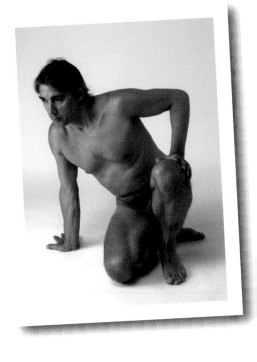

The inspiration for this exercise is a nude male figure on a white background.

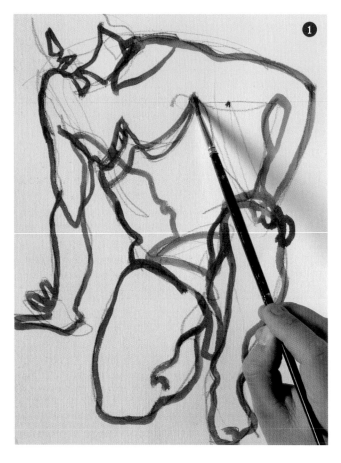

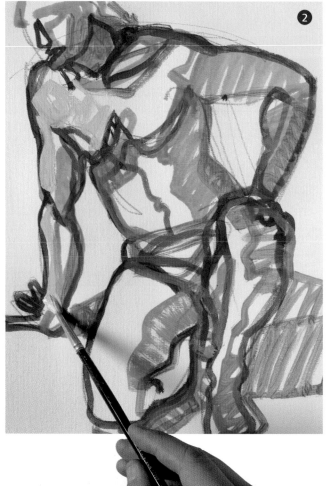

❶ The preliminary drawing is done in pencil very quickly and spontaneously. With a brush charged with red diluted paint we draw new lines over the drawing with rounded and elongated movements.

❷ With green and yellow paint we draw new lines over the previous ones following different paths. The brushstrokes are completely linear and are neither gradated nor blended.

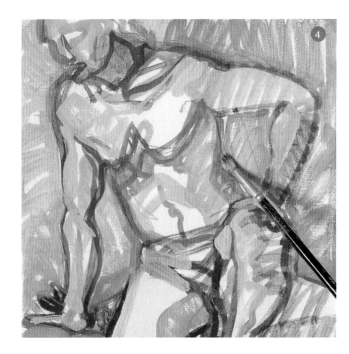

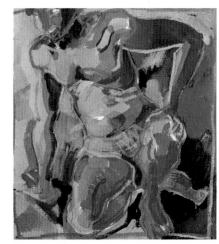

❸ We paint the background with yellow mixed with white, applying quick strokes and leaving white areas of the support partially exposed.

❹ The darker part of the background is finished with orange. The paint is applied with crosshatched lines to convey a dynamic and distorted effect devoid of solidity.

❺ We go back to green to highlight a few anatomical features: especially anything on the legs and pectorals. To finish the work we apply a few lines with red oil pastel.

You can paint the same model as many times as needed to experiment with different interpretations and color combinations.

Chromatic Lyricism

The aim of poetic painting is to represent the real model in a blurry, ethereal way that is full of sentiment. It is related to a dreamlike state, to the irrational, and the most appropriate approach for it is to use watercolors because of their delicate and subtle nature capable of creating objects that look ethereal, running over their edges and physical lines that define it. The model is thus painted with tentative and spontaneous color glazes that blend with the background, devoid of realistic features. Color takes precedence to form, which ends up vanishing. In this exercise we use an ethereal approach with watercolors. The model is white; therefore this allows us to use any color we want.

This still life with a grouping of small white ceramic objects is the subject we chose to convey an ethereal and poetic feeling.

■ The magic of this work is found on the **delicate areas of color** that barely indicate the shapes of the objects.

❶ This creative project is done on fine-grain paper and yellow washes. We use round and flat sponge brushes of various sizes.

❷ The previous wash left the paper wet. Before it dried we incorporated crimson and violet with a flat sponge brush. The water dilutes the color and expands the outlines.

The flat sponge brush is very commonly used with creative watercolors because it is very absorbent and supple.

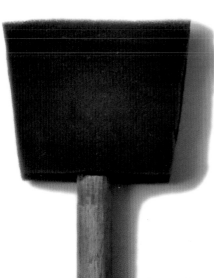

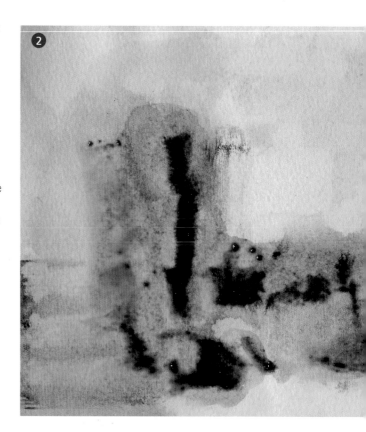

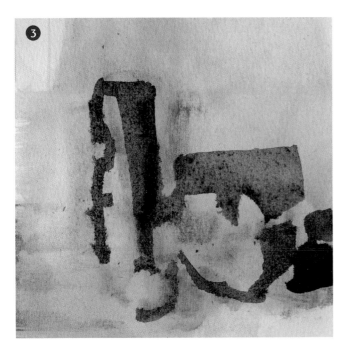

❸ The next addition of crimson is done over dry paper. The form of the model is achieved by painting the negative space, surrounding its outlines with a flat area of color.

❹ We painted an area with burnt sienna, to darken the background and leave a space that represents the objects. This outlines the composition and gives depth to the scene.

❺ Over the wet brown color we outline the form of the still life using Payne's gray. This paint is almost immediately diluted, blending with the previous washes.

Backgrounds with Contrasting Colors

Some artists prefer to use saturated and intense backgrounds for their paintings that provide strong contrast against the chosen subject. They can also leave a few areas unpainted to let the base color be visible between brushstrokes. It is important for the color of the background to interact with the rest of the colors that are included in the painting. Color backgrounds are successful with opaque and thick oil and acrylic paints and gouache, but we strongly advise against transparent treatments like watercolors or acrylic paint diluted with water.

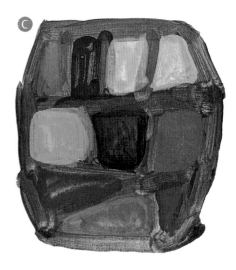

A A saturated red background over which we have painted green shapes to create a contrast between the figures and the background with complementary colors.

B Areas of warm colors over a blue background. The background does not appear as bright and relegates importance to the yellow, orange, and red shapes.

C Backgrounds painted with neutral colors, like gray brown, tend to integrate all the colors harmoniously without causing too much contrast.

Colors for the Background

There are several options depending on the chromatic effect desired. The most common colors are the neutrals: gray, blue, gray blue, and ochre. They create harmony without excessive contrasts. The more daring and the colorist artists prefer saturated colors: orange, red, electric green, yellow. Those who love chiaroscuro and shaded effects can work by slowly integrating light over a black, bright violet, or burnt sienna background.

Blues, browns, and ochres work best for the background if you want a color to create an integrating effect.

A yellow background darkens the green colors painted over it and gives off an unusual light that emerges from the background.

The repetitive presence of a very saturated orange background that is visible between the areas of color produces a vibrant and shiny effect.

The Most Comfortable Way

If you want to paint a background quickly and effectively, the best approach is to use acrylic paints and then paint over them with oils or acrylics. To paint the background, apply diluted acrylic paint evenly over the entire surface. In a few minutes, the color will be dry and ready to paint over. Many artists prefer to work over a pre-painted background because a white support is inhibiting and does not let you appreciate colors properly; most colors seem darker over white than when they are surrounded by other colors.

A dark color base is used traditionally to work with strong contrasts of light and shadow.

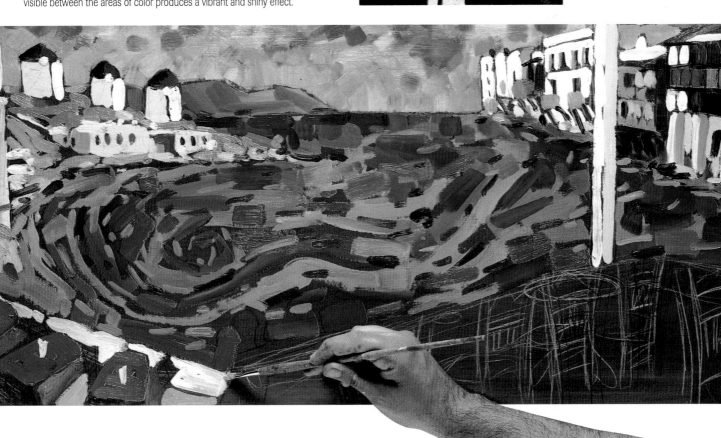

Techniques on a Color Background

This is a very easy painting method. After making a detailed drawing we apply the color that corresponds to each area, leaving a small space between them to let the green of the background define the outlines of all the elements. Working on a pre-painted support makes it easier to use medium and lighter tones because the contrast makes the latter appear more luminous. It is a way to take advantage not only of the contrast between complementary colors but also of the contrast between lighted and shaded areas. Each step has been created completely with oil paints.

The starting point is a frontal view of an old building that does not present any perspective issues.

❶ We cover the support with green mixed on the palette with mineral spirits. Since we are using oil paints, we have to wait two or three days before painting over.

❷ With a charcoal stick we draw the architectural features very carefully. Since we do not want the composition to be too symmetrical we draw the lines of the façade somewhat angled, following the diagonal of the ground.

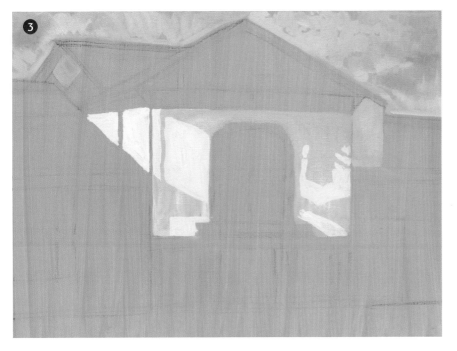

We painted the boards on the door with a variety of colors, creating a tonal scale that produces a certain effect of continuity, and left the space between the color lines unpainted.

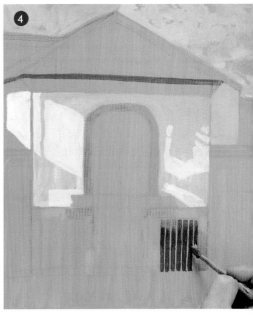

❸ With blue mixed with white we paint the sky with care, to prevent it from covering the green completely. With white very diluted with mineral spirits we paint the shadows on the façade to let the green of the background come through. The most illuminated areas are covered with very opaque white.

❹ With a soft-hair round brush we apply diluted ochre over the stone arches and lintels of the openings. With the same ochre, plus crimson and cadmium red, we paint the wood boards that conform the door.

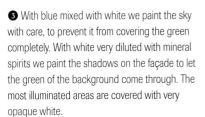

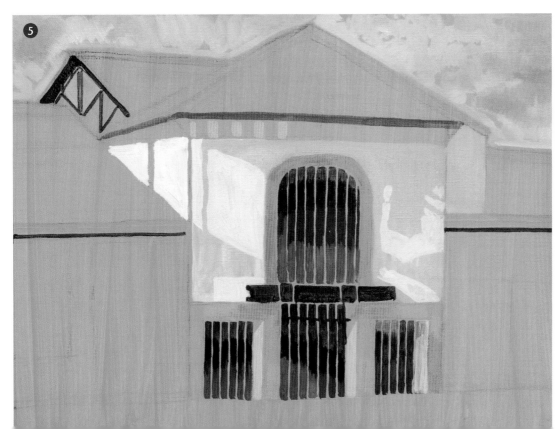

❺ We repeat the same process with all the wood doors in the center of the building, leaving spaces along the way to make the green of the background visible in the form of vertical lines. We add thick yellow ochre in the areas of light.

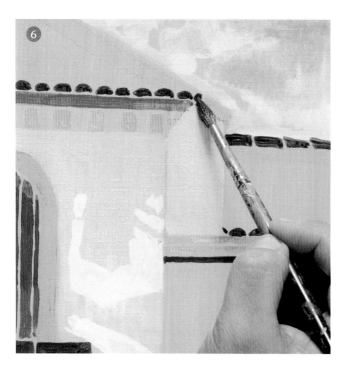

❻ We paint the outstanding features of the roof with burnt amber. The idea is to fill in the shaded areas very carefully. The green of the background is present throughout the painting in the spaces between the areas of color.

❼ Now we are going to tackle the roof. We approach it the same way as the doors, painting the most shaded areas with burnt amber in diagonal bands. Again, the green of the background can be seen through the bands.

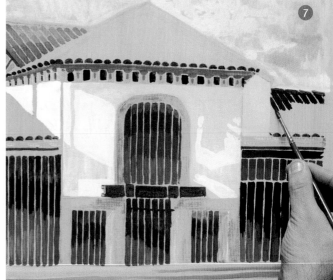

❽ You do not need to paint every tile on the roof. Each row of tiles is painted by blending two or three colors. Then, we add a few linear brushstrokes that portray the shadows.

Negative Spaces

When you work on a pre-painted support you can take advantage of the contrast with the colors of the background to make the objects stand out. Here we did not paint the inside of the chair but the space that surrounds it leaving the chair the color of the background.

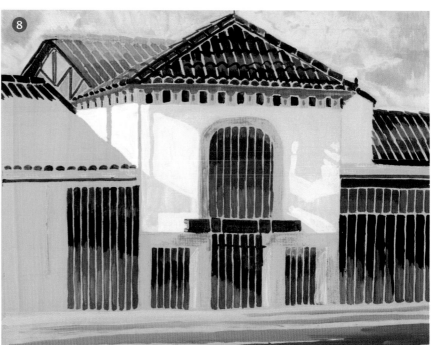

9 We paint a few isolated shingles individually with ochre mixed with white, to break up the monotony of the roof. We do the same to finish the electric post and the left side of the building. Notice how the green always shows through the lines.

To make the lines between the paint strokes, let the color of the background show through between the brush marks.

10 With the thinnest round brush we apply the last touches: the detail of the pulley over the door and the electrical wires. The latter consist of a few lines made with a very sharp black Conte pencil.

Washed Color

Washing color is a direct and aggressive technique that provides very appealing and surprising results. It consists of interrupting the drying process of the acrylic paints by applying a diluting agent before the paint dries completely to create areas of color full of nooks and crannies and unpainted areas. This technique is exclusive to acrylic paints; therefore, the diluting agent should be water. The resulting effect is similar to the one achieved with washes, the paint is not opaque, so the color below remains visible in a very subtle, airy, and atmospheric way.

First Create Puddles with the Paint

With this exclusive acrylic technique, the wash does not dry evenly but gradually from the outside in. For the paint to form puddles on the support, the latter should be texture free, a canvas board primed with gesso or one already primed; the ones sold in art supply stores work well. You can also apply the paint with thick impastos; these need less time to dry.

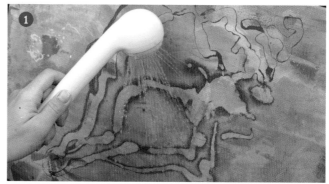

❶ When the acrylic paint is partially dry, drip water over the canvas at low pressure to wash off the wet paint.

❷ The wash leaves a hollow area of color. The shape holds up, however, because of the surrounding paint, which is the first part to dry.

Then Wash

Wait a few minutes for the paint to dry partially. Then, drip water with a hose or a handheld shower set at low pressure, if the support is large. If the area you wish to flood is very small, rub it with a brush charged with water. The wash generates a hollow line or area of color that is empty inside but that holds its outer borders. Dry the surface with a hair dryer or a very soft rag that does not cause any friction. You may repeat this process as many times as you need until you achieve the desired results.

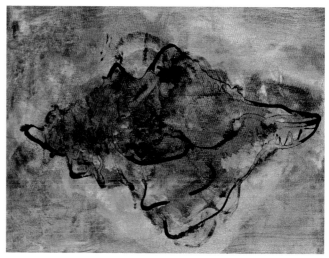

When you superimpose several washes, one over the other, you will get an atmospheric image of the object represented.

■ **Color removed by washing** produces an effect that looks like the ghostly image of the object, a blurry form that is not clearly perceptible.

❶ Washes can also be applied with a brush. First, draw a line with acrylic paint diluted in water over a textured support.

❷ Wait a few minutes for it to begin to dry. Interrupt the drying process by rubbing with a brush dipped in water or with a sponge if you prefer.

❸ Dry the surface with a damp sponge. The wash has dried only partially; now it has unpainted areas, which add great graphic appeal.

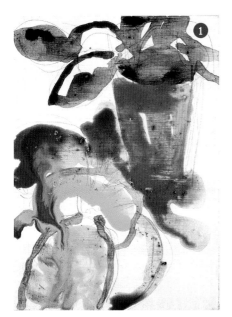

❶ Prime a wood board with a couple of layers of gesso to cover the texture. Apply a few areas of acrylic paint.

❷ Let it dry partially and repeat the process, forming a few layers of paint. The result is pleasantly surprising. This technique can be used to achieve very creative representations of themes that may otherwise appear traditional.

Multicolor Approach

We have seen before that there are three basic ways of combining colors: monochromatic mixtures; harmonizing, which relies on the relationships between adjacent colors to achieve a unifying effect; and the multicolor [colorist] approach, whose goal is to make saturated colors stand out against each other and each color is activated by the ones next to it produce a spectacular effect that is energetic and vibrant. Since the next section is devoted to creativity, we are going to experiment with the latter. Colors are not applied according to their warm or cool scale, or to the rule of complementary colors; their selection is intuitive, and the impression itself is the only guideline. We will use acrylic paints.

To create gradations, we place the saturated colors at opposite ends, and we mix them with a brush until the space in between is covered.

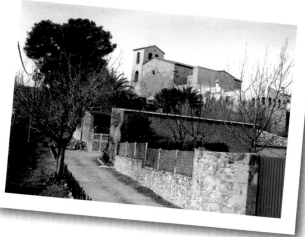

The model may look familiar because we used it before to experiment with warm colors. Notice how the same model becomes a source of inspiration for a different interpretation.

❶ The initial drawing is done quickly, everything is laid out with blocks. We draw with a pencil and go over the lines with ultramarine blue.

❷ The sky has been painted with a mixture of blue and red, while the fronts of the buildings have been constructed with gradations of yellow. We painted the path with crimson, blue, and white.

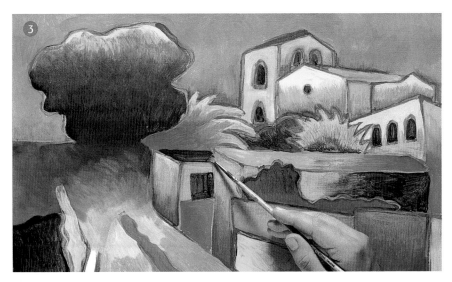

Do Not Repeat the Gradations

If you place several gradations next to each other, make sure not to use like colors. For example, place yellow next to red, because two yellows together minimize the contrast.

❸ To make all the elements of the landscape stand out, we alternate the colors: the farther away from each other they are on the color wheel, the greater the contrast will be. All the areas are painted with gradations; there are no flat colors.

❹ We painted the nearest tree and reinforced the blue lines that were painted over. Working with gradations may cause confusion in the distribution of light, but it enhances the colorist effect.

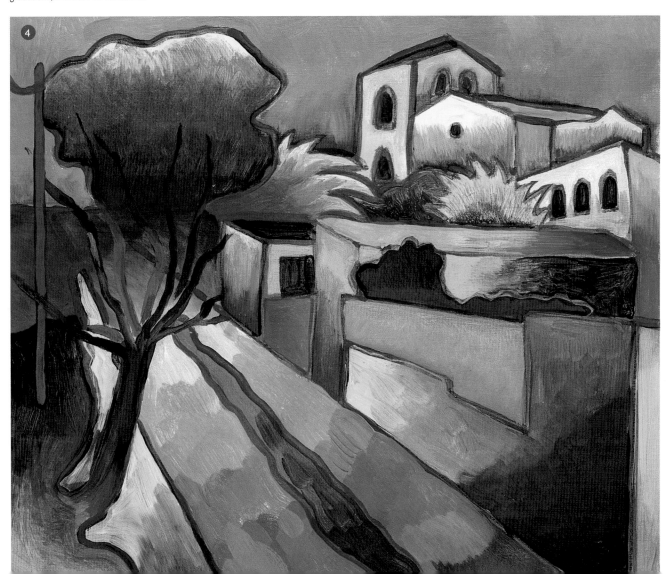

Scraping and Bands of Color

During the scraping process, the paint accumulates around the edges of flat plastic or metal spatulas, which, when pressed against the support, deposits the paint on it forming a very thick and bright layer of color. The effect will be different depending on whether you apply it on wet or dry; or if you drag the spatula forward continuously, forming stripes; or move the hand with a zigzag motion. You can also charge the spatula with two or three colors at the same time, which will produce a striated effect, forming bands of broken colors. Here we are going to experiment with this method.

Pressing hard while dragging the paint will form a thin layer of paint that can be overlaid to act as a glaze.

Spreading the Paint

Scraping or dragging is very simple. Basically, it consists of spreading the paint over a surface with a flat spatula or with any other object that has a straight edge, in such a way that when you apply the paint, a layer of color is formed of varying thickness depending on the pressure applied. It is advisable to apply pressure to create a thin layer of paint that appears translucent, very similar to a glaze. With this method you lose the ability to apply details, but the chromatic richness and the wide range of effects justifies it.

❶ To create bands of colors with the dragging method, deposit a line of paint along the upper part of the support.

❷ With a flat metal spatula drag the paint in one direction without hesitation.

❸ This method transforms the deposited paint into bands of very distinct colors that can be used as a background or to generate particular effects.

A wide spatula makes it possible to blend the colors very easily by spreading them with a zigzag movement of the hand.

Dragging Effects

If you prefer to produce greater combinations and mixtures of colors, instead of dragging the paint in controlled bands or stripes you can spread it in zigzag patterns by moving your hand slightly. The color bands appear fragmented, with very tight and pronounced curves. You can create lined effects by using toothed scrapers. They are available in art supply stores, or you can make one yourself from a piece of hard plastic.

Toothed scrapers spread the paint, producing regular sgraffito effects that look like they have been plowed.

Using a spatula will allow you to make very wide and structured applications.

You can finish the texture on walls and roofs with striated effects.

Rocky Landscape with Dragging

To prevent colors from becoming muddy, you can limit the mixtures for each dragging method to just a couple. The painting is created methodically by applying the predominant colors in each area, no matter how small, with the flat spatula. You will not be able to apply details or minute work; the painting is created with areas of color that differ in size and are well structured. This requires you to work with the edge of the spatula and to limit using the corners to a minimum. The smaller areas can be completed with small additions using a round-tip artist's spatula. The following exercise has been done with acrylics, but the results are similar to that of oils.

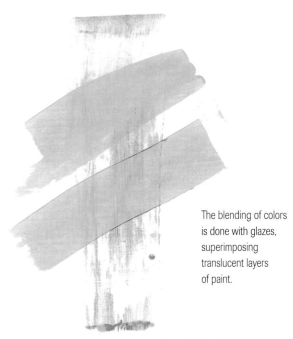

The blending of colors is done with glazes, superimposing translucent layers of paint.

❶ We use just three colors for the first step. The dragging movement should follow the angle of the mountains.

❷ We used both the flat spatula and the artist's spatula for this work, only on very small details or for making sgraffito effects when the paint was still wet.

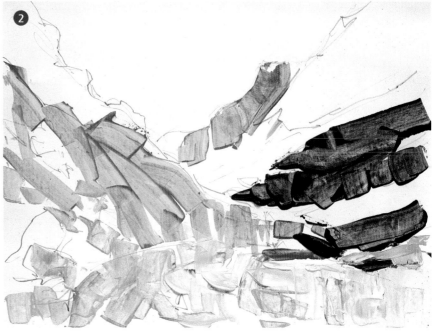

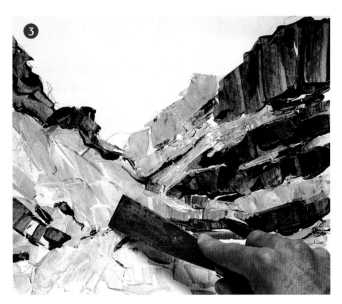

3 The previously applied colors are shaded with further dragging effects. We reduced the saturation of the yellow ochre when we superimposed a new layer of gray mixed with white.

4 The final additions of blue over the mountains are striated and broken. To give the composition some variety, we contrasted some smooth areas of color with blended areas of greater texture.

With the dragging method it is best not to mix the paint too much, or the colors will blend together excessively and the results will look muddied.

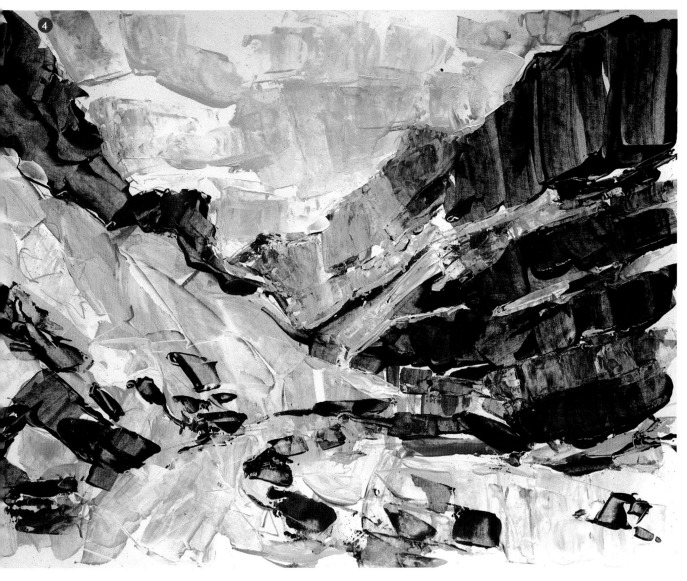

Creative Impasto

Motivated by the creaminess and expressivity of oil paints, we are going to practice making impastos with a flat spatula or scraper. We will apply wide and dense areas of color to create a very tactile effect resulting from the texture created by the edges and the thickness of the amount of paint. We will begin the exercise without a preliminary drawing, using brushstrokes with a generous amount of paint. The brushstrokes must be decisive, well planned, and applied without too much pressure on the brush, unless you wish to mix the colors on the canvas. We will finish with flat spatulas of various sizes for spreading a thick layer of paint over the support. The final result is somewhere between figurative and abstract.

Here is a Nordic landscape during a long, overcast August afternoon, with thick forests and a house with its own dock.

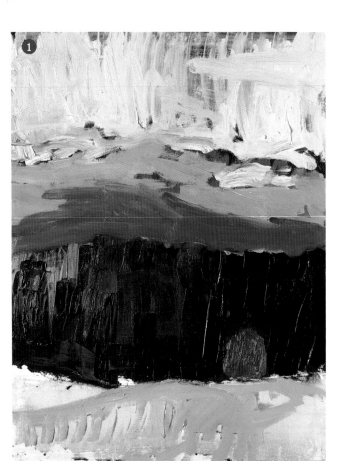

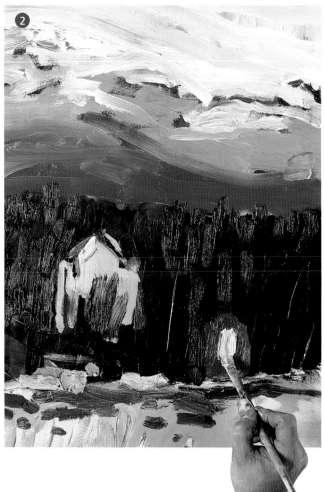

❶ We apply the first colors with a brush making sure that the tones are well planned because it is difficult to correct them after the paint has been applied if there is a lot of paint on the canvas.

❷ We lay out the main forms with the brush, carefully avoiding the accumulation of too much paint. If the latter occurs the colors will be muddied, and they will turn gray. We use very saturated colors, dispensing them directly from the tube.

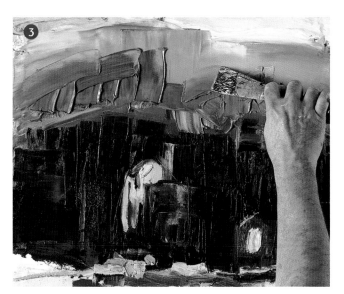

3 We define and blend the areas of color applied previously by passing the blade of a medium metal spatula over them repeatedly. The goal is to create a gradation and a few uneven outlines that give texture to the surface.

4 We finish blending the colors of the sky by dragging with a larger flat spatula, like the ones used by masons. It is better not to retouch too much because you will lose color definition and certain effects with each passing of the blade.

5 We apply the last touches of paint to the houses and the dock. In these areas the colors are left unblended to create a sense of volume and achieve a whimsical contrast of heavy paint against the vegetation in the background.

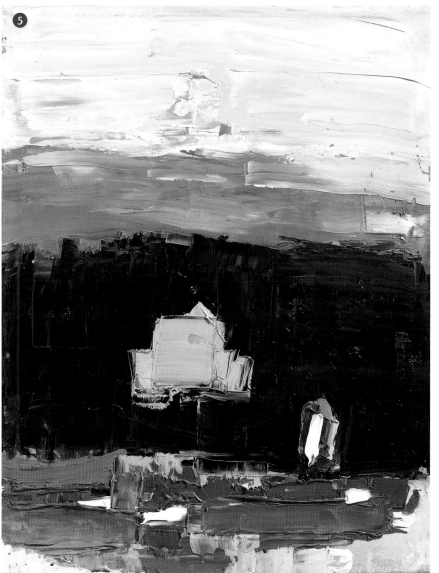

A Lot of Paint

This exercise requires the use of generous amounts of paint. The spatula should leave its mark each time that you pass it over the color surface. To conserve paint, you can add oleopasto to it, which gives it more volume and density.

Adding Texture to a Landscape

Previously, we looked at some of the choices available to give the paint volume and the effect this has in the appearance of the colors. Now, we are going to analyze a few of them with this practical exercise, through which we are going to review the components used and the options for making the colors interact with each other. Here, we have mixed oil paints with marble dust, and we have spread a generous layer over a canvas board primed with gesso. By doing this, we change the oil colors and their silky texture, allowing us to achieve more expressive and dynamic tones without having to use brighter and more saturated colors.

❶ We apply a layer of paint with a wide brush over the gesso base. The paint has been mixed with a generous amount of solvent. We blend and soften the brush lines with a rag.

❷ We now apply the saturated color. To do this we mix the paint with marble dust, oleopasto, and essence of turpentine in a bowl, and we apply it with a wide spatula.

This landscape is the ideal theme for experimenting with fillers and mediums.

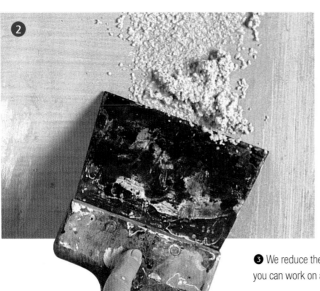

❸ We reduce the forms on the landscape to large textured and thick areas of color. For more comfort, you can work on a flat table, horizontally instead of working on an easel.

If you paint the high part of the relief with a different contrasting color, the relief texture will be emphasized.

4 We add black with a scraper with wide vigorous motions. On the sky, the same color is applied, mixed with a generous amount of solvent; for the land, the paint has a greater amount of filler.

5 To finish, we add blue to the water and to part of the sky, which gives them more light and creates greater contrast with the soil. We also add a few brushstrokes of burnt sienna over the land to lighten the effect of the black paint.

A FORAY INTO ABSTRACTION

M any artists who love the idea of a daring interpretation using bright colors foray into abstraction as a way to synthesize forms found in the real world. Abstract paintings show that the paint itself can provide great visual interest without having to represent objects or figures. In fact, abstraction requires the purification, condensation, and extraction of any form from the real world to the abstract world through an intellectual and technical process. One of the main characteristics of abstract painting is the use of a language devoid of shape and full of chromatic freedom.

■ **"Matter, Color, and Sound**:
these are the phenomena whose simultaneous evolution forms an integral part of the new abstract art."

Lucio Fontana

Colors on a red background. Gabriel Martín Roig (1970). There is no other pictorial style that offers as much freedom in the application of color as abstract painting.

The Essence of Painting

Given that abstract painting does not represent any particular real mode, although it may be inspired by one, the main protagonists of the painting are the colors, the brush marks, the lines, the texture, and any decorative element that may be added. All of these components, cleverly combined, are sufficient to give life and vitality to a painting. The overall effect of an abstract painting is two dimensional, but the contrasts and the modeling of the colors can introduce hints of spatial dimension or three-dimensionality that adds greater interest to any representation.

Watercolors, combined with India ink on silver metallic paper, enhance the lyricism of this abstract painting. The composition is based on a combination of lines and areas of color.

Color in Abstraction

In abstraction, color is manifested in every way imagined by subjectivity. It is no longer dependent on the description of volume; it has its own essence, and it becomes an element in its own right. Therefore, each color on the canvas has an independent interest, regardless of what it represents. In abstract painting, artists can use color synthesis to develop an intuitive thought, to experiment with the composition using only blocks of color, to play with shapes and contrasts, but especially, to create a surprising effect with unusual combinations responding to a single goal: expressivity.

Additional Tools

In abstract painting the end justifies the means. For this reason, you can use any tool to create new effects and textures that provide greater graphic variety to the paintings: scrapers, sprays, sponge rollers, etc.

In abstract painting, color gains autonomy and can be spread on the canvas following the artist's imagination.

Color Fields

At first impression these are very simple paintings that do not have any figure as a reference. They are characterized by their combination of bands or surfaces of solid color that are more or less uniform. The objective of such minimalist representation is to convey a subliminal feeling through color. The idea is to focus on color in its pure state and in its expressive possibilities, leaving aside lines, brushstrokes, form, and graphic elements to analyze color, its possible combinations, its contrasts, and the emotional and quiet feelings that inspire the viewer.

We have created these bands with watercolors and a wide brush. They are arranged vertically in straight and curved combinations. The airy effect on the left is achieved by passing the brush over a wet surface several times.

"This new reality is only the ABCs of the expressive techniques that quench their thirst with the **physical elements of color** (…) alone, creating architectural structures, orchestrated dispositions that arise like color phrases." Robert Delaunay

Composing with Just a Few Colors

This consists of experimenting with geometric abstractions, playing with compositional rhythms described with bands of color with edges that are somewhat blended together if oils or acrylics are used, or more diffused and transparent with watercolors. The composition should be very simple to allow color to be the main focus. Colors should be limited to only a few, the idea is not to create a colorist and bright painting but to experiment with the relationships between colors.

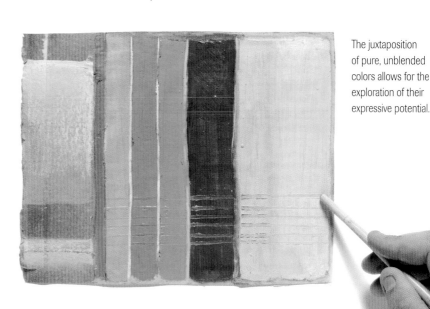

The juxtaposition of pure, unblended colors allows for the exploration of their expressive potential.

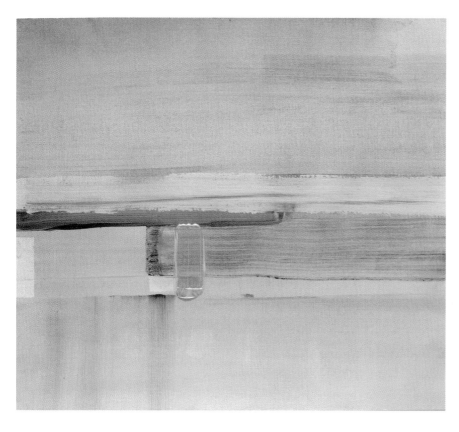

Applying and Changing Moods

Paint should be applied smoothly and evenly to create an airy feeling. Do not rush; keep in mind at all times the tones, values, saturation, translucence, and texture of the paint, because they form an integral part of the mood conveyed by the paint, all with a high degree of simplicity. Whether you use oils or acrylics, the areas of color can be changed or adjusted when they dry by defining, increasing, or reducing the contrast to see how the saturation of a particular value, tone, or color by another changes the final perception of the painting and the feeling transmitted by it.

You can create very subtle representations by painting different areas of color. Here is an example of gray acrylic colors combined with magenta in a very harmonious way.

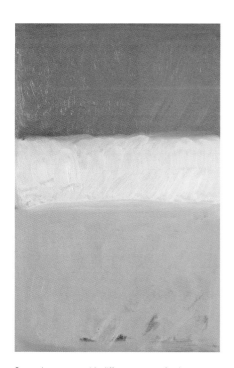

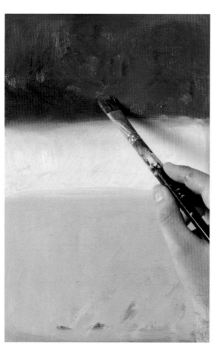

Cover the canvas with different areas of color painted with oils: pink, broken red, and orange over a completely solid red background.

When the paint is dry you can substitute colors. A green will break up the previous harmony because it creates contrast between complementary colors.

Harmony is restored with the addition of black and dark ultramarine blue. Now, the red that outlines the areas of color turns, together with the white, into one of the most luminous colors of the painting.

Dripping

Dripping consists of splattering or pouring paint on a canvas spontaneously, without a fixed pattern, in such a way that the painting becomes an "action space" that has no resemblance to the simple replica of a model. This way the force of the color will be dominant, not only because of its color value but also for the whimsical and spontaneous forms that it creates, as if the artist's actions or the physical act of painting itself gave greater meaning to the work.

Spattering the Paint

To drip paint, place the canvas or support completely flat on a table or on the floor. Dip a large brush or a spoon in a jar where the paint has been previously poured to make it more fluid, to give it a creamy consistency. Then, shake the brush charged with paint over the canvas to create drips and spatters. If you move the arm fast the drips will form curvy and rounded marks. Without touching the canvas, hold the brush a few inches away from it. If you use a spoon, when it is full of paint, place it over the canvas and pour the paint while you move the arm to guide the spattering.

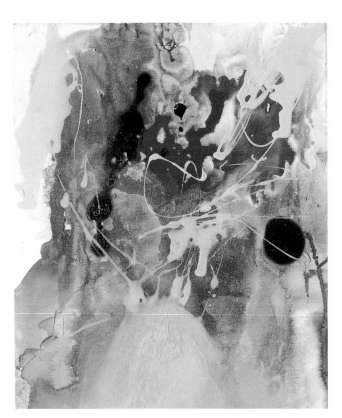

Mix the acrylics with various mediums to change the density of the paint so it is easier to drip. Pour the paint over the canvas with a large brush and a spatula.

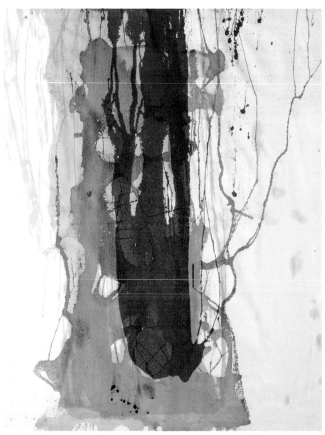

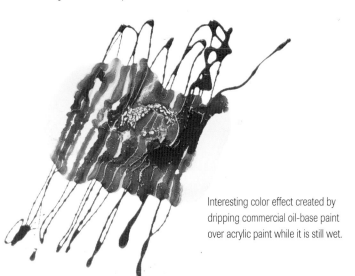

Interesting color effect created by dripping commercial oil-base paint over acrylic paint while it is still wet.

You can achieve interesting delicate and sinuous dripping effects when you tilt the support to one side.

To create an interesting dripping effect; the brush should be held at a certain distance from the canvas, which should be flat on a table or floor.

Watercolors are an ideal medium for improvising, testing, and experimenting with dripping and spattering in an easy and quick way.

Mixing Products

The dripping effects are very attractive and varied. First, because mixing oils and acrylics with different products (latex paint, metallic paints, and synthetic enamels) provides a good medium for experimentation. And second, because when the paint is applied in an unconventional way, you avoid stereotypes producing more creative results. Color and form fill up the space so intimately that they provide a very vivid, lively, and emotional effect.

For dripping, brushes can be replaced with less conventional tools, like a plastic spoon.

Gestural Abstraction

Even though the process for synthesizing the model is based on forms and colors, the gestural experience is based on the impulse and the gesture of the brush as the main method for applying the paint on the canvas. The colors are applied very intuitively with a quick movement of the forearm aiming at exploiting the expressive potential of a loose and energetic stroke. This approach is very common if you work in a genre between figurative and abstract.

Emphasizing the Gesture

Gestural painting emphasizes the value of motion, color, and material, relegating the subject matter to a background role and thus causing the viewer some confusion. This impulsive approach frees the colors from a subconscious order to transform them into vital energy that responds to the artist's emotions and personality.

A composition with fruit inspired the artist to paint this whimsical gestural abstraction in a very unusual circular format.

This abstract composition was made with quick and wide movements of the brush and a sponge. The colors activate the surface of the painting with rhythmic, even impassioned, applications.

■ For gestural abstractions **it is preferable to use large canvases**, because this technique relies heavily on the act of painting itself.

By observing a simple brushstroke close up you can see the force that its graphic quality is able to convey.

The Most Appropriate Paints

This technique can be used to paint either figurative or abstract paintings. Oils and acrylics are the mediums that make fluid, fresh, and heavy applications possible. Acrylic paints, because of their fast drying time, are ideal for a quick and direct application. Oils also provide good results as long as you do not work them too much with the brush to keep the colors from mixing too much with each other.

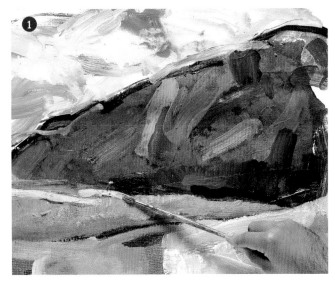

❶ The starting point is a simple coastal landscape that little by little becomes fragmented. The gestural brushstrokes give it energy and bring it closer to abstraction.

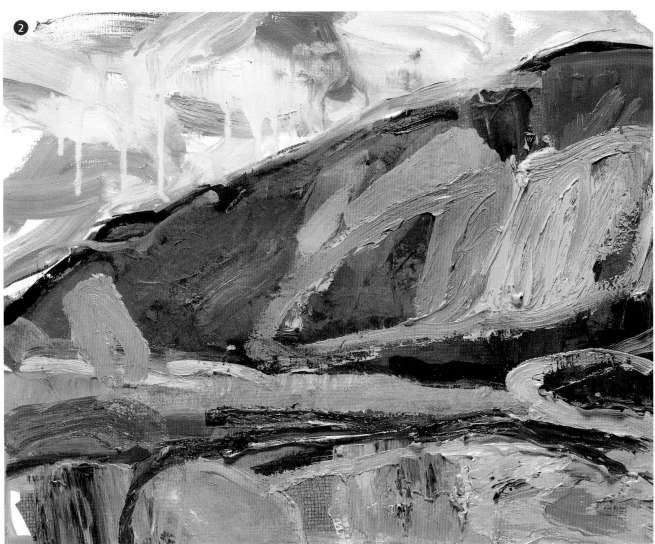

❷ We added impastos, forms, colors, and elements that have nothing to do with the real model but that have quite a lot to do with a spontaneous interpretation, mainly due to the strong gestural feeling of the lines.

EXPERIMENTS AND COMPARISONS

Noting different aspects of a subject is a good way of making an analytic and compositional study, with the intention of developing a series of color sketches that include different information about a particular model. In these small and quick color studies, it is important to change the composition, the point of view, the technique, and the painting style, and to try to experiment with many different aspects of the same theme. In this section we are going to review a few very useful methods and approaches for those who are eager to experiment and advance their knowledge of the model. It is a matter of learning how to take full advantage of the interpretative possibilities, to paint the model from a very personal and subjective point of view.

Revere Beach. Maurice Prendergast (1859–1924). Using watercolors allows you to make quick sketches of the model and to experiment with colors, because with them you can create several different notes or color studies in a short amount of time.

■ It is important for all the color notes to be **small format**.

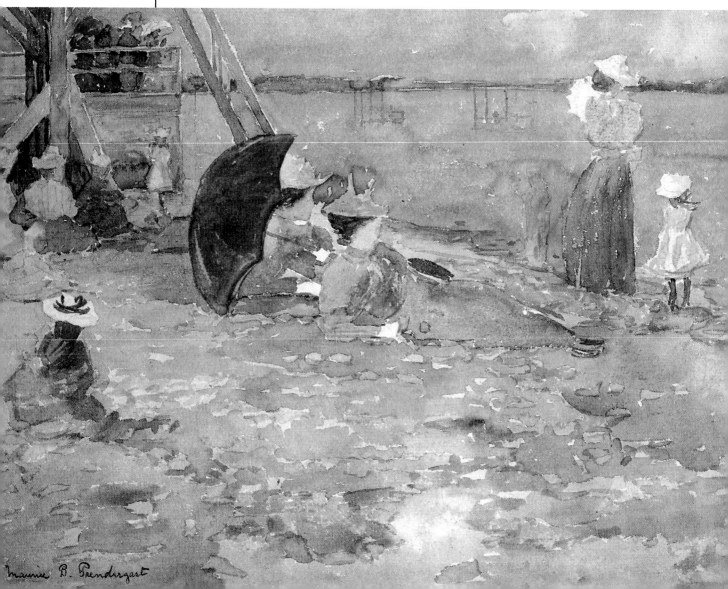

Maurice B. Prendergast

Resources for Professionals

When experimenting with the subject matter and attempting
to give it a very personal interpretation, it is important to make
many drawings or color studies; this allows you to discover all
the representational and expressive possibilities that are available.
The purpose is not to analyze the model but to test yourself as a
painter and to find out how many compositional variations you
are able to make: the more varied and diverse, the better. This is
achieved by approaching colors without hesitation, developing
the most daring effects and mixtures, and having different types
of supports available for the task: boards, sheets of paper,
textured supports of various sizes to make quick studies of any
subject matter, etc.

Photographs are very useful to
complement the information about real-life
models; they help make sense of them, and they
also allow you to appreciate colors better.

Working Schematically

To experiment you do not have to make very elaborate
works of art; it is better to create a quick study in order
to capture the basic concept of a model, an instant of its
life, which forces the artist to work with few lines and
graphic resources.

What It Suggests

It is important to spend a few minutes observing carefully the
model until you discover its most important aspects, the ones
that are worth analyzing and working in greater detail. The goal is
not to scrutinize the real image, trying to find textures or hidden
details, but to try to assimilate it internally, to see what feelings it
conveys and which colors are going to describe it best. Use your
own sensibility as a guideline to transform the real model into a
very personal and creative interpretation, even if in the end it has
no resemblance with the objects it represents.

The small color studies are a good way to test all the color effects and contrasts
that the artist may not dare to try on a larger canvas.

When you repeat a model try to change the type and placement of the colors
deliberately to experiment with different interpretations.

Several Versions of the Same Model

The best way to make progress in painting is by working in series and by relying on practicing with the same model, even if it seems repetitive, to take full advantage of all its representations and expressive possibilities. Many artists have the habit of working in series, which allows them to make many versions of the same model until they find the one that pleases them the most. This also gives them a format to analyze the composition more rigorously and to study carefully all the elements that form part of the work. When you spend time observing the real model, you will discover new details and aspects that tend to escape us and that play a role in each representation.

Comparison as a Method

One of the main tools available to artists is comparison, that is, to be able to make different versions of the same model by changing the tools and the approach used to be able to compare the results and decide on a specific approach. Then, you can spread all the studies on a table or on the floor (depending on their sizes), and you can compare them to see which ones you like the most and choose the ones that fulfill your criteria and eliminate the ones that do not. Next, you select the color notes that are more interesting and eliminate the rest as well. To better understand this method of work, here is a quick example that allows you to see the formal evaluation of several comparative paintings done with only a few sections of colors.

On handmade paper we painted a few lines with a fine brush, combining greens and reds with brown colors.

We continue experimenting with the same model as many times as needed. It is important to change the painting tools: in this case we used a fan brush.

The interpretation changes completely when we use a different combination of colors, even if we apply them with a similar brushstroke.

Changing the Atmosphere

All representations have a characteristic atmospheric effect that is determined by the interaction between colors, their distribution, the exaggeration of some effects, and the brushstrokes, in other words, the way the paint is applied. The variation of one or several of these approaches makes the subject matter look very different because they are conditioned by the atmospheric effect that each one conveys through the use of key colors.

A With reds and blacks, we create a dramatic scene; the effect is very warm, almost burning.

B An ultramarine blue sky and the green of the vegetation give the impression of a cold landscape, bathed in sunlight.

C The effect becomes cold with the addition of blues and violets mixed with white. A wider brushstroke gives the image a more fragmented feeling.

D The fluidity of the paint makes the subject matter look more fragile and intangible. It is as if everything is blended in a humid and misty environment.

Trying Different Views

Professional artists study a model carefully, and they are able to interpret it by making several versions of it to explore all the expressive possibilities. They study especially the way to break down each color and how to use composition to fit their style, even if the color study looks different from the model they started with. Every color sketch is guided by an intuitive creative impulse that is a departure from realism, supported by the effects that are created with brushstrokes and by the dialogue between the colors that are chosen in each case. This way, by combining several types of brushes and on supports that are covered with varying amounts of paint, they create a wide range of results. Let this small gallery be an example.

Below we present a series of paintings on paper. The model is a mountain with a unique shape, bathed in the light of a sunset.

A In the first interpretation, the color is applied with small dabs of thick paint over a red sky that interacts with the superimposed brushstrokes.

B The interesting aspects of paintings that look unfinished become more evident in this version. We partially painted the mountain, leaving a large part of the pink background exposed.

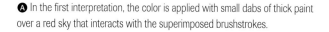

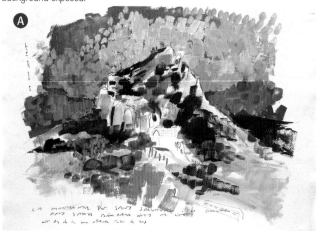

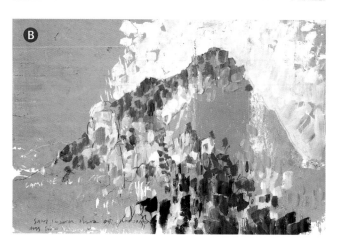

C This time we chose a vertical format to include part of the landscape in the foreground. The colors are more natural, and the interpretation looks more impressionistic.

D Using a lightly charged brush we painted a very ethereal version with blended and blurry colors on yellow paper. This is the dry brush technique, with indistinct and very atmospheric results.

E The focus of this painting is determined by the use of a fan-shaped brush. This is a very interesting tool because it produces open and airy areas of color, leaving very fine brush marks.

F The approach here begins with a solid red background and is worked with very thick and direct brushstrokes. The lines are long and project the mountain upward.

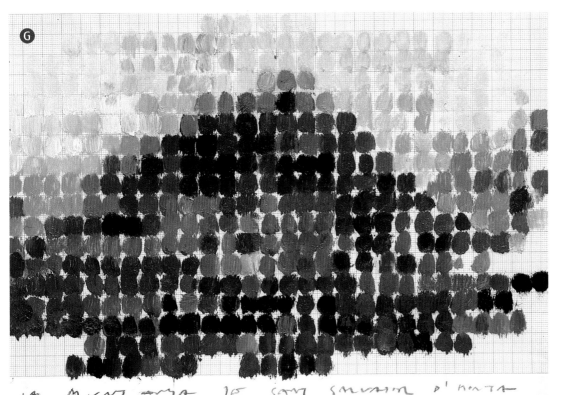

G Perhaps this one is the most radical of all the interpretations. It is a tonal study in which all the colors are broken down into small units that follow the grid pattern of the graph paper.

Glossary of Color Applications

Throughout this book we have seen that it is important to select the proper colors for a particular model, as well as select the way we apply them on the support to create a particular effect. We finish the book by reminding the reader, with this glossary, of some of the color techniques used in the preceding exercises. The main difference between them lies in the painting tools that we used, the consistency of the paint, the intent of the brushstrokes, and the way in which the colors blend and interact with each other. Here is a sample of the most relevant ones.

Application of colors mixed or diluted with a large amount of solvents. They tend to drip as they mix.

The dry brush technique consists of using paint that is barely diluted. This makes it possible to see the texture of the support between the brush marks.

Painting with blocks of color consists of using quick, short brushstrokes of opaque and thick paint.

Pointillism is one of the best-known optical color effects. It is the technique of juxtaposing many dots of color.

The technique of painting over wet white paint allows you to produce pastel-like effects resulting from the colors blending with the white layer of wet paint.

Gradations between colors are most commonly used for modeling an object or for describing the roundness of its surfaces.

By painting on wet you can blend different colors directly on the support before they dry.

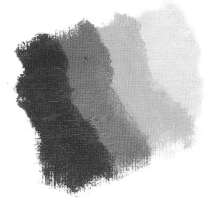

The tonal range represents the progressive gradation of a color, from dark to light. Each tone offers a small jump that does not contrast much with the previous one.

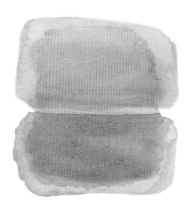

A glaze is a thin layer of translucent paint that modifies the color tone underneath.

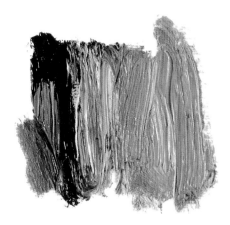

An impasto is opaque and dense, and the bristles of the brush usually leave their mark.

Thick paint can be applied directly from the tube or from a container with a spout to provide a strong relief effect.

Applying paint with a spatula is a method that provides a greater expressive feeling to the painting.

Color blocks allow you to combine different areas of saturated colors, which generally produce a geometric effect.

Textured colors are created by painting on a base primed with gel or with modeling paste; this way, the color mixes with the shadows projected by the texture.

The dripping method consists of spattering paint over the support to create splashed effects. The colors mix in an uncontrolled and accidental manner.

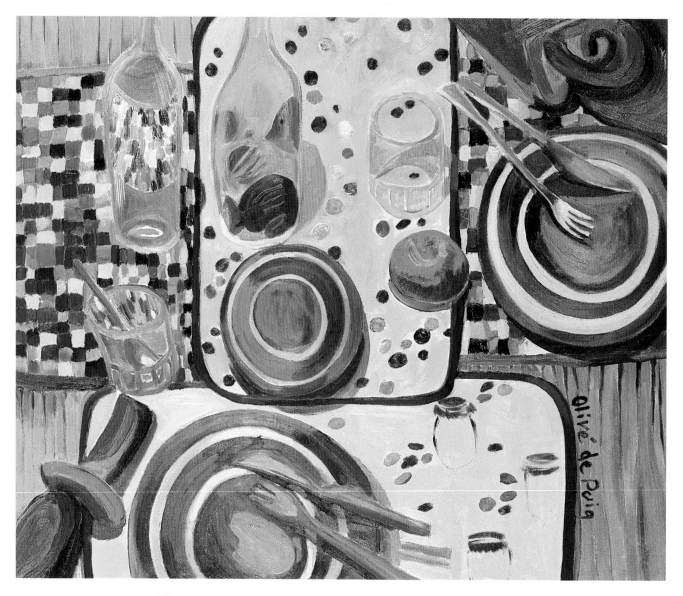

"The eye is fascinated by
the beauty and qualities of color.
The viewer experiences a feeling of satisfaction, of joy, much like
an epicurean upon tasting a delicacy."

Wassily Kandinsky